VISIONS OF
MARS

OLIVIER DE GOURSAC

CONTENTS

To my parents, my wife, and my five children: Maÿlis, Caroline, Christian, Henri, and Philippe.

Visions of Mars is warmly dedicated to all those, and their wonderful teams, who made possible the imaging of the planet Mars through the design of clever cameras mounted on spacecrafts: Robert Leighton (*Mariner 4, 6,* and *7* orbiters); Vladimir Perminov and Georgi Nikolayevich Babakin (*Mars 2, 3, 4, 5, 6,* and *7* orbiters and landers); Harold Masursky (*Mariner 9* orbiter); Raymond Arvidson and Thomas Mutch (*Viking* landers); Michael Carr and Gerald Soffen (*Viking* orbiters); Jacques Blamont (*Phobos* lander); G. Avanesov and Alexey Kuzmin (*Phobos* orbiters); Michael Malin (*Mars Observer* orbiter); Jacques Blamont and Gerhard Neukum (*Mars 96* orbiter); Peter Smith, Matthew Golombek, and Horst Keller (*Mars Pathfinder* lander); Michael Malin (Mars Global Surveyor orbiter); Philip Christensen (*Mars Odyssey* orbiter); Colin Pillinger and Andrew Coates (*Beagle 2* lander); Gerhard Neukum (*Mars Express* orbiter); James Bell and Steven Squyres (Mars Exploration Rovers), Michael Malin, Alfred McEwen, and Richard Zurek (*Mars Reconnaissance* orbiter); and Michael Malin, Peter Smith, Roger Tanner, and Horst Keller (*Phoenix* lander).

Also, to all those who supported (for more than twenty years in some cases) my educational projects and nonprofit activities for the promotion of space and planetary exploration in France as well as in America: Adrian, Alain(s), Albert (s), Alexandre, Antoine(s), Audouin, Barry, Béatrice(s), Bernard(s), Bertrand(s), Brigitte, Charles(s), Charley, Cheick, Christian, Constantin, Conway, David, Denis, Dorothée, Edmond, Elizabeth, Etienne, Francis, Frank, Franky, Gilles, Glenn, Henri, Jacques(s), James(s), Jean-Claude, Jean-Louis, Jean-Paul, Jean-Vincent, Jurrie, Louis, Luigi, Marjorie, Maria, Marie, Martine, Maryline, Michel, Michèle, Mourad, Myriam, Nadège, Nathalie, Nicolas, Olivier(s), Palme, Phil, Philippe(s), Pierre, Richard(s), Robert(s), Rodrigue, Romain, Salsa, Serge, Stephen, Sue, Thierry, Timarette, Valérie, and Virginia.

The moon Phobos flies over the giant volcano Ascraeus Mons. Only the volcano's summit at 59,774 feet (18,219 m) is visible above the clouds (*Viking*). ▼

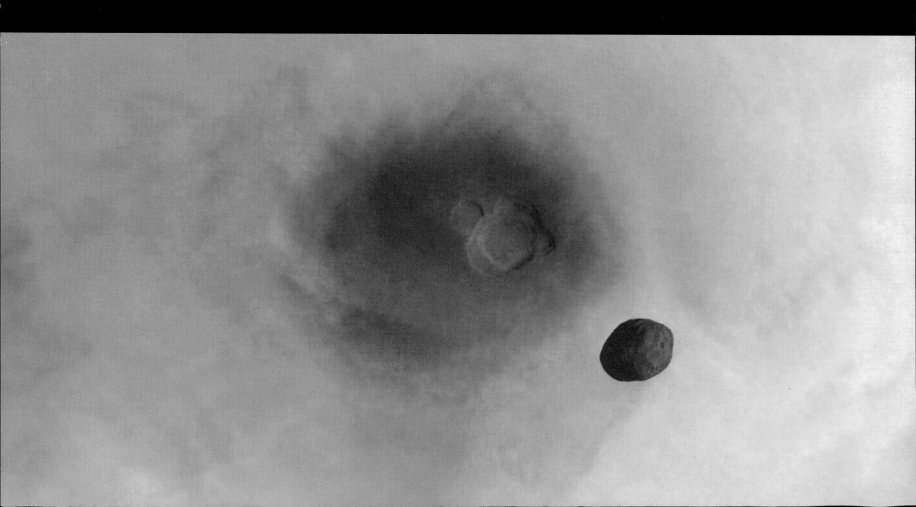

Mars has been called the "final frontier" because it evokes the sense of wonder and mystery that science fiction valiantly tries to capture. The real Mars is far more magical and impressive than anything science fiction has ever been able to capture, thanks to the amazing voyages of a fleet of robotic spacecraft that only today are providing all of us with a sense of what the planet is and was really like. In *Visions of Mars,* Olivier de Goursac describes the emerging face of Mars with evocative images drawn from the best of the robotic exploration missions to the red planet, starting with the *Viking*s of the later 1970s. Mars is always best imagined through the lens of images because in words it loses its sense of majesty, and Olivier's *Visions of Mars* gives anyone a firsthand view of some of the most memorable vistas the red planet has ever provided.

The story of the real Mars is an unfinished one, awaiting perhaps decades of continuing robotic exploration until the time that people journey to the sandy shores of our neighboring planet. Until that time, the images captured by spacecraft such as *Viking,* the Mars Global Surveyor, *Mars Odyssey, Mars Express,* and the rovers *Spirit* and *Opportunity* are the best means of sharing in the experience of exploring another world as if one were there. To many scientists, myself included, Mars comes alive in the mind's eye through such beautiful images, bringing its mysteries into focus. *Visions of Mars* brings Mars alive to any reader, providing a sense of artistic wonder to its sometimes-beguiling vistas and landscapes. For today, the Mars we imagine is very different from that of less than a generation ago. The *Viking* mission of the late 1970s provided one view of a rather bleak, inhospitable world, perhaps not well suited for life at any time. Yet thanks to the brilliant discoveries of the Mars Global Surveyor, the wealth of information from Martian meteorites found here on earth, and the latest results from the *Odyssey, Mars Express,* and Mars Exploration Rover missions, the new Mars is staggeringly more compelling, offering possibilities not imagined even only a decade ago.

Today we know Mars harbors a vast reservoir of modern water as ice within its polar ice caps and within its high-latitude soil as well as processes that allow liquid water to emerge from cliff-sides to produce gullied landscapes commonly observed here on earth. In addition, the Mars Exploration Rover *Opportunity* has discovered evidence of ancient shallow salty seas on Mars of unknown extent but suggestive of a former environment on the red planet much more conducive to life as we understand it than ever before. The picture of the new Mars is far from complete, much like a great masterpiece unfinished, yet the images displayed in *Visions of Mars* are representative of what is to come as the robotic voyages of a new generation of spacecraft reveal the true nature of our planetary neighbor.

On a more personal side, I have known author Olivier de Goursac for twenty years, and his unbridled enthusiasm for the exploration of Mars is contagious, and knows no earthly bounds. This gorgeous book is a fitting tribute to Olivier's passion for Mars, which I have observed firsthand when he and I first began our joint exploration of the planet through the fantastic images from the *Viking* landers. Throughout the ensuing years, Olivier and I have followed our different pathways, but have always intersected through our mutual passion for things Martian. It is an honor and privilege for me to provide a few fleeting comments at the opening of Olivier's latest book, *Visions of Mars,* because of the bond to Mars we both share.

This is Mars's "time," and *Visions of Mars* brings the planet alive for all to share amidst the wonder of who we really are and where we are going. Its timing is ideal, given the renewed interest in the exploration of Mars catalyzed by the wildly successful robotic explorers presently charting the landscapes of a planet with a rich story to tell. These images evoke a side of the real Mars that is beckoning—stay tuned, they seem to say, as the best is yet to come!

DR. JIM GARVIN, NASA CHIEF SCIENTIST
NASA HEADQUARTERS, WASHINGTON, D.C.

Why Does Mars Fascinate Us So Much?

Interest in the small red planet is nothing new. A huge body of imaginative work, created mainly since the nineteenth century and the discovery of supposed "canals," has fed our hunger to know more of Mars. With science fiction's adoption of the Martian theme, the planet has become the refuge of our far-reaching imagination. Because of it, humanity lives new adventures. At this point in history we no longer navigate unknown seas, but we do send silver ships through interplanetary space to discover new worlds.

Mars is the next planet beyond Earth, according to position in the solar system. It is one of the two worlds close to Earth; on the other, Venus, the nearness of the sun creates infernal climatic conditions. The study of Mars enables us to understand Earth and its particular place in our solar system.

Mars didn't actually interest many people before 1610, when Galileo turned his small telescope to the red planet. It earned its name in antiquity, when people associated its color with the god of war. In 1666, the French astronomer Jean-Dominique Cassini learned that Mars's period of rotation was 24 hours and 40 minutes, a measure that today's calculations still show was accurate to the minute. Cassini saw a white spot at each of the planet's poles that increased in winter and decreased in summer, and he correctly identified those as polar caps. He also calculated that Mars was 150 times farther from the earth than was the moon. Finally, he deduced that Mars was half the size of Earth.

Developments in refracting telescopes led to big advances in the study of this neighboring planet. The first maps of Mars were made in 1840. The famous "canals" were first described as such in 1869, when Father Secchi, an astronomer in Rome, called the fine dark lines that can be discerned on the planet's surface *canali*. Observations increased. Astronomers wanted to take advantage of the particularly favorable opposition (the moment when the sun, Earth, and Mars are aligned) predicted for 1877: on September 5 of that year, Mars was only 35 million miles (56.2 million km) from Earth. At that time, two small moons were discovered in the planet's cloudy atmosphere and named Phobos and Deimos.

Some time later, Giovanni Schiaparelli, using his excellent telescope, drew the most detailed map of Mars ever made up. He also believed that he could see many lines and called them *canali* in his cartography. In 1894, the American astronomer Percival Lowell thought that these lines represented the irrigation canals of a dead civilization. Four years later, the writer H. G. Wells took up the idea in his legendary *War of the Worlds,* in which seemingly invincible Martian killing machines invade the English

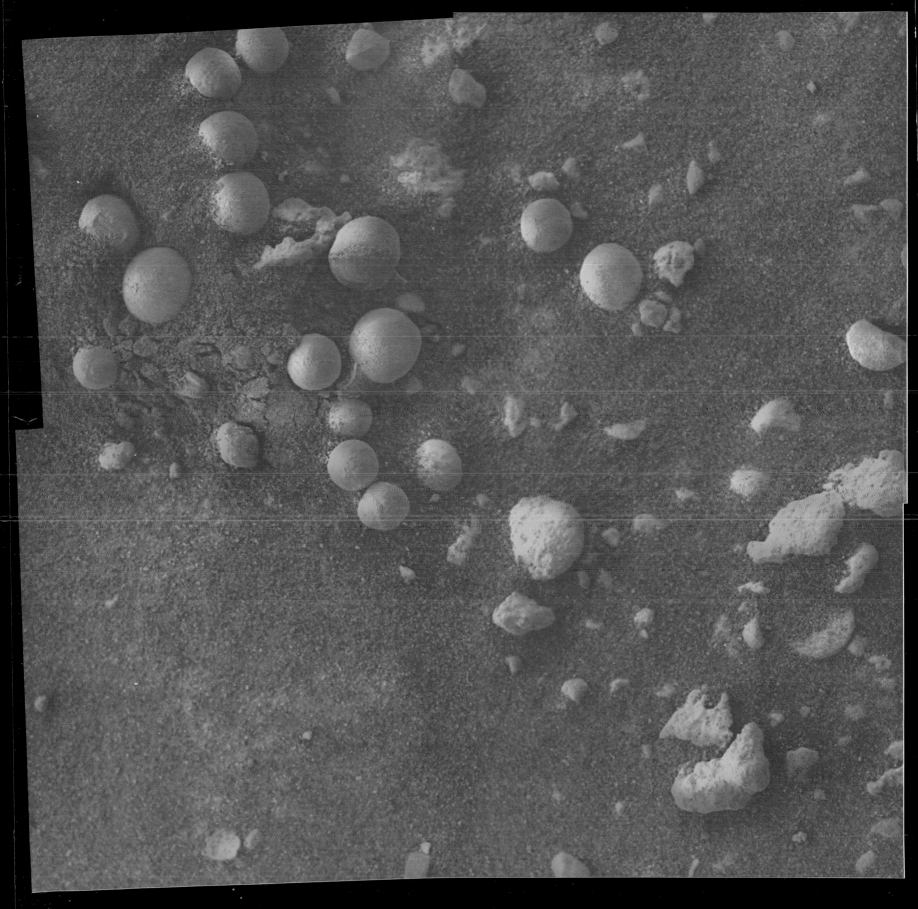

countryside. This myth would fuel the imaginations of millions of earthlings for many decades to come.

In 1909 Lowell's canal theories came under dispute. Astronomers had calculated that the Martian air must be less dense than Earth's due to the planet's weaker gravity: at most, it could have only 14 percent of Earth's air density, with an average temperature close to −40° F (−40° C). Mars was then perceived as a world too cold and hostile for life. It was thought that the most advanced Martian life would resemble moss or lichens.

But the public did not take in these facts, and everyone still believed in Martians. On October 30, 1938, the twenty-three-year-old Orson Welles caused a real panic in New York with a radio broadcast. On this night before Halloween, his too-realistic adaptation of *War of the Worlds* caused thousands to flee New York City in the wake of a supposed Martian invasion.

After World War II, the red planet once again inflamed the imagination of the public and researchers. Two cult novels were published in 1950: *The Martian Chronicles,* by Ray Bradbury, and *The Sands of Mars,* by Arthur C. Clarke. In 1952, Werner von Braun published what quickly became bedside reading for any missile engineer: *The Mars Project,* in which ten large rocketships are sent to Mars. Finally,

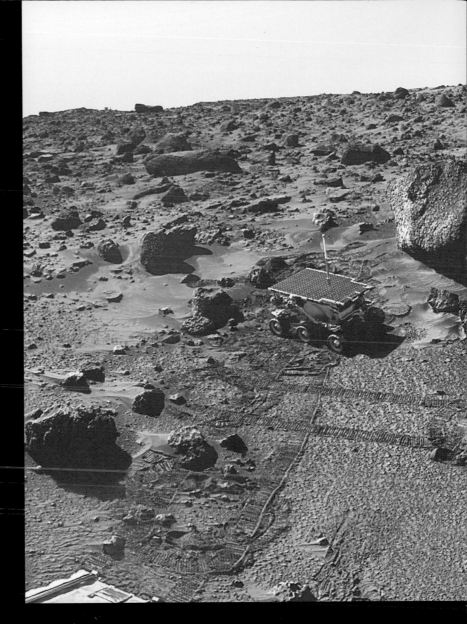

1954 witnessed the great cinematic success of *War of the Worlds,* directed by George Pal.

While the drought and volcanic inactivity of the planet were eventually confirmed, it was seen that if they were in a state of lethargy or hibernation, certain microorganisms from Earth could survive on Mars. After *Mariner 4* transmitted its findings in 1964, scientists concluded that developed life did not exist on Mars. If there were such things as Martians, they must have taken refuge underground in the form of anaerobic bacteria. However, just before the second *Viking* probe landed on Chryse Planitia in 1976, the astronomer Carl Sagan was still imagining organisms that lived under carapaces—like turtles—or used stones as shelter from the sun's lethal ultraviolet rays.

Through the use of space probes, we have finally set out to explore Mars. Formed by the four primal elements—earth, fire, water, and air—Mars offers us spectacular images and panoramas while it awaits the arrival of man. Will we know how to respect it, or will we prefer to form it in our own likeness?

The red planet is a formidable dream machine, capable of inflaming visions of conquering new worlds: Mars, our gateway to the stars!

▲ The *Sojourner* microrover has just descended *Pathfinder's* ramp (foreground left) and is going beside the large rock Yogi to the right (MPF).

EARTH

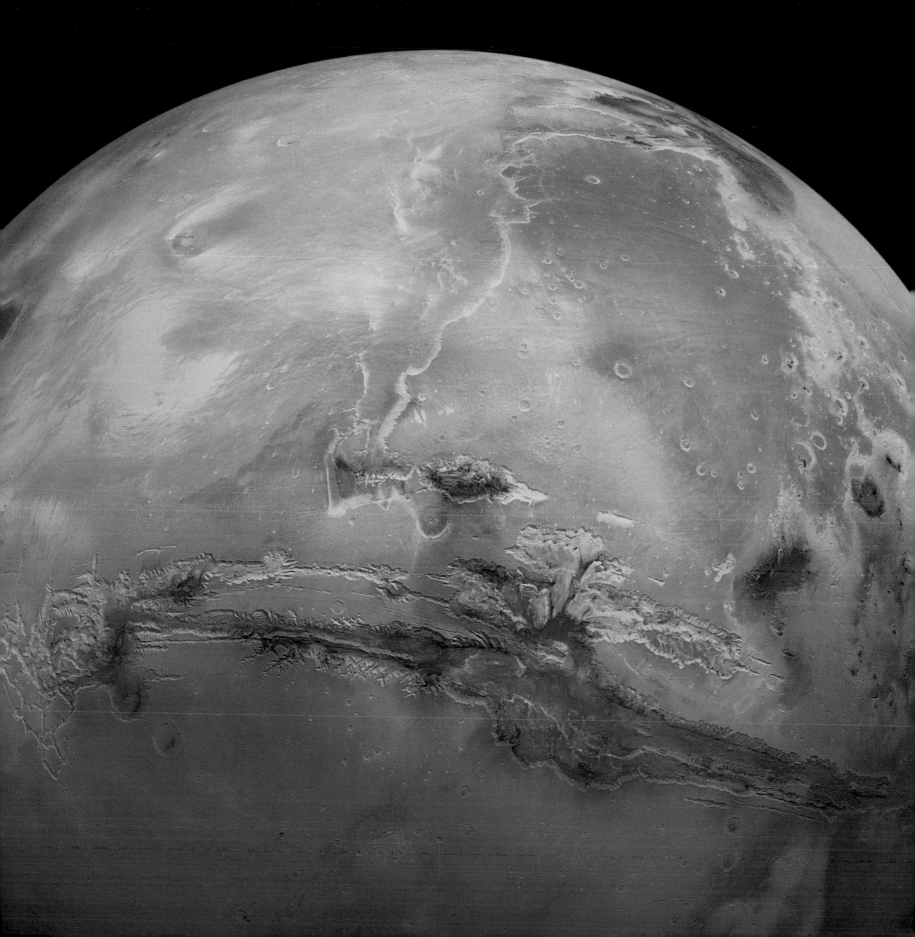

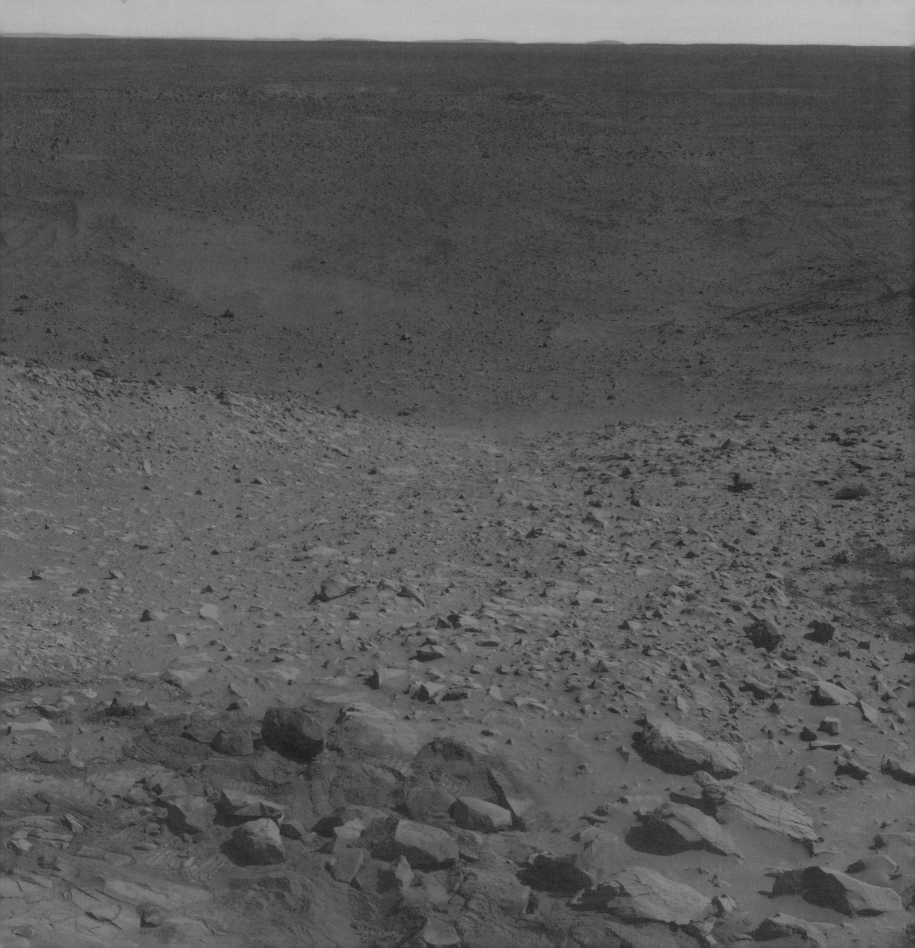

ALL MODERN KNOWLEDGE OF MARS COMES FROM SPACE EXPLO-
RATION. THAT WORLD HAS NOW BEEN REVEALED TO US
FROM EVERY ANGLE. WHEN AN INTERPLANETARY SPACESHIP
APPROACHES THE RED PLANET, ITS BEAUTIFUL COPPER COLOR IS THE FIRST

In size, Mars falls between Earth and the Moon, and all three bodies share a similar history. For instance, Mars's past seems to have been very much like Earth's. Here and there traces of gigantic floods testify to an abundance of water that once flowed freely in a climate that was probably favorable to the emergence of life. The red planet has already shown its very active geological life. It could be seen as a small Earth that aged too fast and is now frozen.

The surface of Mars has an uneven topography, and we have discovered a great difference between the planet's two hemispheres. The planet's northern hemisphere seems very young. Covered with large, flat plains and few craters, it also features rugged landscapes. Its many volcanoes, plains of cold lava, and enormous canyons are evidence of a once-active geology. Between latitudes 20° N and 75° N, sea level is measured at approximately 3 miles (5 km) *less* than the planet's average radius. Above 50° N, great expanses of the surface are flat. These lands of gorged ice resemble Siberia's huge tundra, with two exceptions. The volcanic Tharsis Plateau bulges up

nearly 5 miles (8 km) above the mean radius at the base of three of Mars's four giant volcanoes; the volcanic region of Elysium rises 2 to 3 miles (3 to 5 km) above the surrounding plains.

Mars's southern hemisphere looks much like our moon. It is dimpled with impact craters that testify to the upheavals marking the beginning of our solar system. Altitudes reach to about 2 miles (3 km) above the planet's average radius. The only exceptions are two large basins, Argyre and Hellas, created by gigantic asteroid impacts. They are the deepest places on the planet, at up to 5 miles (8 km) below average Martian level. The shock that created Hellas is thought to have been powerful enough to make the whole planet vibrate like a bell. In the antipodes, this could have generated a convective movement under the crust in the planet's pasty and hot mantle, which may have created the volcanic bulge of Tharsis.

Titanic bombardments from giant asteroids are probably responsible for the astonishing dichotomy between the hemispheres. But very soon after Mars was born, the

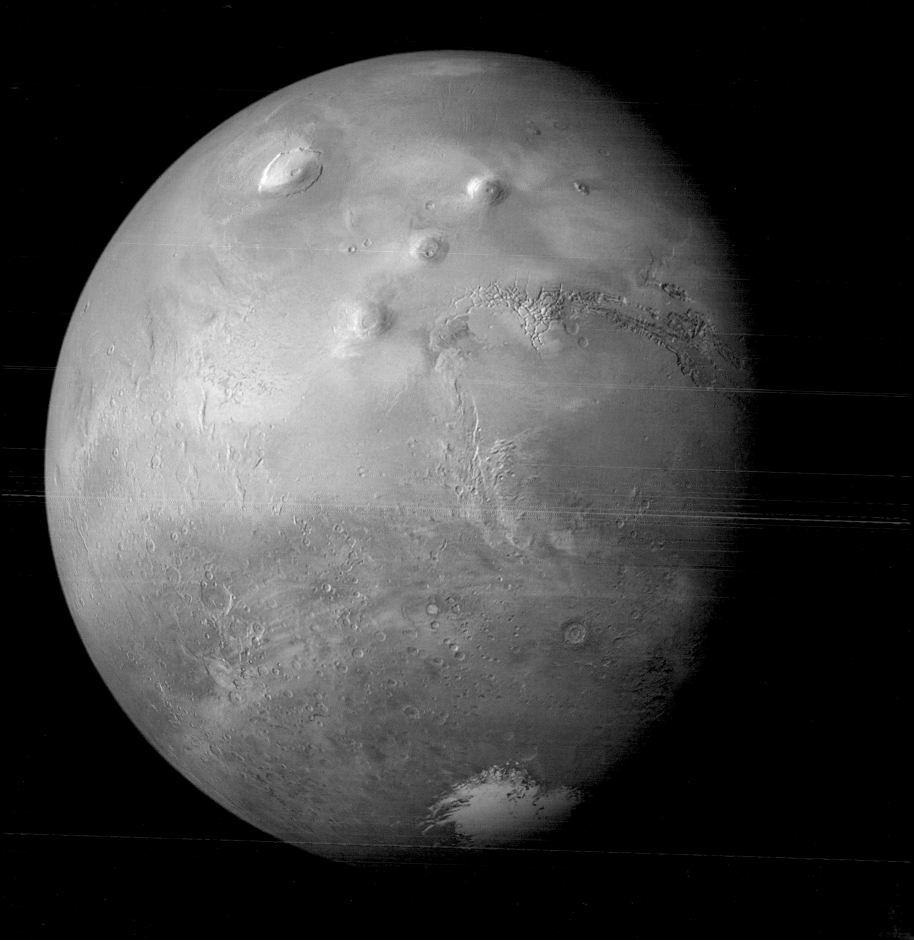

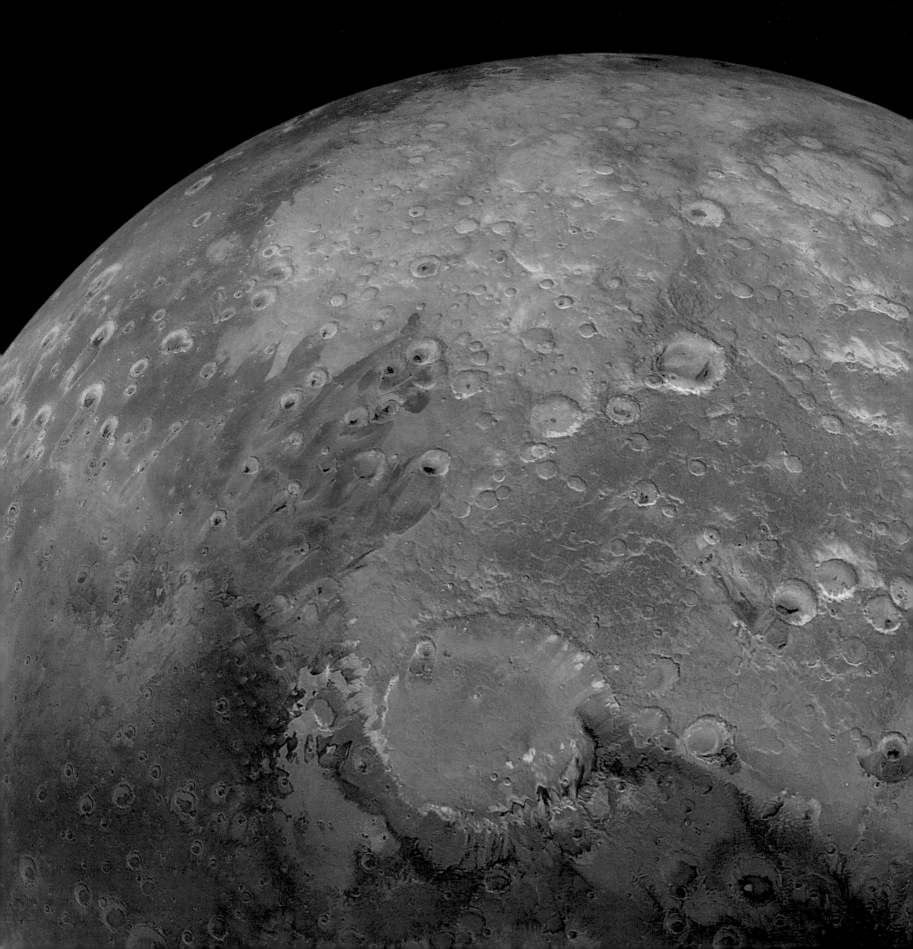

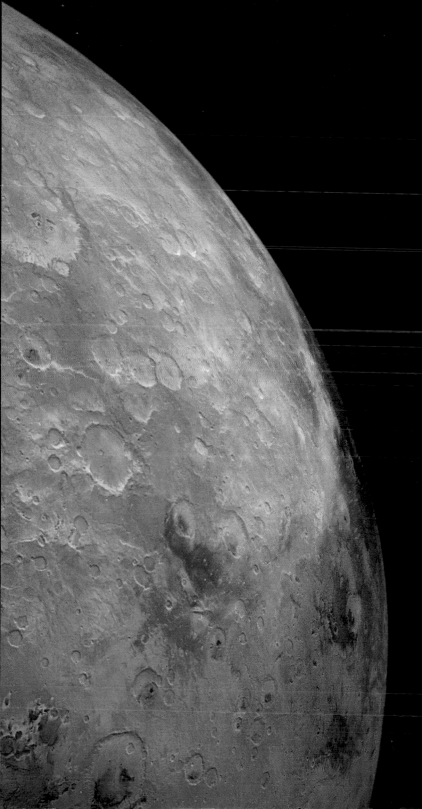

planet's crust was flattened out. The only vestiges that we can find today of these events are the most recent basins, Chryse and Utopia, huge depressions that were filled with sediment during the massive flooding this world once experienced.

The interior of Mars must have a colder and thicker mantle than Earth, as its consistency is pastier, with slower convection. The planet's crust is also thicker: 31 miles, on average, (50 km), compared to an average of 15.5 miles (25 km) here on Earth. The crust is thinnest under the great northern plains, about 22 miles (35 km) thick compared to 37 miles (60 km) for the southern hemisphere, 90 miles (150 km) under Tharsis, and grows to 125 miles (200 km) under Olympus Mons. Moreover, the planet has a partially melted ferrous metallic core, with a radius of about 1,000 miles (1,600 km). A weak magnetic field of unknown origin surrounds the planet.

In the center, the large Schiaparelli crater about 280 miles (450 km) in diameter. *Opportunity* landed farther to the west (far left), in the dark region (USGS).

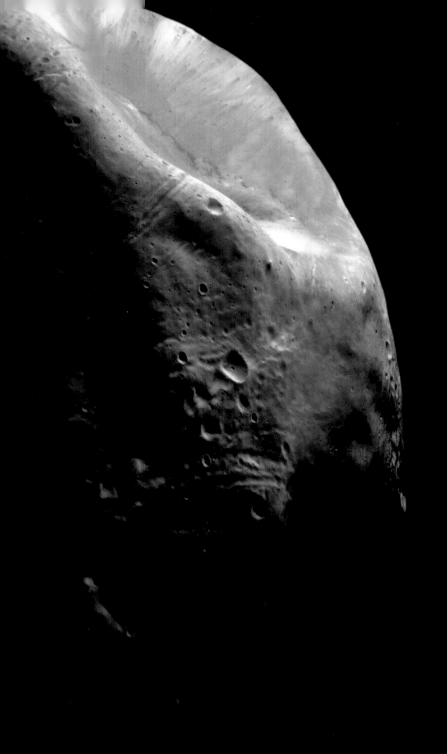

Two Potato-Shape Satellites

Mars's two small natural satellites, Phobos and Deimos, are now well known. In 1877 the American astronomer Asaph Hall took advantage of Earth's close approach to Mars to find out if the planet had moons. Discouraged at not finding anything, he was abandoning his research when his wife, Angelina Stickney, insisted that he return to his telescope. This is how Mars's two little moons, flying "mountains" of irregular shape, were discovered. Hall named them Phobos and Deimos ("fear" and "terror") after the horses in Greek mythology that pull the god of war's chariot. Respectively and on average, these asteroids captured by the planet measure 14 miles (23 km) and 7.5 miles (12 km) across.

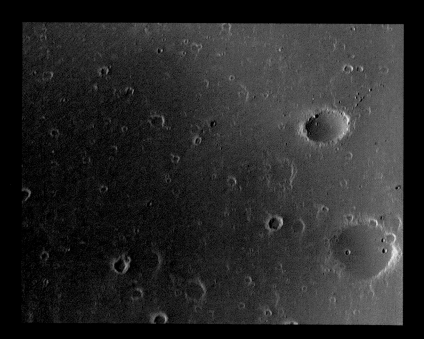

Deimos's craters are almost obliterated under a thick layer of debris. The rocks above right are about 10.9 yards (10 m) across (*Viking*).

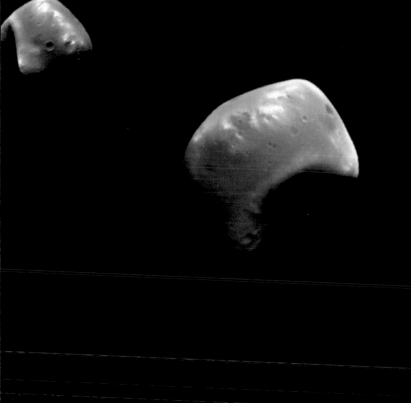

A view of Deimos fully sunlit. Debris has formed light trails running gently along the slopes (*Viking*).

Deimos has an almost smooth morphology. Its surface is dotted with craters partially filled with the debris created when they were formed. This moon revolves far from Mars and behaves in the sky like our moon. However, Deimos gains speed in its orbit and is gradually moving farther away from the red planet.

Phobos rotates so fast (7 hours and 39 minutes) and so close to Mars (3,722 miles or 5,990 km above the surface) that an observer on the planet surface would see it as a small star rising in the west and setting in the east, the opposite of our moon's movement. Its orbit is decreasing

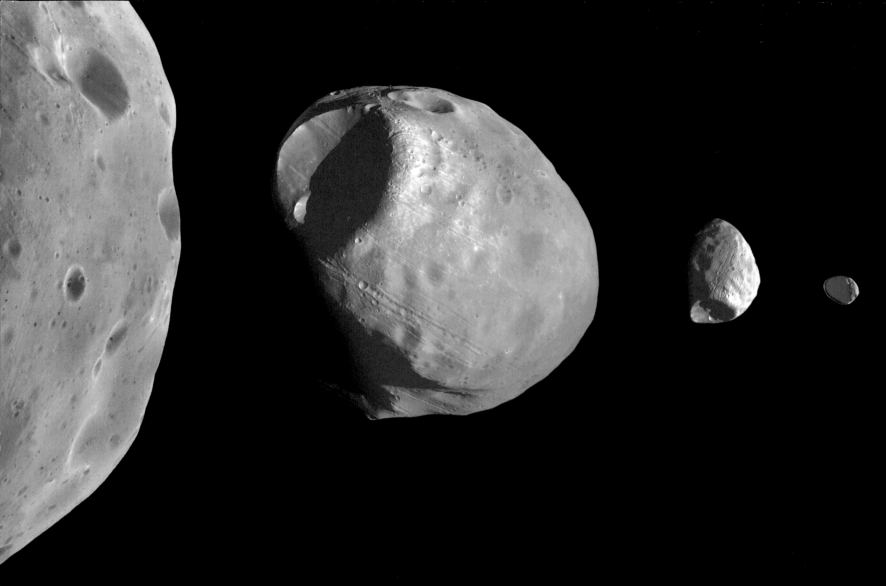

as the planet's gravitational influence gradually slows Phobos down. In less than 100 million years, astronomers estimate, Phobos will crash on Mars and create an enormous crater.

This moon has an impressive system of fractures caused by the large Stickney crater, with a diameter of 6.2 miles (10 km). The shock that created Stickney made Phobos vibrate and produced this vast network of faults, some as wide as 656 feet (200 m) and as deep as 65 feet (20 m), and several miles in length. The temperature of Phobos varies from 25° F (−4° C) in the sun to −170° F

with a layer of dust (regolith) 3 feet (1 m) thick, created by the pulverization of the ground by small celestial bodies crashing into it. Large rocks appear in it half buried.

Despite the light gravitational force that reigns over the surface, materials still manage to slowly slide along the slopes. Gravity on Phobos is 1,200 times weaker than on Earth: a 176-pound (80-kg) person would only weigh 2.3 ounces (66 grams)! If an astronaut were to throw a ball out straight, it would go into orbit around the satellite, skim over the surface, then return to hit the astronaut in the back.

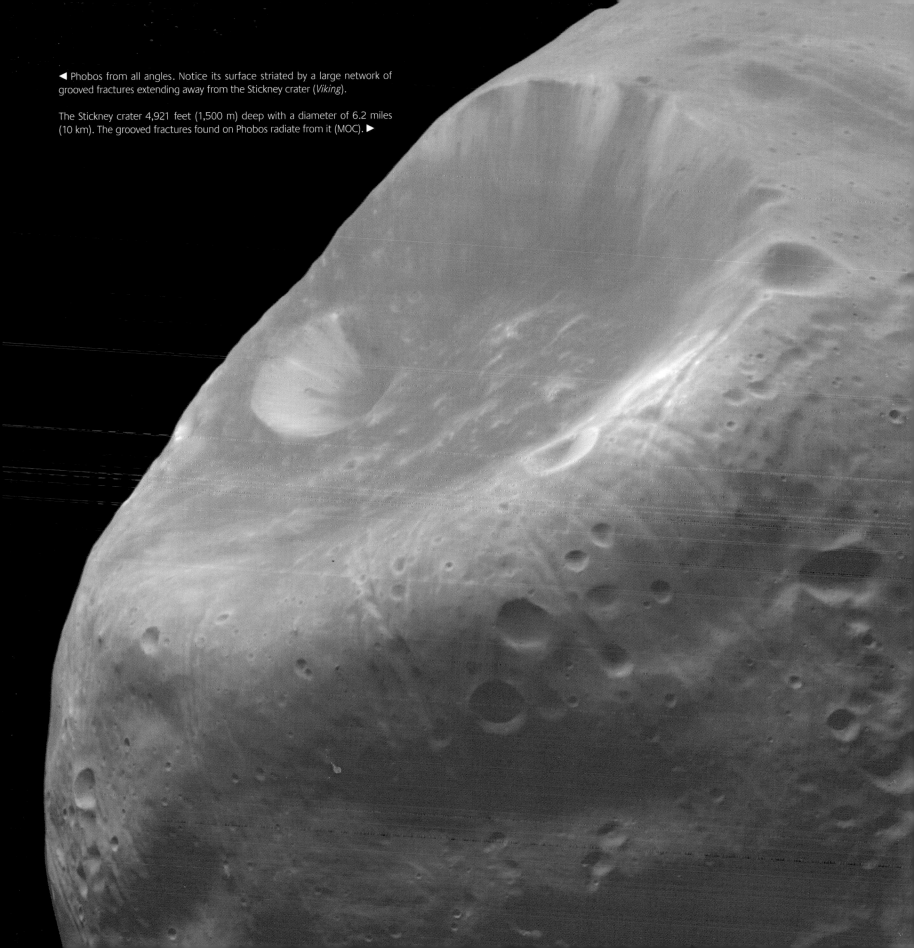

◄ Phobos from all angles. Notice its surface striated by a large network of grooved fractures extending away from the Stickney crater (*Viking*).

The Stickney crater 4,921 feet (1,500 m) deep with a diameter of 6.2 miles (10 km). The grooved fractures found on Phobos radiate from it (MOC). ►

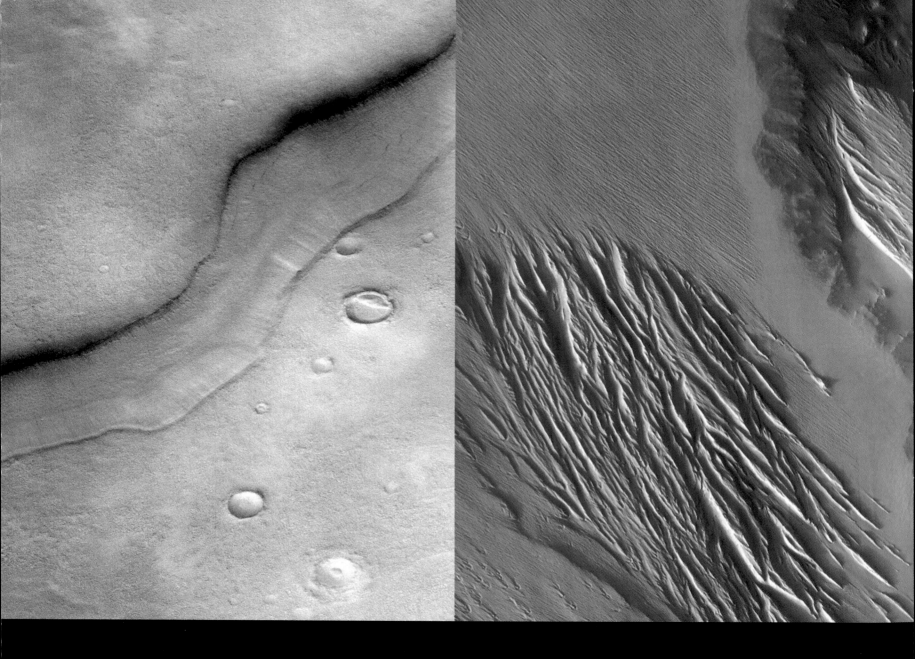

Vast Windswept Plains

Plains cover more than a third of the Martian planet surface. They are found mostly in the northern hemisphere where sudden events like mud or lava flows, fractures, and the impact of celestial bodies have left their marks. In the Great North, the rugged landscape takes on the look of a frozen land, with small buttes, the extended grooves of fractures in polygonal shapes, and craters with bases shaped like pancakes. In the plains of Acidalia and Utopia, these polygons extend to as much as 18.6 miles (30 km) across. They are surrounded by flat-bottomed grooves, hundreds of

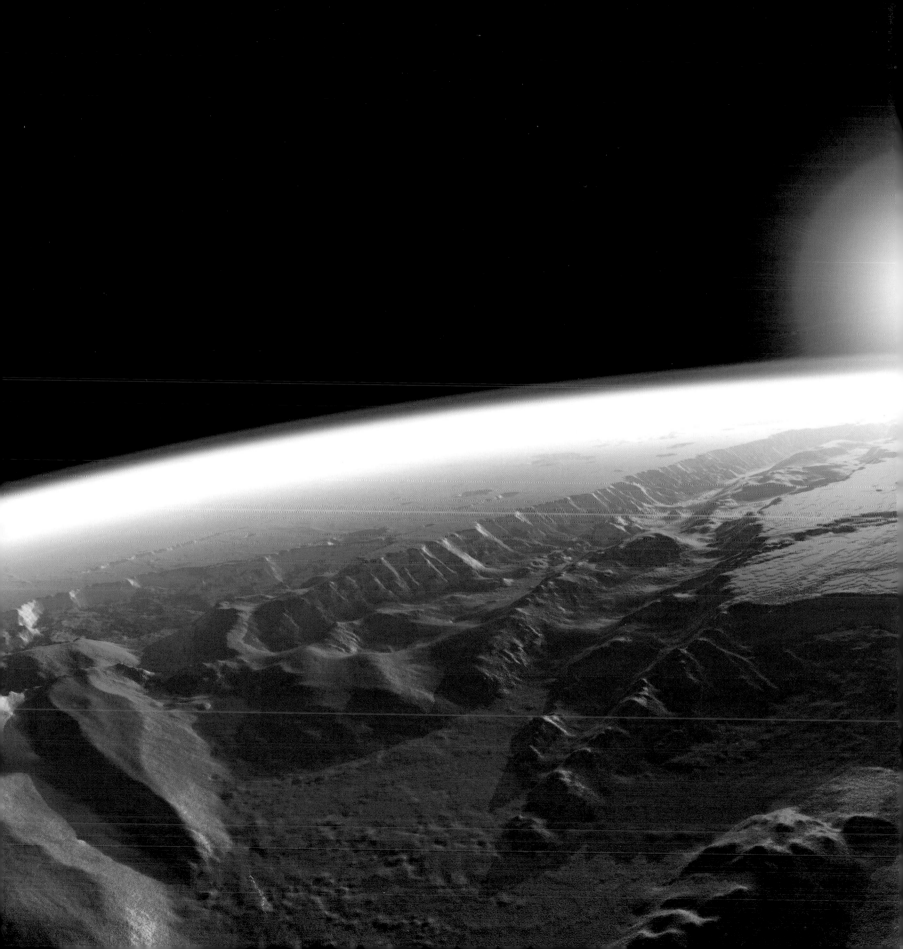

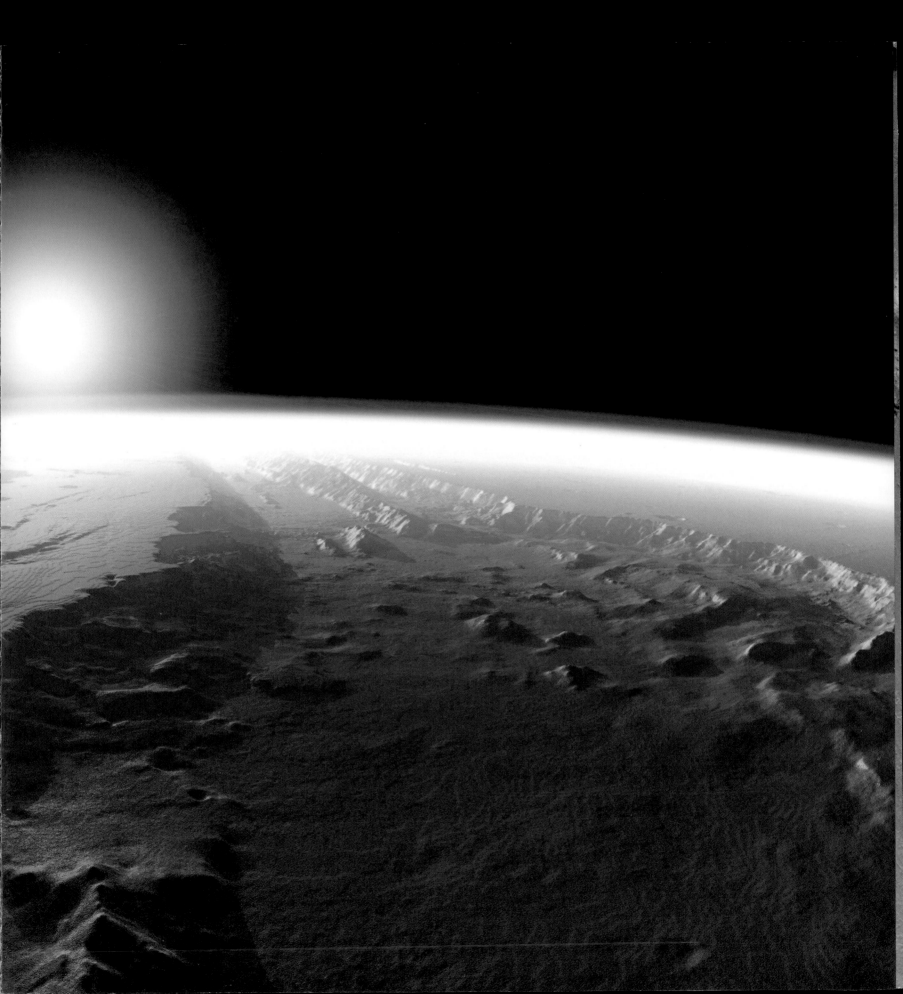

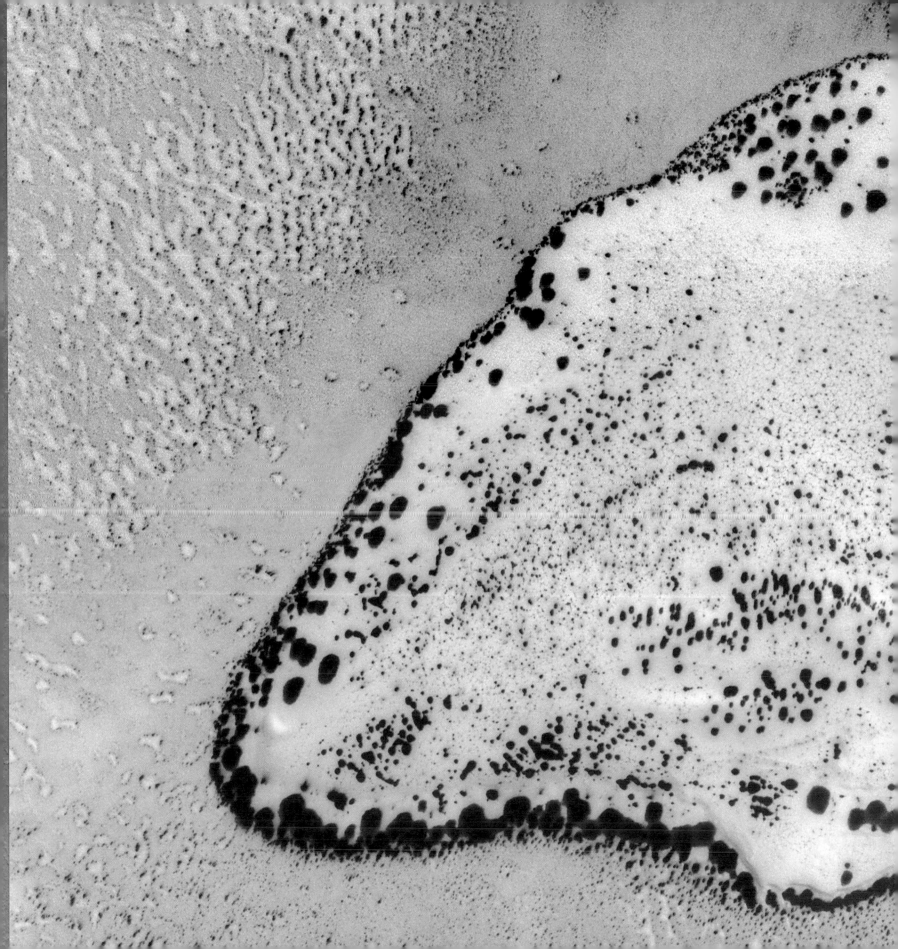

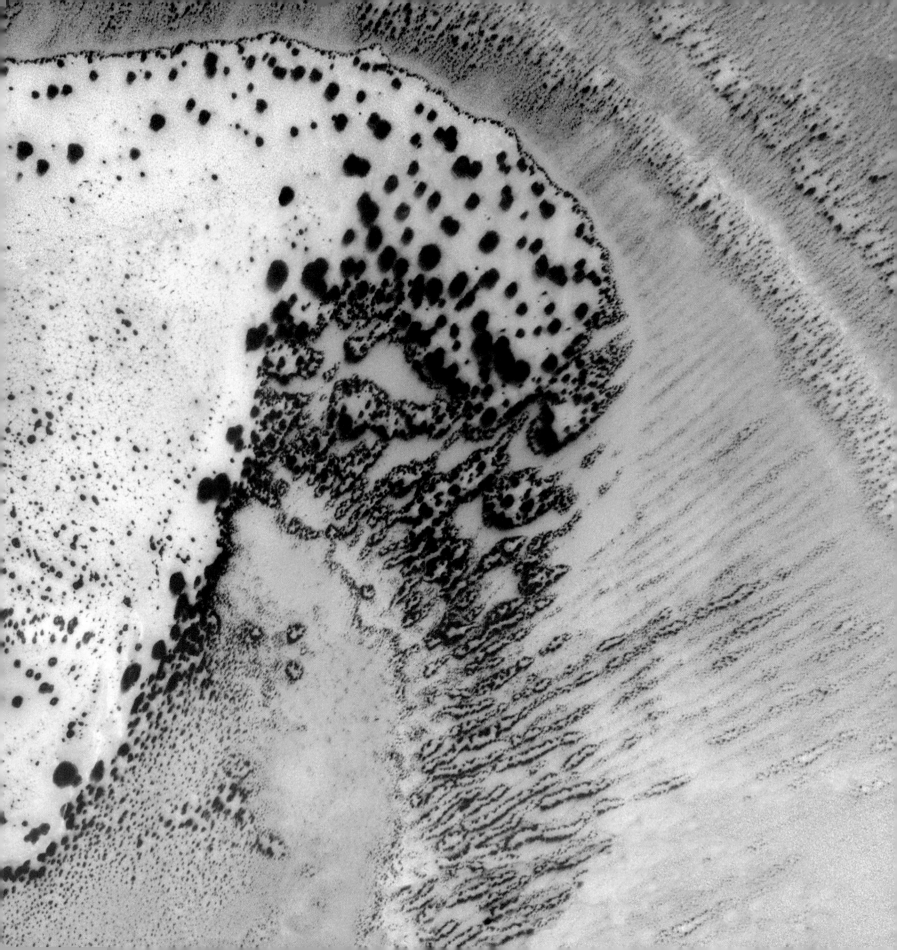

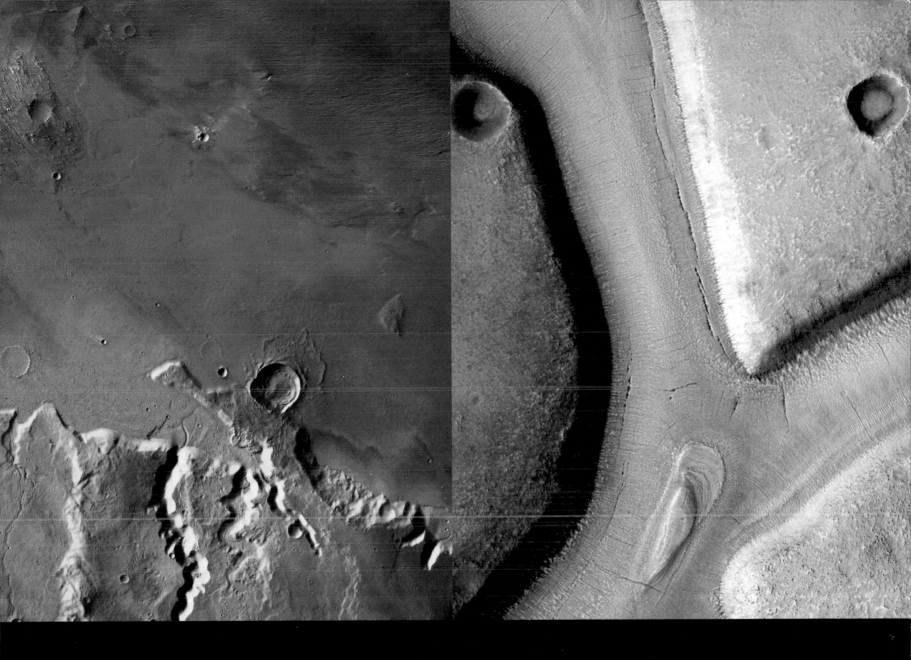

yards/meters wide, created by the cooling and contraction of frozen ground. Periods of warm and cold that have alternated through the ages have also deformed the ice in the soil. In addition, plates of volcanic sediment had sometimes covered the original topography, roughly molding it.

▲ Pp. 24–25, from left to right. 1. Section 3,608 yards (3,300 m) across of frozen terrain in Utopia Planitia, at 41° N and 258° W (MOC). 2. At 5° S and 160° W, surface 14.3 miles (23 km) across, west of Tharsis, the plains have been sculpted by the prevailing winds (Themis). 3. Between the terrains of the southern hemisphere (bottom) and the northern plains (top), at 5° S and 147° W, the impact that created the crater, 5.6 miles (9 km) wide at the center, made a "splash" by liquefying the frozen terrain (USGS). 4. Section 2,515 yards (2,300 m) wide, west of Utopia Planitia (at 38° N and 282° W): mesas of frozen terrain, eroded by the winds (MOC).

Next page. Section 1.9 miles (3 km) across, topography west of Olympus Mons, at 12° N and 158° W, sculpted by the winds on the volcanic plains (MOC).

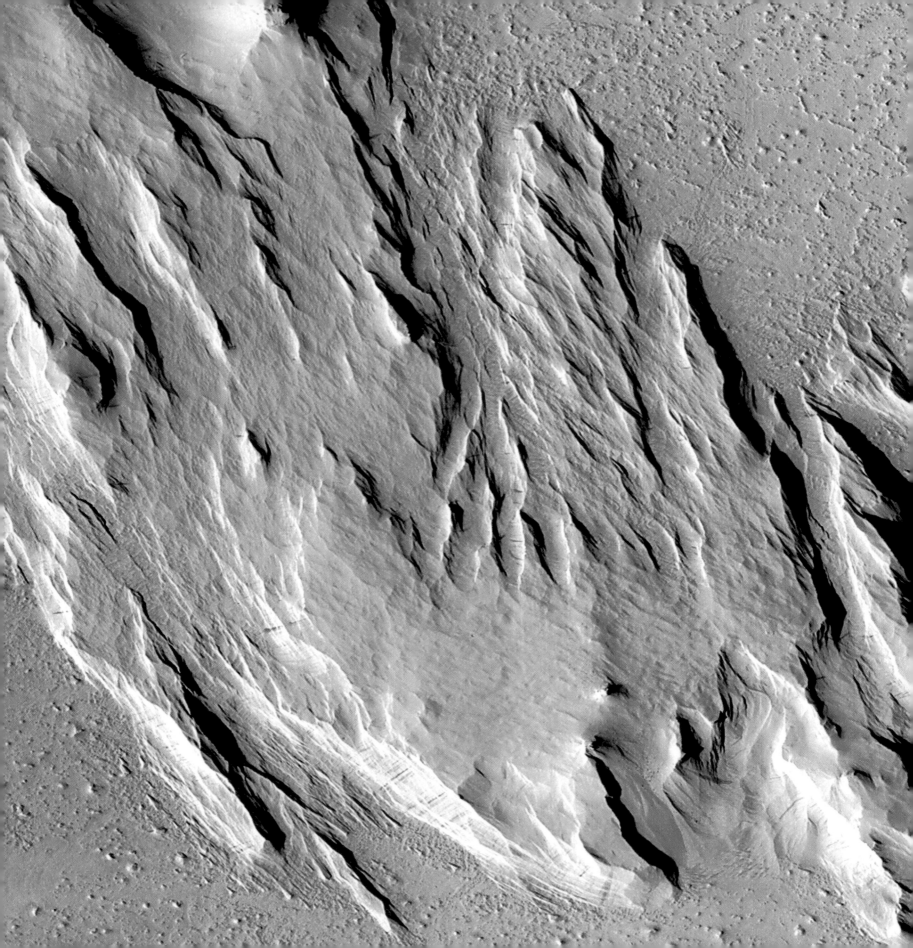

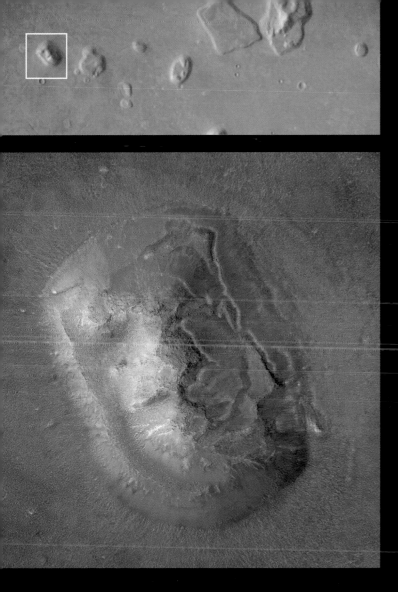

Another illusion is the "fossil" discovered in the center of the Guadalupe rock (above, Mars Exploration Rover, or MER). This is actually a cavity, measuring 0.07 inches (2 mm) across, left after crystallized salts in the rock were dissolved by water. The rover *Opportunity* sanded it down along with the small surrounding spheres (below, MER).

Mars has lost its "face" and "fossil," but maybe, elsewhere, there really is a hidden microbial life.

An old mystery dating from 1976 has finally been resolved. At 9.6° W and 40° N we find the "face" of Mars (top, *Viking*). Is this a trace of civilization, now disappeared? Using a resolution ten times stronger than that of *Viking,* the Mars Global Surveyor camera revealed a worn geological formation, 437 yards (400 m) high and 1.5 miles by 1.2 miles (2.5 km by 2 km), which looks like an eroded desert mesa on Earth (above, Mars Global Survey Probe, or MOC).

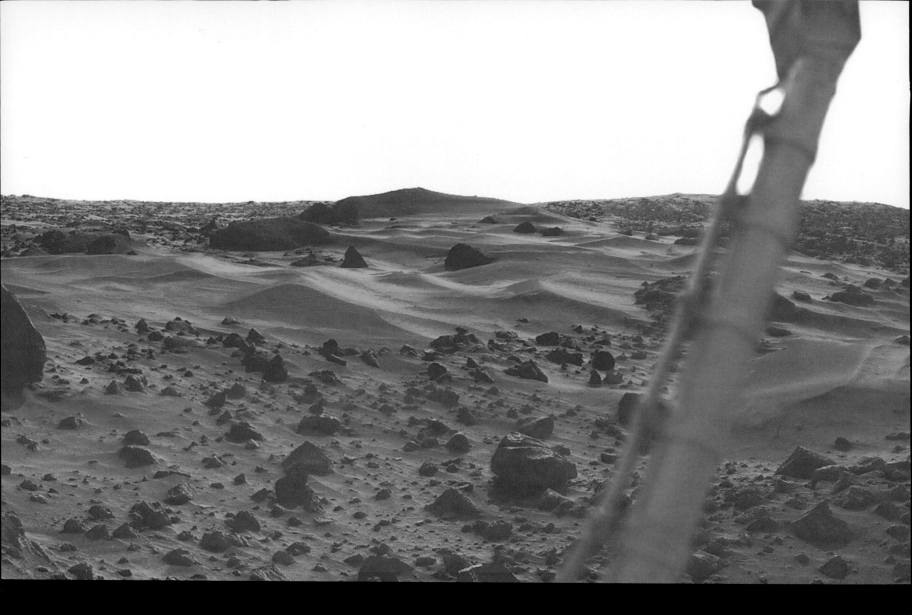

Fields of Giant Dunes

The three Martian years that *Viking 1* spent on the planet surface have shown that winds have not sculpted much of the landscape. Large dust storms disturb only the surface, moving small stones and accumulating sediment along-side them. But over thousands of years, on the other hand, the winds are able to shape immense expanses by covering large fields of gigantic dunes (called "barchanes"),

▲ "I almost expected to see camels," said a *Viking* scientist when looking at this shot taken early in the morning by *Viking 1* (*Viking*).

Section of dune fields, 1.7 miles (2.7 km) across, in a crater north of Argyre Planitia, at 34° S and 49° W (MOC). ▶
Another section of dunes shaped by the winds, 1.2 miles (2 km) across, in the Rabe crater, at 44° S and 326° W (MOC). ▶▶

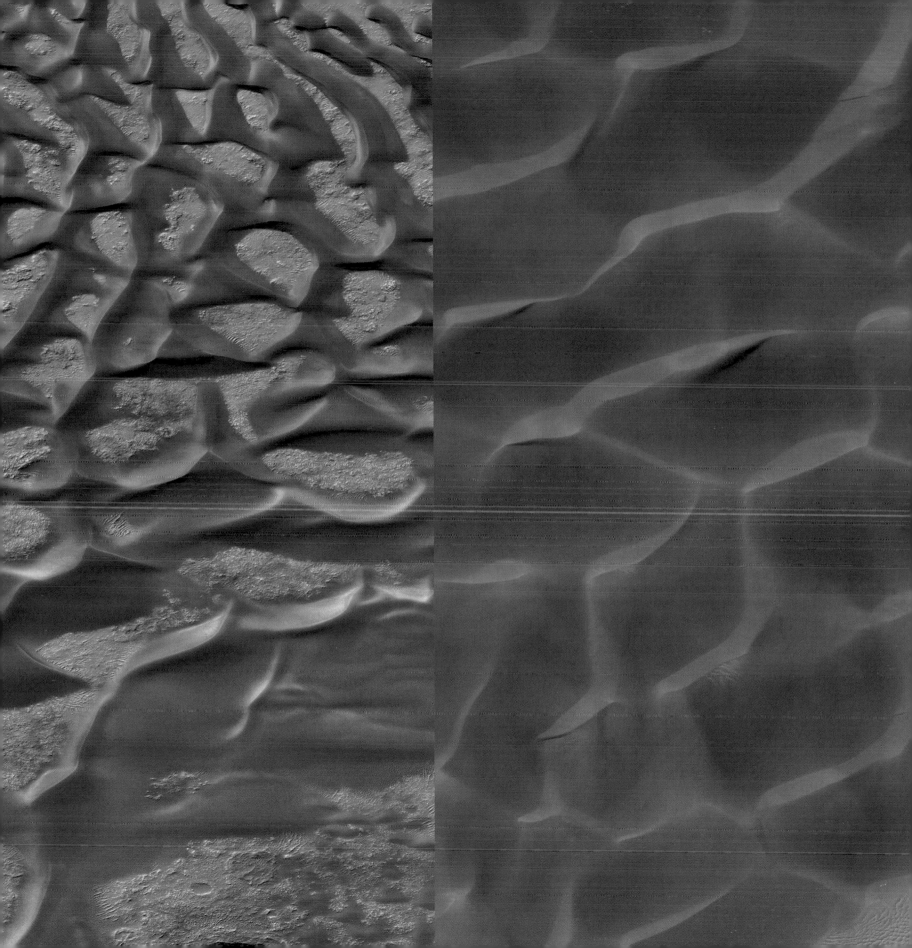

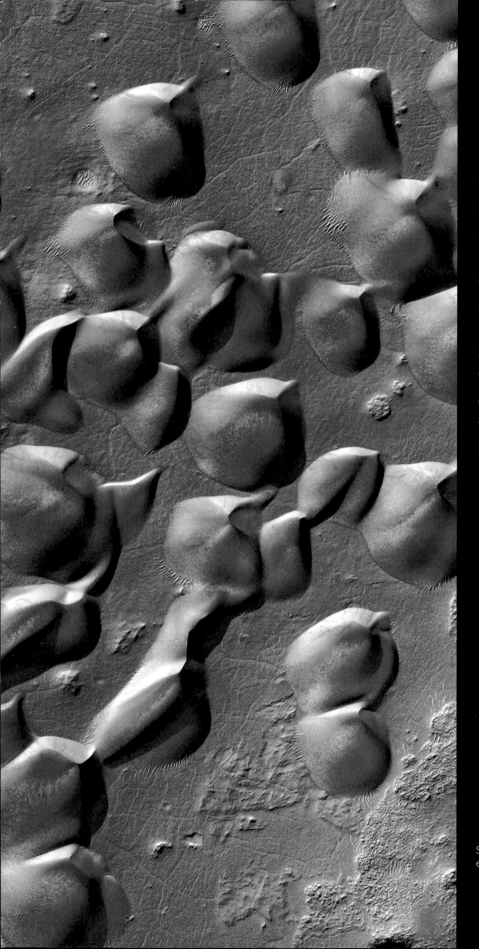

identical to those found in Namibia near the ocean. These dunes are 164 feet (50 m) tall on average but the biggest can reach as high as 328 feet (100 m). Some dunes, sculpted by the winds, create strange shapes whose beauty recalls Oriental calligraphy. Other regions are covered with yardangs (ridges sculpted by the wind in soft sediments).

Martian winds have also filled the inside of craters with sediment, sometimes leaving only a slight hollow to reveal the shape of the planet surface. Close-up images of small dunes show that they are made of grains of sand. The existence of sand testifies to an active eolian erosion on Mars by winds that are capable of transporting sediment.

Section 1.5 miles (2.5 km) across, of circular dunes in the Wirtz crater, at 49°S and 26°W, east of Argyre Planitia (MOC).

n, the magic of Mars: Martian winds have shaped the sediments near the planet's north pole to create an Oriental calligraphy. On the left, a section of dunes measures about 2 miles (3.2 km) across, at 78° N and 255° W. To the right is a section 1.5 miles (2.5 km) across, at 78° N and 250° W (MOC).

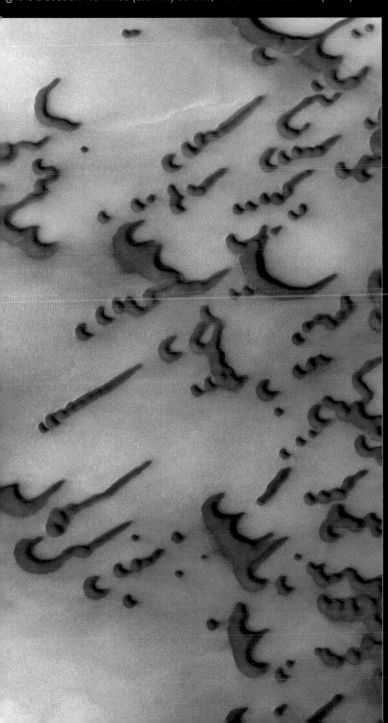

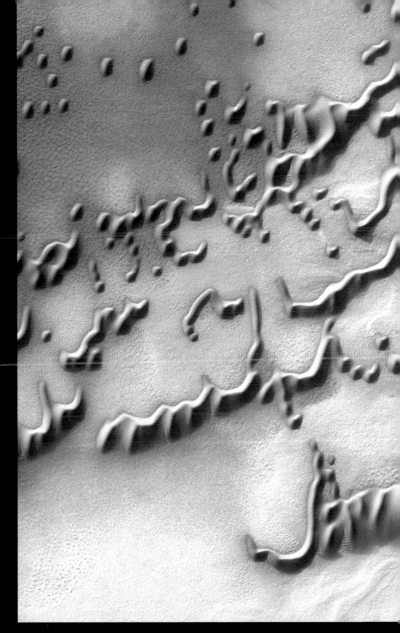

There is another surprise at the south pole. Mars unveils its zero meridian ("ini Y" or "initialization of Y coordinates"), with a hole 984 yards (900 m) long in the frozen carbon dioxide, at 86° S and 0° W (MOC).

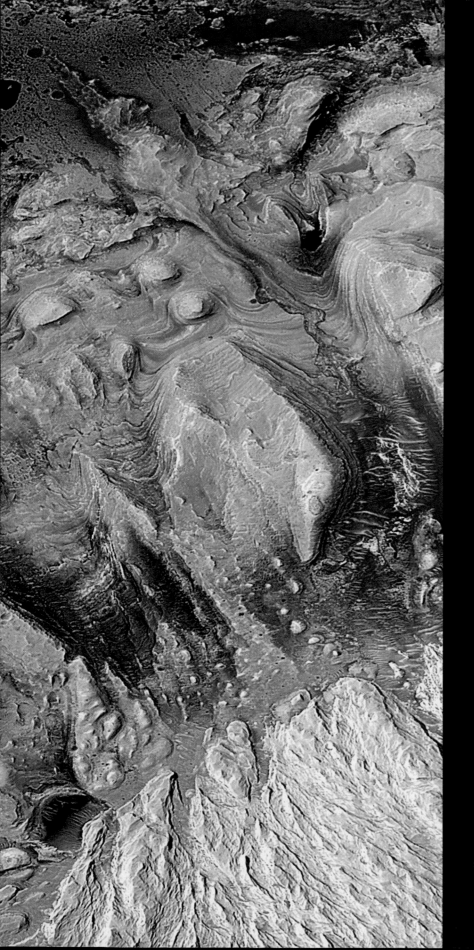

The Fossil Hunt Begins

Successive traces of sedimentary deposits, accumulated in lake or marine environments, can be seen at the bottom of some craters and in the Valles Marineris giant canyon. These stratifications are deposited in regular layers anywhere from a few yards to some 10 yards/meters thick and were formed by the action of water stagnating for a long time, in the form of a lake or small sea. This happened during a warm period that began about 4.3 billion years B.C. and lasted some 700 million years.

We know that at the beginning of its history, a large part of Mars looked like the great Canadian North in the spring, with landscapes dotted by frozen lakes in gullies and craters. They came together to form first small seas, then a large ocean in the northern hemisphere. When the planet cooled and climatic conditions degraded, the water gradually disappeared from the surface and took refuge in the subsurface. Next other major events, like the emptying of the huge reservoirs of the giant Valles Marineris canyon (about 3,100 miles—5,000 km—long) created the vast northern ocean. The bottom of the canyon still holds clear traces of mineral-salt lake deposits blown about and sculpted by the winds. There may also be limestone sediment, the result of a reaction between carbon dioxide, a major component of the Martian atmosphere, and calcium found in the water. These layers of sediment accumulated on the bottom of ancient lakes would be the best place to find fossils, if life developed on Mars. The fossil hunt has now begun!

Pile-up of sedimentary layers produced by the action of water in the Gale crater over a section 1.9 miles (3 km) across, at 5° S and 223° W (MOC).

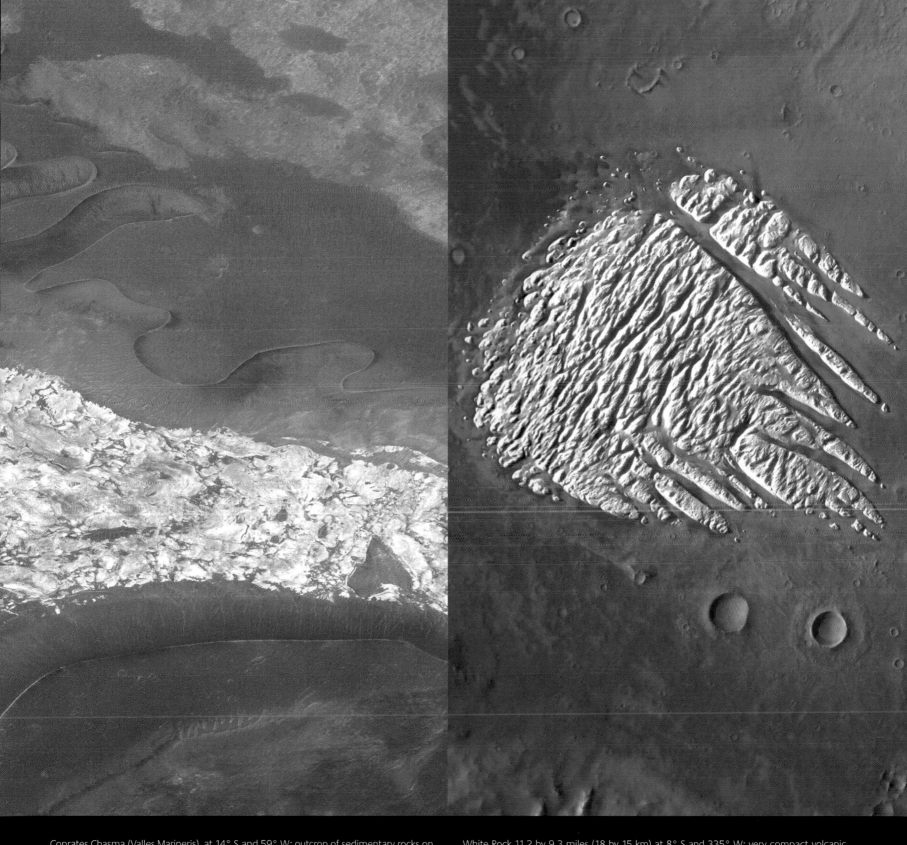

Coprates Chasma (Valles Marineris), at 14° S and 59° W: outcrop of sedimentary rocks on the surface 765 yards (700 m) across (width of outcrop taken vertically; MOC).

White Rock 11.2 by 9.3 miles (18 by 15 km) at 8° S and 335° W: very compact volcanic ashes eroded by the winds (Themis).

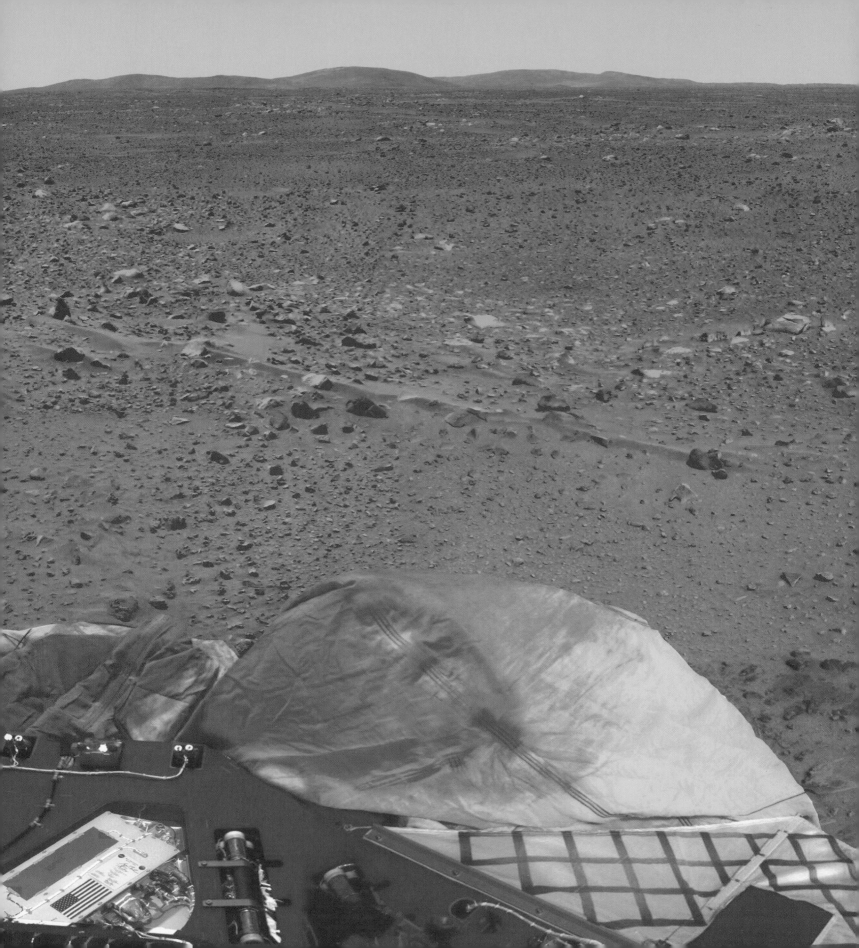

Varied Landscapes Bear Witness to Mars's Past

For a long time, our view of the surface of Mars was that of the two *Viking* landers. We had to wait until 1997 and the Mars *Pathfinder* to discover a chaotic landscape, the very one where *Viking* was unable to land in 1976. For *Spirit* and *Opportunity,* the two Mars Exploration Rovers (MERs), scientists chose to land on sites shaped by water, flat and with the least amount of stones possible. They were not disappointed.

Thanks to the collecting arms of *Viking* and the wheels of the rovers, we see that the Martian soil acts like the sand on a wet beach, even though it is dry. The magnets on the probes have shown that Martian soil makeup includes maghemite at anywhere from 1 to 7 percent. A highly magnetic mineral, maghemite gives the planet its yellowish brown color. The atmosphere seems to transport very fine particles (2 microns in diameter) that look like aggregates of clayish materials fused together by iron oxides and maghemite. This is a proof of the past action of water on Mars: the iron on the surface was dissolved in flood after flood. The water disappeared and maghemite, a dry precipitate, was left behind. It was then transported by the wind.

◀ *Spirit* landing site. In the foreground, the airbags stained with dust. In the background, the Columbia hills (MER).

El Capitán zone of sedimentary rocks at the *Opportunity* site. The Guadalupe rock, top center, is going to be sanded (MER).▼

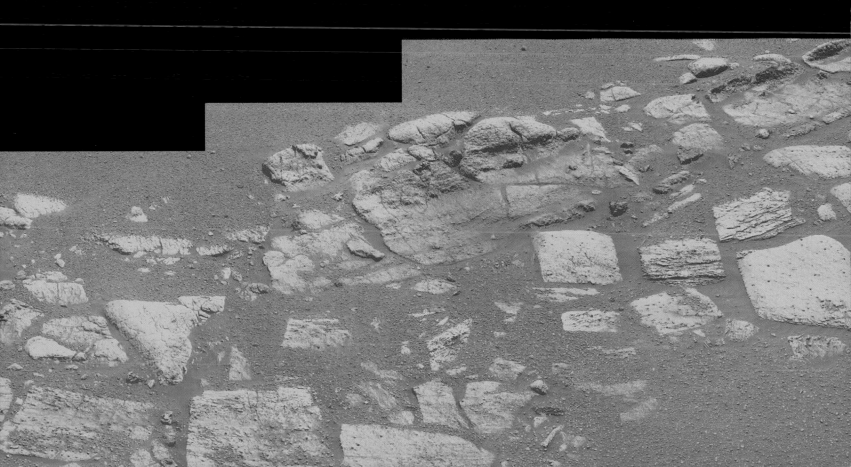

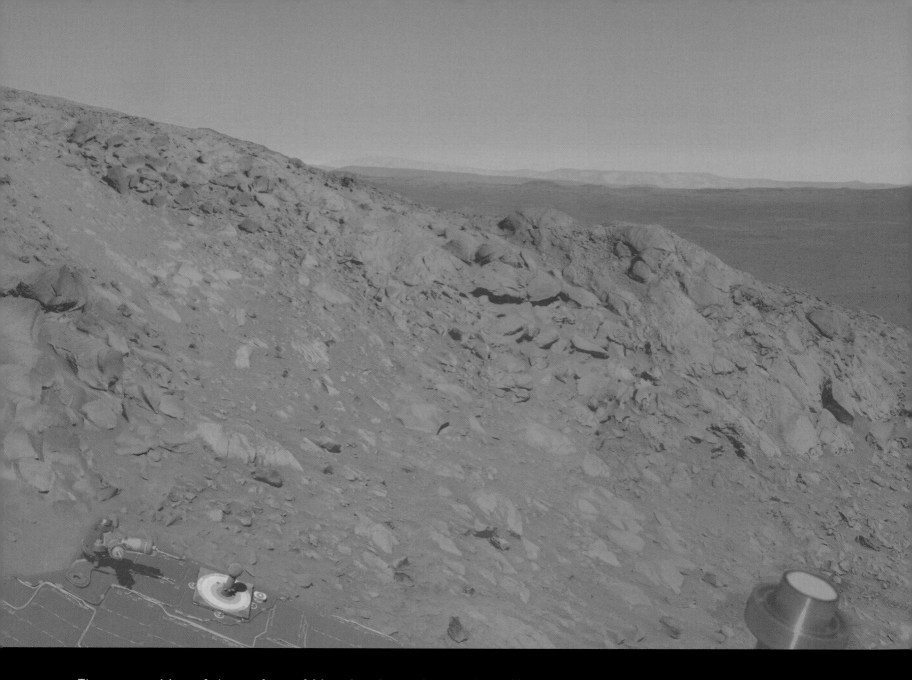

The composition of the surface of Mars has been the same at all the sites explored by probes. The main components by weight are silicon (20 percent), iron (13 percent), magnesium (5 percent), calcium (4 percent), aluminum (3 percent), chlorine (0.7 percent), and titanium (0.5 percent). Because all the elements but chlorine take the form of oxides, oxygen technically represents nearly 50 percent of the soil's mass. The surface of the red planet is composed primarily of a mixture of iron-rich clays (80 percent), magnesium sulfate (5 percent), and iron and silicon oxides (5 percent). There is a hundred times more sulfur here than on Earth. It is found in the form of sulfate, which cements the sediment materials together and forms a superficial ground crust with good cohesion.

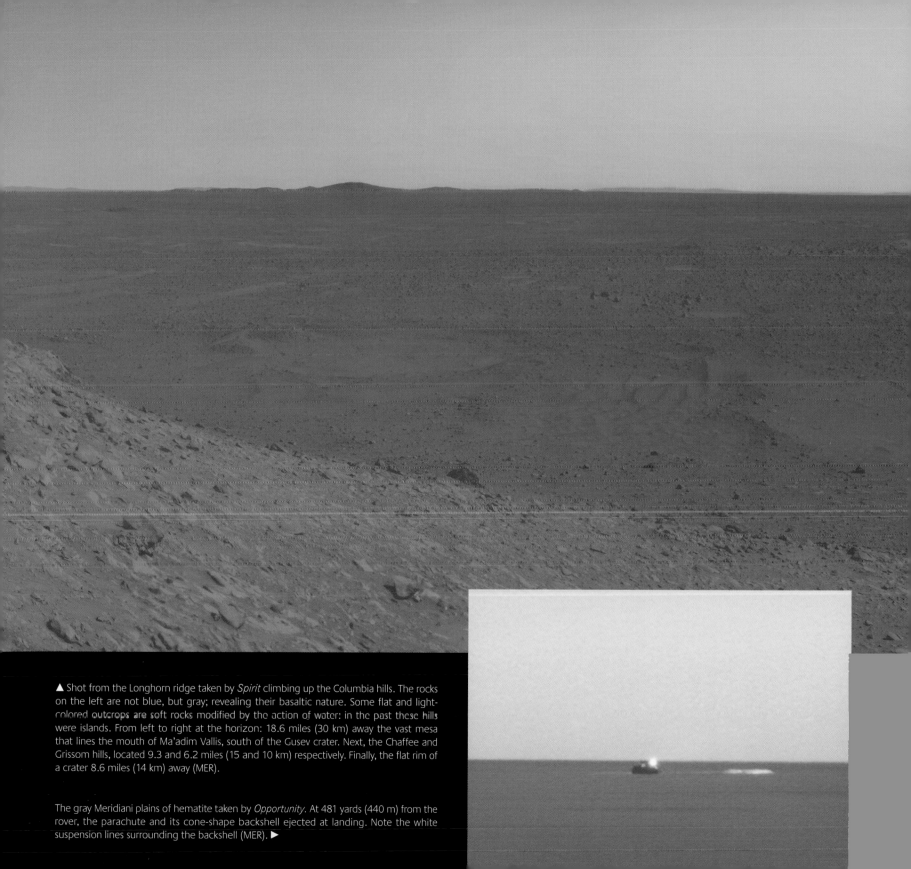

▲ Shot from the Longhorn ridge taken by *Spirit* climbing up the Columbia hills. The rocks on the left are not blue, but gray; revealing their basaltic nature. Some flat and light-colored outcrops are soft rocks modified by the action of water: in the past these hills were islands. From left to right at the horizon: 18.6 miles (30 km) away the vast mesa that lines the mouth of Ma'adim Vallis, south of the Gusev crater. Next, the Chaffee and Grissom hills, located 9.3 and 6.2 miles (15 and 10 km) respectively. Finally, the flat rim of a crater 8.6 miles (14 km) away (MER).

The gray Meridiani plains of hematite taken by *Opportunity*. At 481 yards (440 m) from the rover, the parachute and its cone-shape backshell ejected at landing. Note the white suspension lines surrounding the backshell (MER). ▶

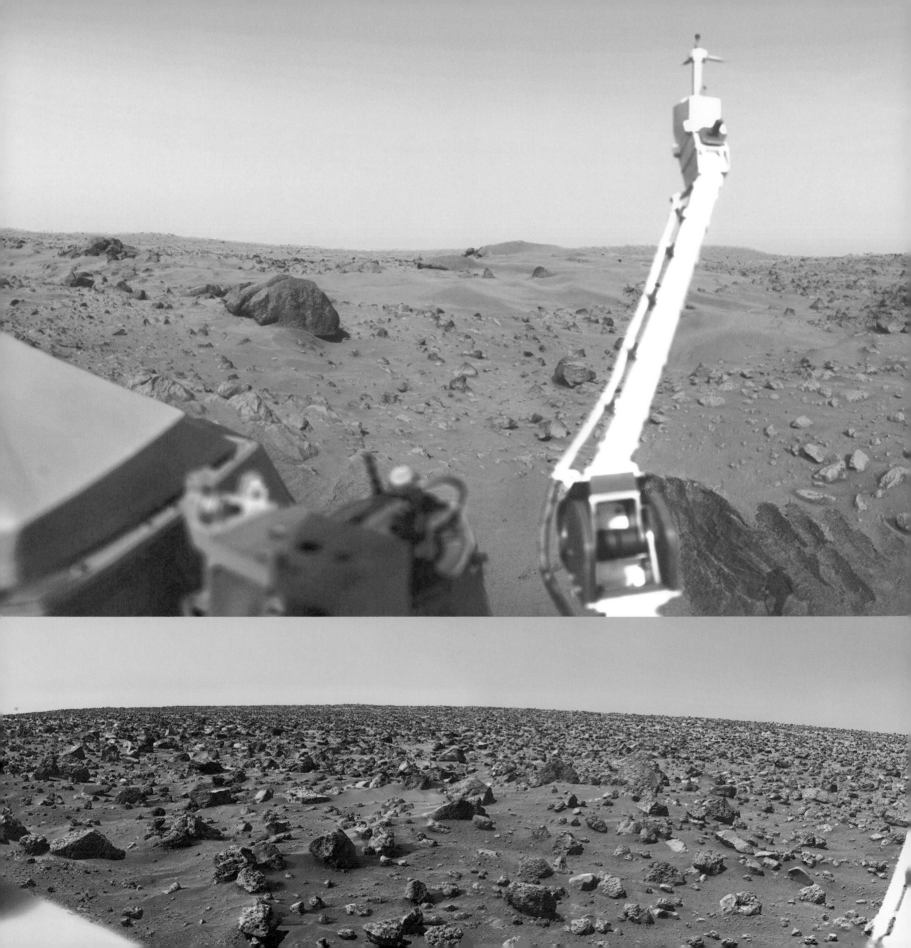

Typical Mars Landscape for Viking 1

In 1976, images taken from orbit revealed that the planned landing site for *Viking 1* was too chaotic. With its insufficient ground clearance of 8.6 inches (22 cm), the probe would have been damaged if it had landed in Ares Vallis, where a rock could have pierced its insulating bottom. Chryse Planitia, a site 530 miles (850 km) to the northwest, was chosen instead.

Viking 1 set down in a quintessentially typical Mars land-scape. The relief there undulates gently. The bases of rocks are sometimes set in a fine-grained sediment, created by the wind, that covers firmer ground with a granular, sandy texture. Here and there these sedimentary materials have formed dunes more than 10 yards/meters across. The site is also sprinkled with small stones and blocks. The raised rims of craters can be seen on the horizon, and to the south the rocky subsoil has risen to the surface.

Topographic readings tell us that water flowed northward through this site to fill the low plains and form an ocean, even though the traces of its passage are not very visible. Nevertheless, after the period of floods, the water must have stagnated for some time in the depressions, one of which holds *Viking 1*. Thus at this site, fossils of a primitive life could have been preserved, if it existed. Maybe traces of Martian life are still there also if they managed to survive. In fact, some scientists want to return to this place to coun-tertest the *Viking* biology package and the fascinating pro-life results of its labeled release experiment, and also to measure the aging of the probe components.

A commemorative plaque waits in Washington, D.C., at the Smithsonian National Air and Space Museum for future astronauts, who will place it on *Viking 1*.

Ancient Sea Floor for Viking 2

Viking 2 landed in the heart of the vast northern plains on the Utopia Planitia. The probe's cameras showed a flat, monotone horizon with less than a meter of relief—a view much different from the expanses of sediment dunes foreseen at some point before the landing. Two ancient craters' rims are also visible from a distance, although only their flattened bases, where the force of impact had compressed them, remain intact. (These are called pedestal craters; *see also pages 126–127*). Topographical readings tell us that this location was once an ancient ocean floor. It was filled in by debris and a variety of sedimentary materials that were first carried by water and then hurled by the most recent crater impacts (ejecta).

Around the probe, a series of depressions measuring 1 yard/meter across and 4 inches (10 centimeters) deep, align to form huge polygons. Filled with sediment, these troughs were created by the contraction of the frozen surface associated with a seasonal freeze/thaw cycle.

The recent detection of hydrogen atoms, a component of water that has migrated to the surface, signals that the crust of the vast northern plains still holds a lot of water in the form of ice. But its presence was intuited in 1976 and in 1978. When *Viking 2* recorded two local seismic events (or "Marsquakes") with magnitudes of 3 on the Richter scale, the vibrations were stilled after only one minute. This provided more evidence that water, after sitting stagnant for a very long time has not disappeared, and is still stored in the form of frozen subsoil.

Top: 3:00 P.M. at the *Viking 1* site on Chryse Planitia. At a distance of 10.9 yards (10 m), the large Big Joe boulders 6.6 feet (2 m) wide and 3.3 feet (1 m) high (*Viking*). Bottom: 12:30 P.M. on Utopia Planitia, an ancient seafloor, uniformly covered with rocks from surrounding craters. The curvature of the horizon is an illusion caused by an 8-degree tilt of the lander toward the west due to a footpad perched on a rock. In reality, the Utopia site is flat (*Viking*).

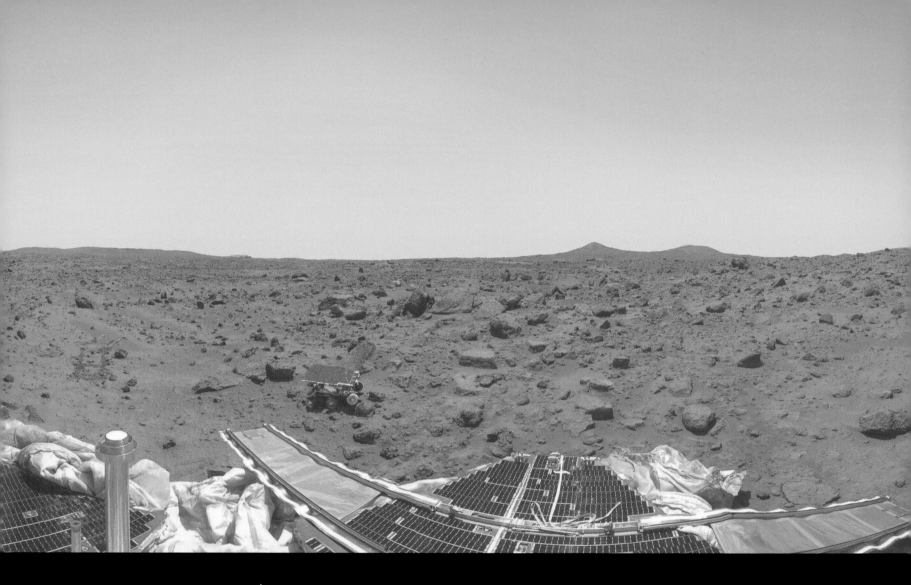

Chaotic Site for Mars Pathfinder

In 1997, Mars *Pathfinder* landed at the confluence of the Ares Vallis and Tiu Vallis in the same place that had been found unsuitable for *Viking 1* in 1976. Approximately 2 to 3 billion years ago, huge flows of water and mud molded this chaotic spot in floods powerful enough to fill the Mediterranean Basin or empty the North American Great Lakes in less than two weeks. The current piled rocks on top of each other, all inclined to the northeast. Two hills called the Twin Peaks are about 0.6 miles (1 km) from the probe. The South Twin is

115 feet (35 m) high, and the North Twin has a height of a hundred feet (30 m). They show horizontal traces created by the flooding episodes.

This landscape has been eroded in the past by very liquid mud that flowed at a rate of up to 18.6 miles (30 km) per hour with an average thickness of 65.6 feet (20 m), sometimes submerging the landscape. Some topographical features are visible above the horizon, remnants of the ancient plateau that was washed away. Misty Mountain is one example, with

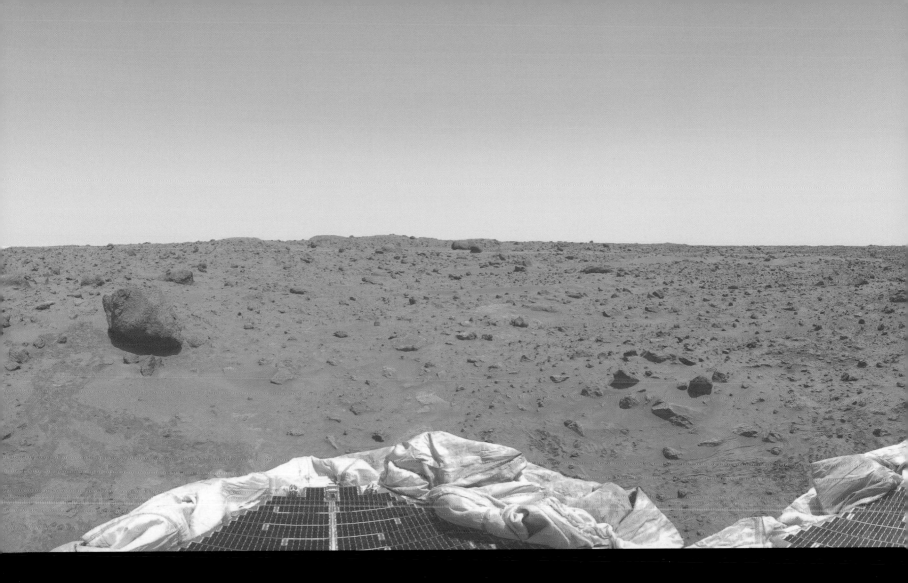

an altitude of 1,476 feet (450 m), about 19.2 miles (31 km) to the south. *Pathfinder* touched down on a slight slope created in the wake of the Twin Peaks.

The cameras of the *Sojourner* minirover showed rocks 9.8 inches (25 cm) high, as seen from a dog's perspective. Sand grains measuring less than a millimeter in diameter were collected by scratching the surface of the Mermaid dune. Small rounded pebbles, 1 to 1.5 inches (3 to 4 cm) across, had once been shaped by water, though wind now

seems to be the only active means of erosion on Mars. Sediment with a thickness of 0.7 to almost 2 inches (2 to 5 cm) has been blown away in the last tens of thousands of years from the surface of Ares Vallis.

Noon for *Pathfinder*. Left, *Sojourner* climbs a rock. Near the horizon, the Twin Peaks. In the center, the gray rock called Yogi (MPF)

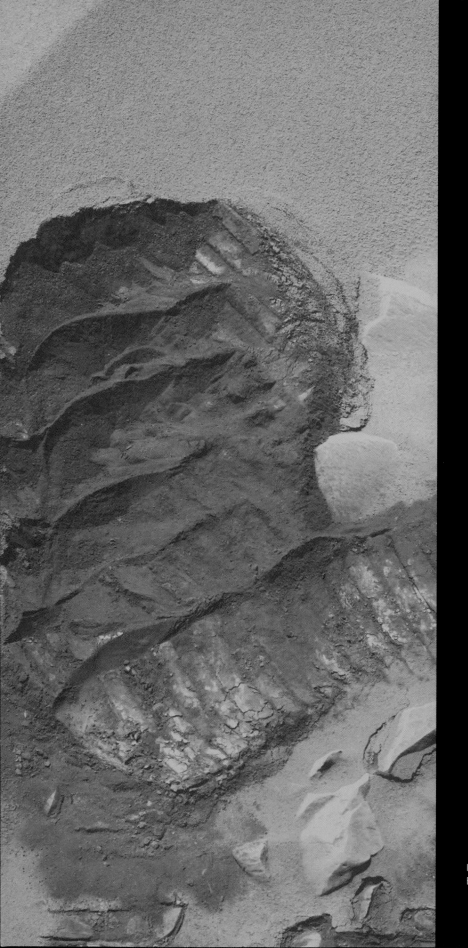

Spirit: *Search for an Ancient Lake*

In 2004, the Mars Exploration Rovers (MERs) landed where water once flowed. *Spirit* touched down on the Gusev Crater, with a diameter of about 99 miles (160 km), located 155 miles (250 km) south of the Apollinaris Patera volcano, which covered the crater with ashes. Approximately 621 miles (1,000 km) south of Gusev, water once filled a myriad of lakes over a surface area as large as the Amazon basin. A natural dam gave way, and the streams were transformed into a huge torrent of mud that created the Ma'adim Vallis channel. This valley extends over 621 miles (1,000 km) and is sometimes as wide as 12.4 miles (20 km). It formed a lake with a depth of 1,310 feet (400 m) in the Gusev Crater, collecting a variety of sediment. At the *Spirit* landing site, water once stagnated for a long time in a residual lake with a depth of some 100 feet (30 m).

Spirit is surrounded by small craters that were eroded and filled with volcanic and eolian sediment. Just 1.8 miles (3 km) to the east are the Columbia Hills, standing 328 feet (100 m) high. Long ago they were islands. About 350 yards (320 m) to the north is Bonneville, measuring 240.5 yards (220 m) across, a crater that *Spirit* explored.

The ground is littered with volcanic rocks and eolian sediment carried by the winds and the Apollinaris Patera volcano. The best evidence that water has not stagnated here for a long time came from the detection of olivine, a mineral that weathers and easily breaks down in water. The lake sediment is still there but remains hidden underneath. A superficial layer with a thickness of 0.39 to 1.96 inches (1 to 5 cm) is made up of grains of sand and granules compressed together and mixed with tiny round pebbles. They may likely be remnants left by the passage of water long ago and mixed with sediment later on.

Imprint 13.8 inches (35 cm) wide of *Spirit*'s wheel on the drift dubbed "Serpent," near the Bonneville crater, revealing very dark sediment (MER).

◄ At the *Opportunity* site, fine vertical plates, so-called Razorbacks, a few inches (several centimeters) high. Actually they are residue of minerals deposited by water in the past inside the fractures of rocks that have been fully eroded since (MER). Bottom: With *Spirit*'s microscope, detail 1.2 inches (3 cm) wide of the imprint's rim *(see p. 42)* on the Serpent drift (MER).

Following double page. In the background, rocky outcrops circling half of the Eagle crater, where remains *Opportunity*'s now-empty lander that carried the rover. In the foreground, scientific instruments for analyzing rocks at the end of *Opportunity*'s robotic arm (MER).

Opportunity, *on an Old Shallow Sea Floor*

The *Opportunity* landing site, Terra Meridiani, is characterized by deposits of hematite. This gray mineral was formed when lukewarm water flowed over iron-bearing rocks. The iron dissolved in the water and was carried far away, eventually to be deposited as hematite.

In Arabia Terra, across from the Tharsis Plateau, a natural dome was created some 3.5 billion years ago. The water that once flowed to the Chryse Planitia basin completely denuded the dome's west side, where Terra Meridiani is located. This huge ground wash dates to the same period as the hematite deposits, which are also found in Valles Marineris, Aram Chaos, and Margaritifer Chaos.

Opportunity set down in a crater 72 feet (22 m) across and nearly 10 feet (3 m) deep, where bedrock as well as sedimentary layers were both revealed. The landscape is very flat. The surface is composed of small fine grains, among them tiny spherical concretions of hematite named "blueberries" measuring in diameter from 1 to 2 millimeters.

The regional topography is explained as being either the floor of a shallow lake with an area of 127,400 square miles (330,000 km²), or the southern shore of the first ocean that covered the northern hemisphere 3.8 to 4 billion years ago. It was also a slightly acidic saltwater that dissolved the rocks. After evaporation, salt minerals were left behind, such as magnesium sulfates, which are very abundant at the *Opportunity* landing site. This area was once warm and humid, conditions favorable to the development of prebiological chemistry

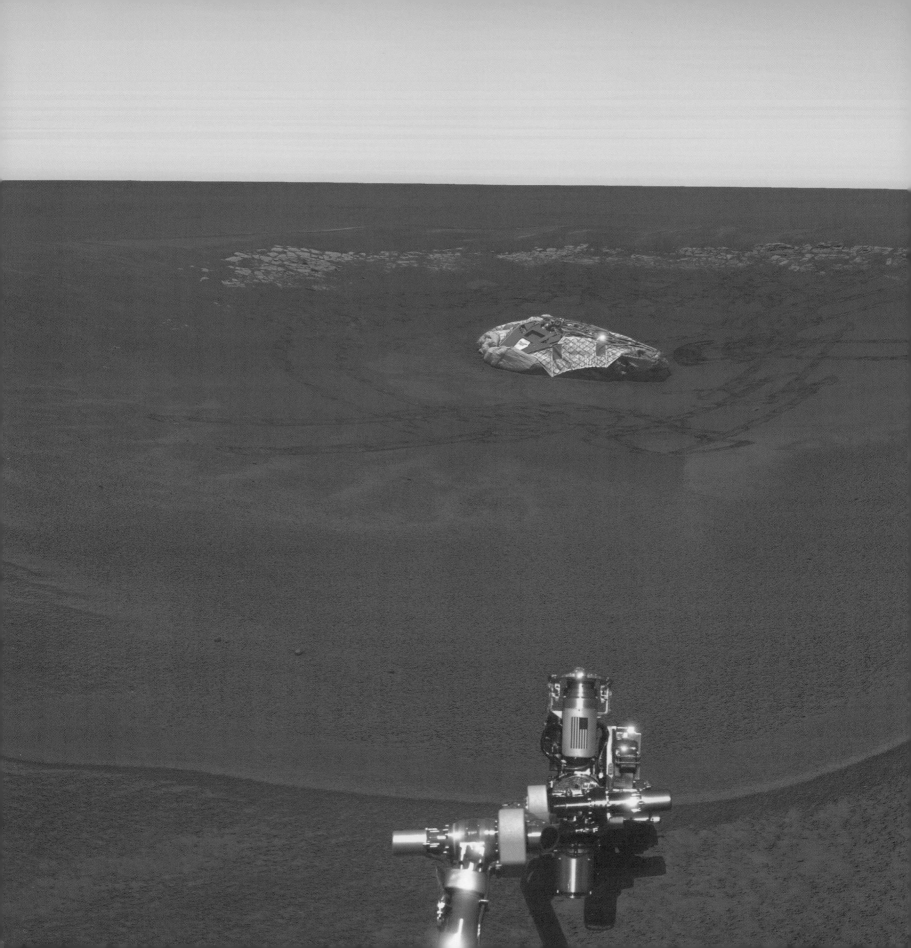

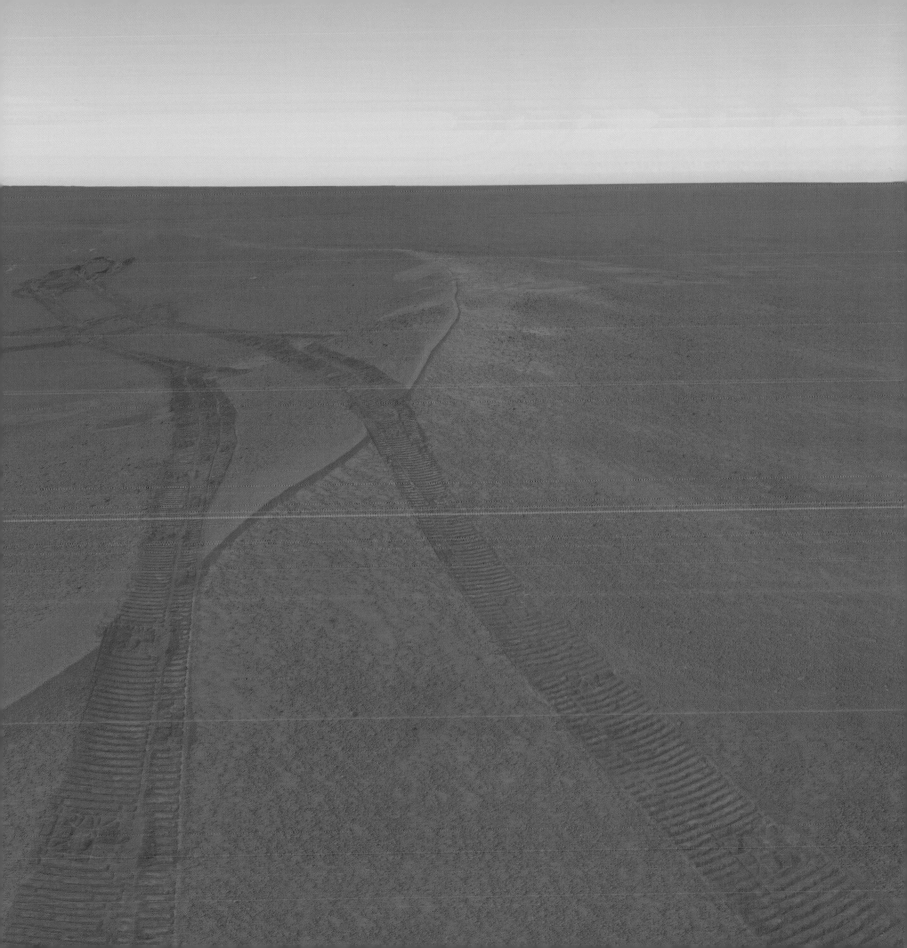

FIRE

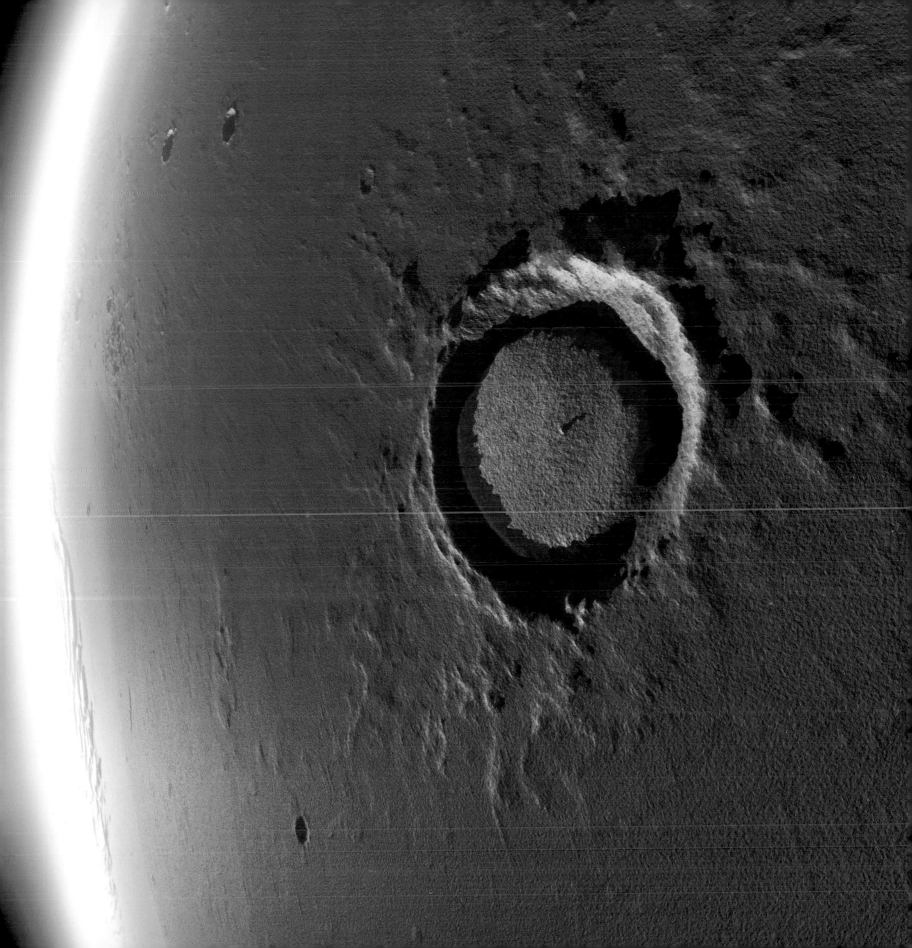

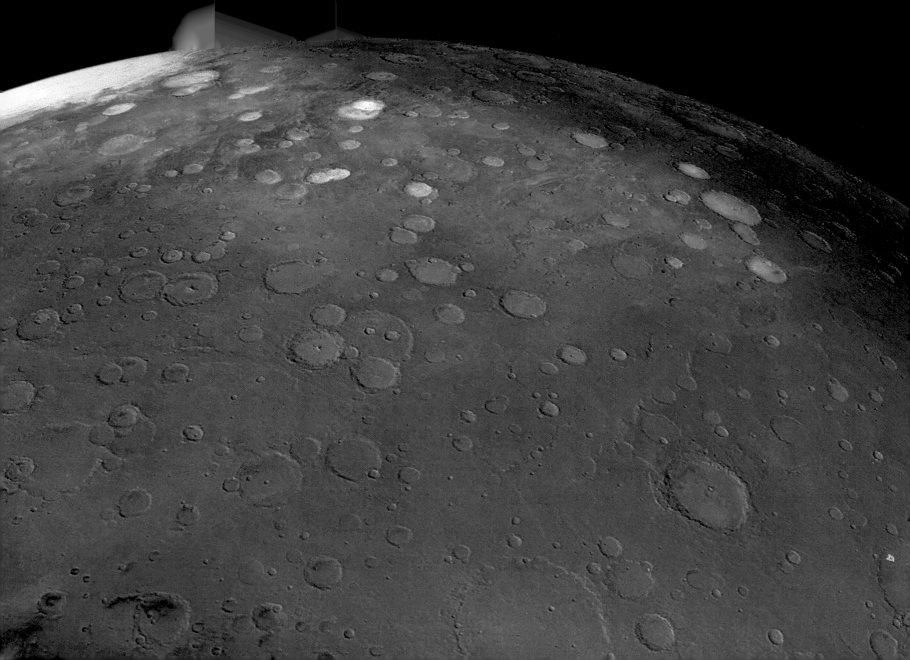

MARS IS A DREAM PLANET FOR GEOLOGISTS. THIS SMALL WORLD HAS HELPED US TO MAKE CONSIDERABLE ADVANCES IN ALL FIELDS ASSOCIATED WITH GEOLOGY, SUCH AS STRATIGRAPHY, CARTOGRAPHY, GEOMORPHOLOGY, AND EVEN EXOBIOLOGY, WHICH ATTEMPTS TO PIERCE THE MYSTERIES SURROUNDING THE APPEARANCE OF LIFE. MARS HAS SHOWN ITSELF TO BE A PLANET OF PARADOX. ON THE ONE HAND, IT IS SIMILAR TO EARTH'S MOON, THOUGH ITS EARLY YEARS WERE MUCH MORE TURBULENT. ON THE OTHER, IT IS LIKE A SMALL FRACTURED VOLCANIC EARTH. THE RED PLANET OWES THIS AMBIGUOUS NATURE IN PART TO ITS ORBITAL POSITION AND SIZE, WHICH HAVE STRONGLY AFFECTED ITS EVOLUTION. THE MEETING OF FIRE AND WATER LED TO THE APPEARANCE OF LIFE ON EARTH. COULD IT BE THE SAME FOR MARS?

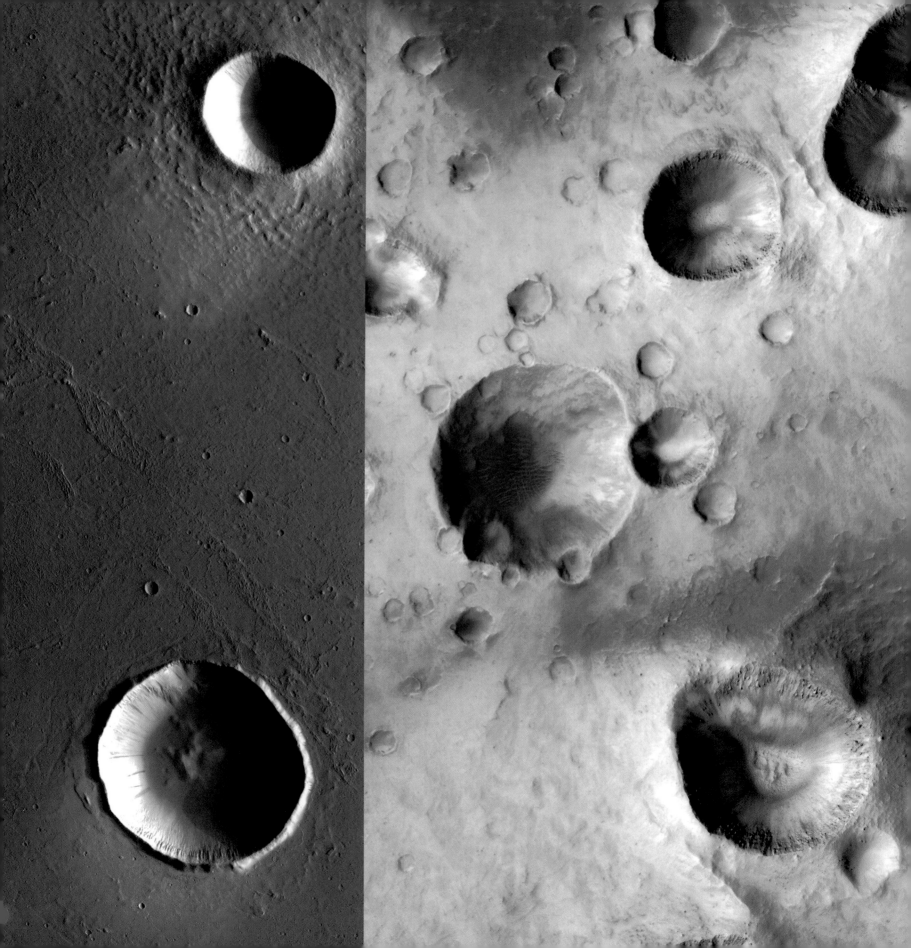

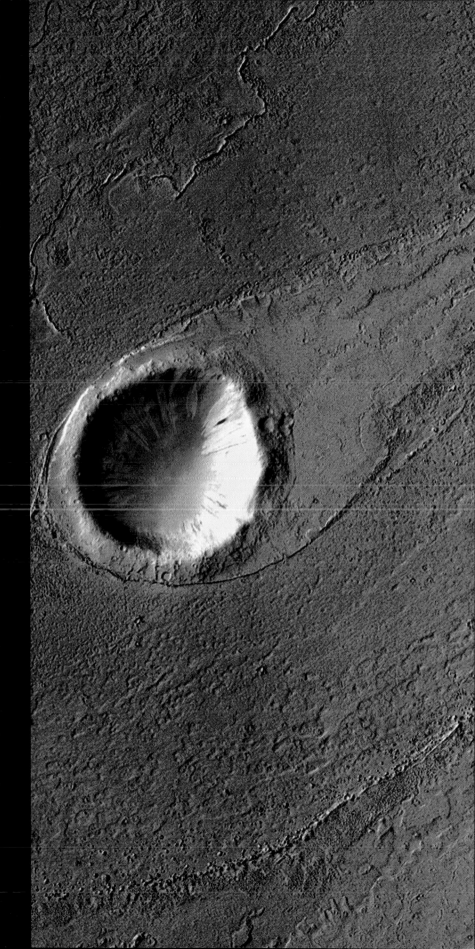

Pp. 46–47. Korolev crater (71° N, 195° W), 49.7 miles (80 km) across and seen under the midnight sun. Its bottom is filled with ice. On the horizon, the north polar cap (MOLA).

Pp. 48–49. Very craterized southern hemisphere. Left on the horizon, cross-section, the great Hellas basin, still covered with winter frost (USGS).

◄◄ Two craters 2.5 and 3.7 miles (4 and 6 km) in diameter, at 21° N and 161° W. The Martian winds have blown clear wind streaks on their lee (downwind) sides (MOC).
◄ Small craters with dusty bottoms in Arabia Terra, at 30° N and 14° W. In the center, the largest crater has a diameter of 0.6 miles (1 km; MOC).

Crater 1,312 yards (1,200 m) across in Marte Vallis, at 19° N and 175° W. The terrain was eroded into a teardrop-shape island by the floods (MOC). ▶

Moonlike Craters

Seen from orbit, the ramparts of Mars's many craters are softened, the work of millions of years of erosion. At the beginning of its history, the red planet experienced a period of intense meteor bombardment, as did most bodies in the solar system. This is how Mars is similar to the moon.

Mars has different types of craters. Most craters were built on hard, rocky ground, but some are "rampart craters," where a lobed ejecta is formed all around by a shock on frozen ground. The impact suddenly reheated and liquefied the ground on either side. The ejecta of mud then froze on site, giving the impression of a large splash (giving this type of crater its other name, "splash crater"). Other types of craters are identified by their rounded bases, compressed by the force of the impact, which remains still intact in the midst of softer terrain eroded through time (forming what is known as a "pedestal crater"). Other craters are evidence of a more active past. Their flanks were suddenly torn down by a strong flow of water and mud. The elements then gullied the loose soil all around. However, the ground that was very compressed by the force of the impact resisted the force of the current. The hollow of the crater itself with its rim is all that now remains.

Giant Volcanoes

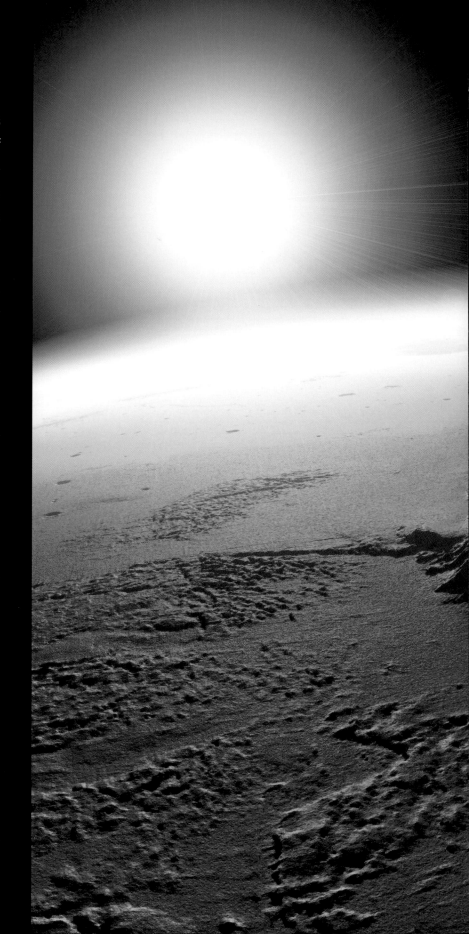

Mars's crust hardened soon after the planet was born, and as a result, Martian volcanoes are enormous. Lava always pierced the crust in the same places. The volcanoes are of the Hawaiian type, with a gentle slope of only two to five degrees. An astronaut standing on them would have trouble seeing the summit. Two large volcanic regions predominate: Elysium, whose large volcano Elysium Mons reaches an altitude of 46,358 feet (14,130 m); and Tharsis, a gigantic bulge where the crust has been lifted by the rise of magma. The Tharsis Plateau was most likely created by the gigantic impact that made the huge Hellas Planitia basin, which initiated a strong convective movement in the planet's mantle at the antipodes.

Tharsis has four huge volcanoes. The largest, Olympus Mons, measures 342 miles (550 km) across with an altitude of 69,882 feet (21,300 m), so high that it is often surrounded by clouds. In the northwest, some of the volcano's steep cliffs are 3 miles (5 km) high and extend into a vast ring of chaotic ridged topography made up of the remnants of slides of material from its collapsed western shield (called the "aureole deposits"). The three other volcanoes are aligned and may follow a fault line: Ascraeus Mons (59,711 feet or 18,200 m); Pavonis Mons (46,260 feet or 14,100 m); and Arsia Mons (58,399 feet or 17,800 m). Arsia Mons and Olympus Mons were very active 200 million years ago, when dinosaurs were walking the earth. Their latest big eruptions occurred about 120 million, 30 million, and 2.5 million years ago, suggesting that the volcanoes may be still active today. Other older volcanoes dot the southern hemisphere.

Olympus Mons viewed from the northwest. The largest volcano of the solar system reaches 69,882 feet (21,300 m) high (MOLA).

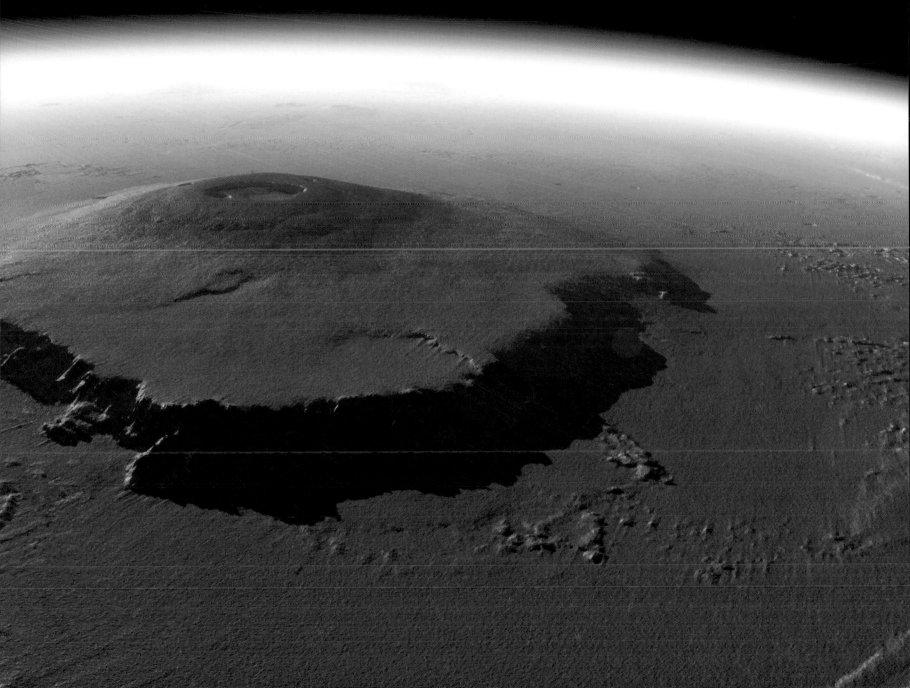

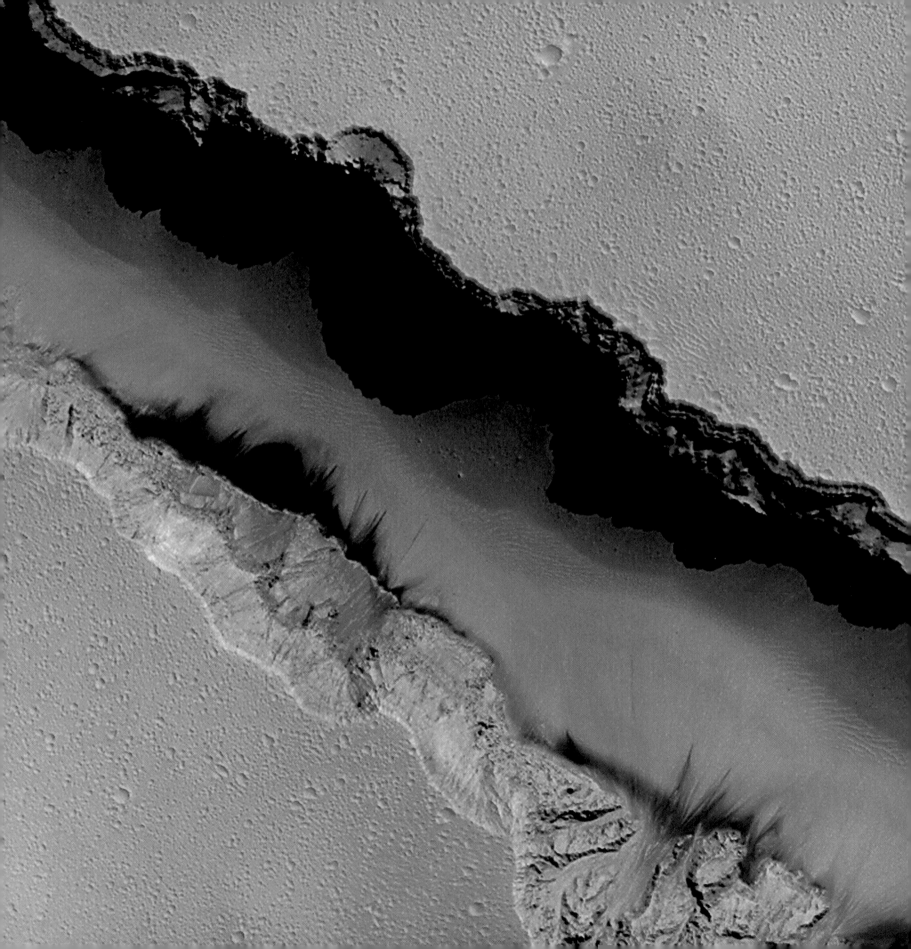

The Great Faults of the Martian Plains

Numerous faults and fractures cross the surface of Mars. On the Tharsis Plateau, for example, the fault line is made manifest by an extension of the crust that has risen up, like a cake rising in the oven. This is how fault troughs (also called "grabens") are created. In places where the crust is compressed by the effect of internal forces, on the other hand, small longitudinal hills (also called "ridges") are formed along the compression.

Apart from Valles Marineris, the most spectacular fault system is certainly Cerberus Fossae to the southeast of the Elysium volcanoes. Two flood valleys emerge from its fractures: Athabasca Vallis to the west and Marte Vallis to the east. The flanks of ancient craters were deeply eroded, even uprooted, by the force of that long-ago rush of water in their wake. The events that sculpted this region are thought to be very recent, perhaps dating back less than 5 million years. Underground lava melted huge quantities of frozen soil in the subsurface. The water may have formed gigantic water tables before gushing out of the faults. At least a million cubic meters of water per second poured toward the west to form the Athabasca Vallis. The water then dug out the surface to a depth of about 164 feet (50 m) and was probably absorbed by the vast fields of porous lava below.

The Cerberus fault network is still very active today. It is half as long as Valles Marineris, but we may be witnessing the birth of another Martian Grand Canyon. A billion years from now, perhaps someone will contemplate a vast network of steep valleys here, more than 620 miles (1,000 km) long and as much as 62 miles (100 km) across.

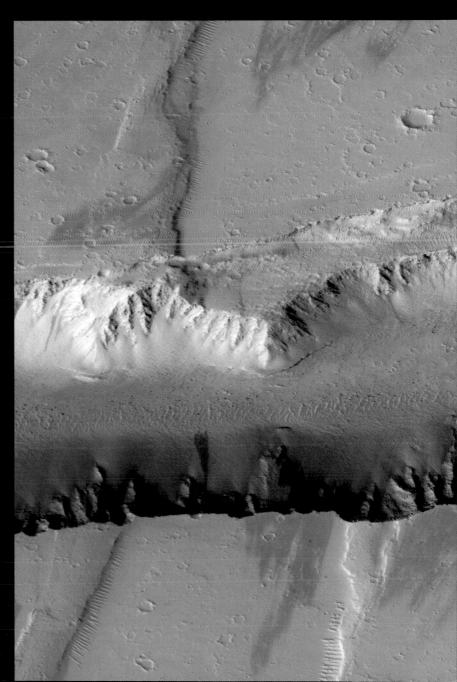

◀ Cerberus Rupes trough in Elysium, at 9° N and 198° W. In places it is 0.6 miles (1 km) wide and 656 feet (200 m) deep (MOC).

Fault trough (at 22° N and 104° W) about 1 mile (1.7 km) wide, west of the Ceraunius volcano, on the Tharsis Plateau (MOC). ▶

Following double page. The Valles Marineris giant canyon. In Coprates Chasma (from left to right), it stretches thousands of miles to the east (MOLA).

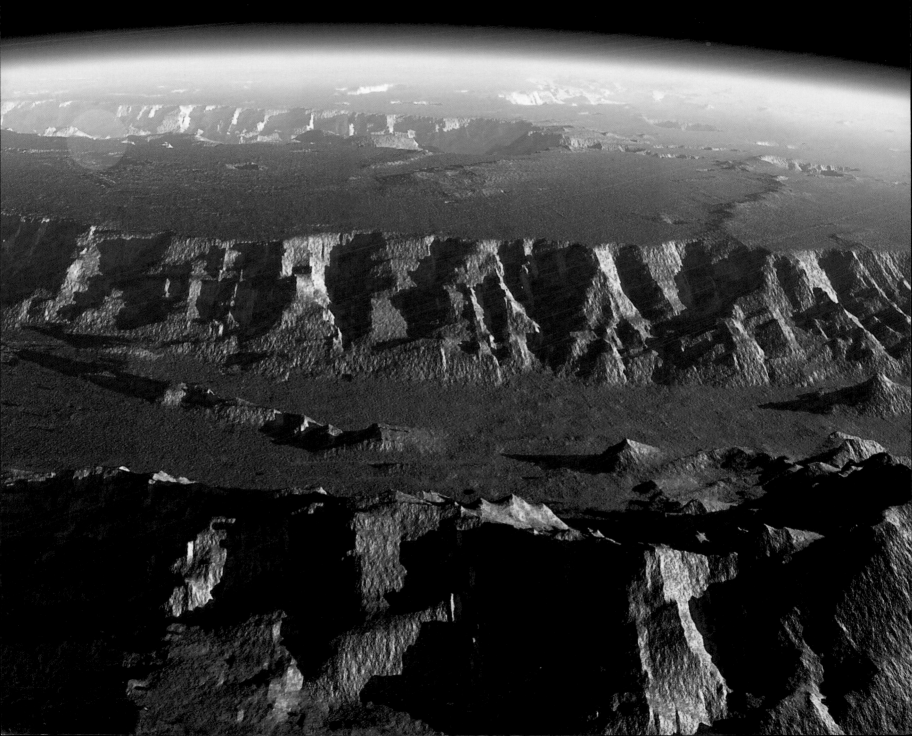

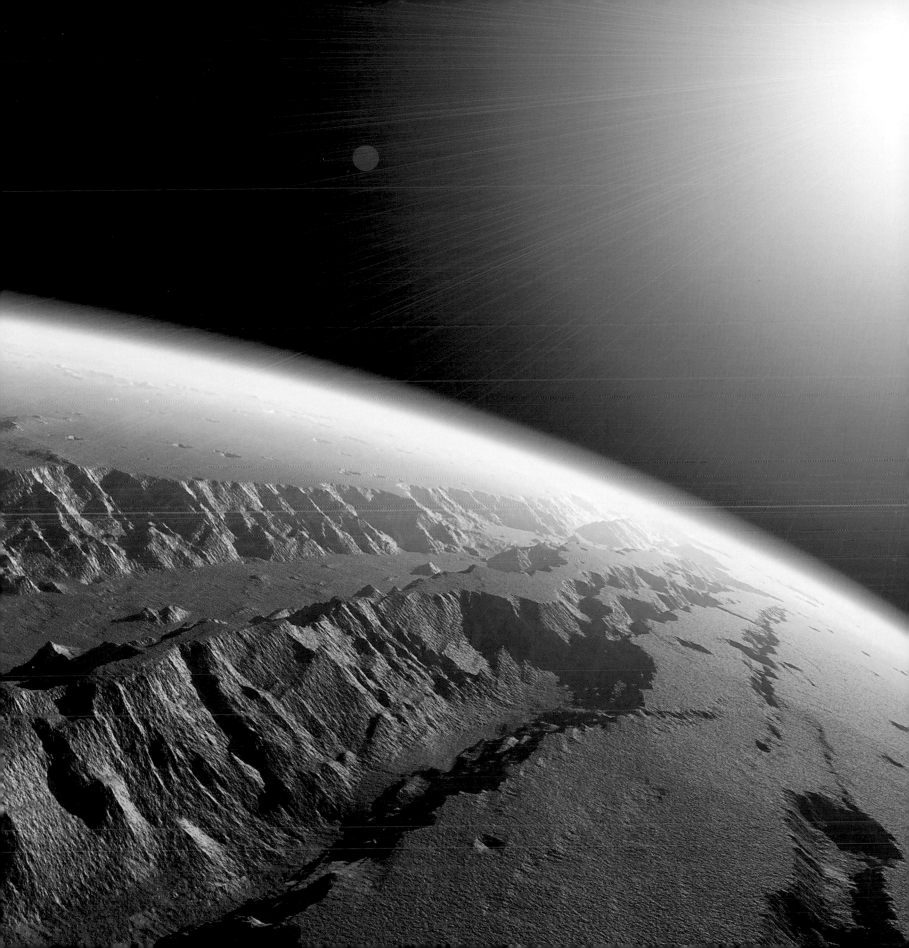

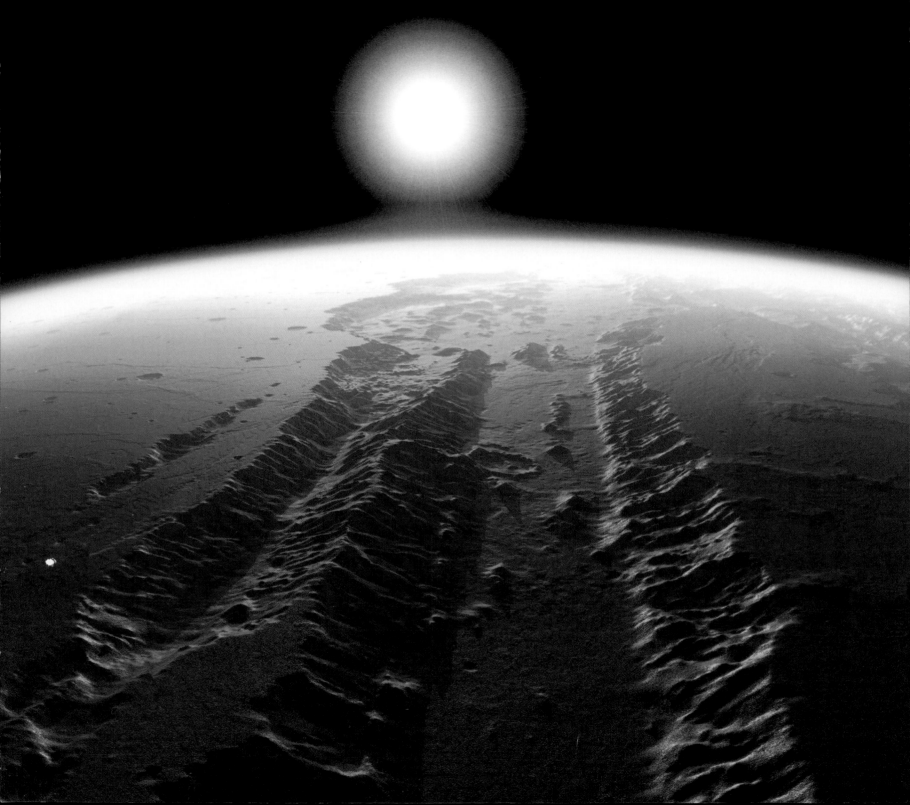

◀ View toward the west of Valles Marineris. A difference in height of 29,528 feet (9,000 m) separates the plateau from the canyon floor (MOLA).

Walls in the Hebes Chasma (Valles Marineris), at 2° S and 74° W. The piling of geological layers is very visible (MOC). ▶

Following double page. At a depth of −18,373 feet (−5,600 m), inside the lowest depths of Coprates in Valles Marineris. The wall to the left is about 28 miles (45 km) away and is 26,247 feet (8,000 m) high (MOLA).

Valles Marineris Giant Canyon

Mars's most beautiful natural site must be the gigantic Valles Marineris canyon. It is 3,107 miles (5,000 km) long and 75 miles (120 km) across and up to 6.8 miles (11 km) deep. This canyon was formed to the east of Tharsis, following the thrust of the crust that was fractured under the enormous pressure from the planet's interior. Valles Marineris was then reshaped by erosion and its sides show traces of spectacular avalanches of rock and sediment.

Its creation is also due to a massive extrusion of magma along the faults created to the east by the Tharsis Bulge. As the magma emerged, it melted the ice-filled ground. The gigantic eruptions of ash and mud collapsed the landscape, which was hollowed out more as the water rushed out. Thus a successive string of canyons was carved from the surface. Strange sedimentary formations with hundreds of striations can sometimes be seen at the bottom, proof that great lakes once filled this canyon. When the climate cooled, the lakes were covered by a thick crust of ice. Now all that remains is an impressive series of geologic formations linked together and swept by the winds.

Valles Marineris is so deep and wide that an astronaut standing in the middle of it would have trouble figuring out where he or she was. Only a few cliffs at the horizon would emerge from the dusty haze.

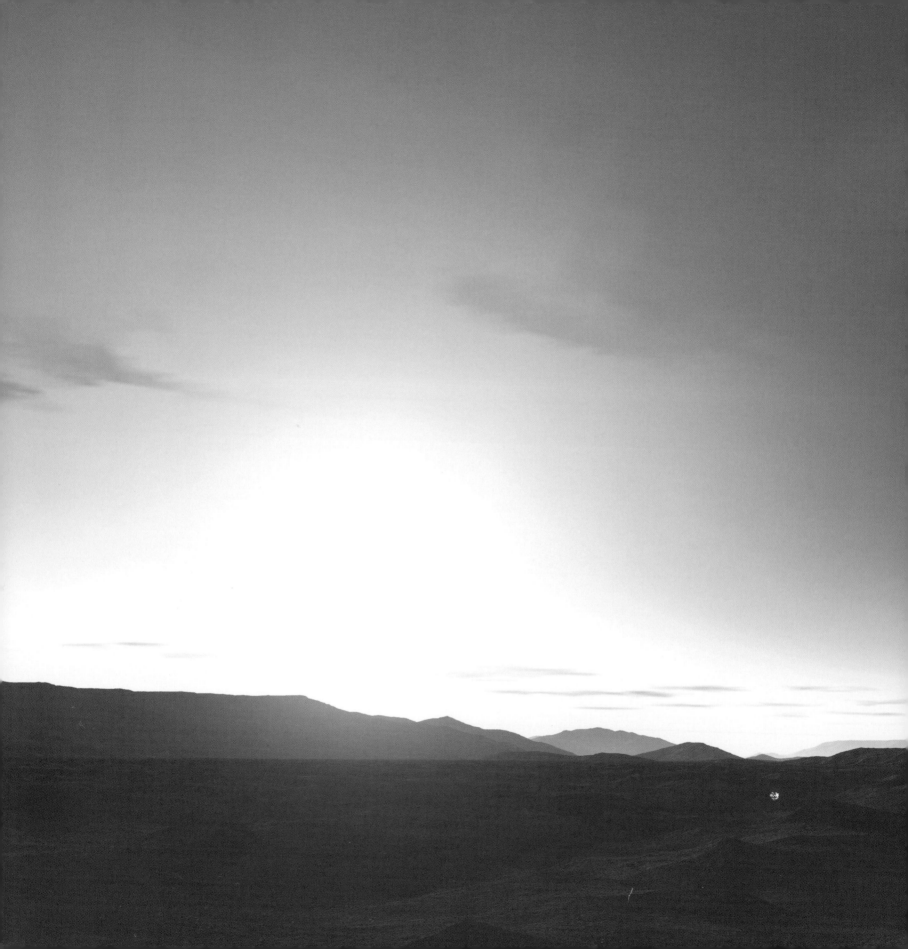

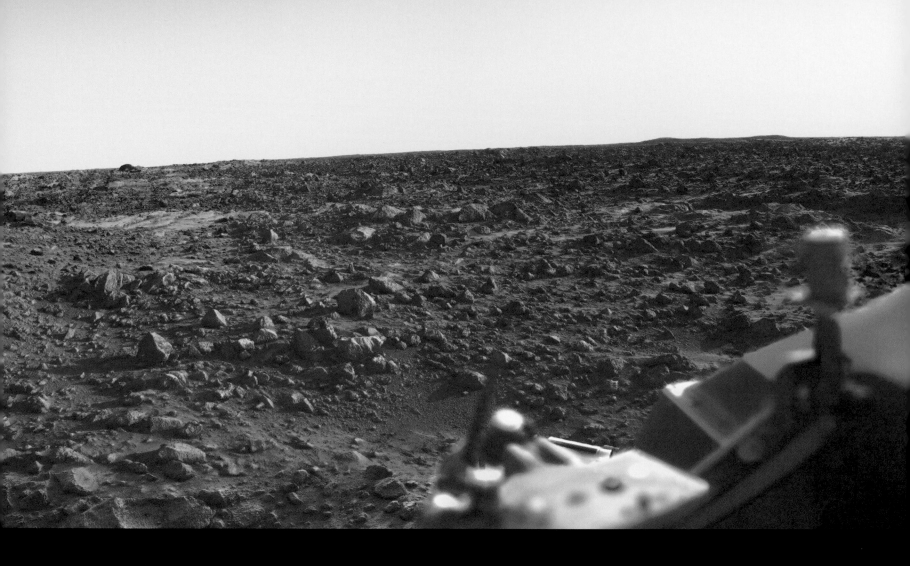

Mars's History, As Told by Rocks

The *Viking 1* landing site on Chryse Planitia is surrounded by rocks of many colors. Most of them are angular in shape, the result of meteorite impacts that formed the surrounding craters. Some were deposited by the water and mud floods that once swept through the region.

On Utopia Planitia (the *Viking 2* landing site), the surface is uniformly covered by volcanic rocks that are larger and less diversified than those of Chryse Planitia. Small cavities mark their surface, giving them a spongelike appearance. This landscape was shaped by the impact that created the

great Mie Crater 112 miles (180 km) to the east. The layer of debris on the site is almost 10 feet (3 m) thick.

Ares Vallis is the stoniest area: 16 percent of the *Pathfinder* landing site (compared to 6 percent and 14 percent for those of *Viking 1* and *Viking 2*) is carpeted with rocks over an inch (3 cm) wide. In front of *Pathfinder,* in the Rock Garden, nearly 25 percent of the surface is covered with rocks. Many angular blocks come from the subsurface, hurled here by the impacts of surrounding craters. The raised rim of Big Crater, measuring 1,640 yards

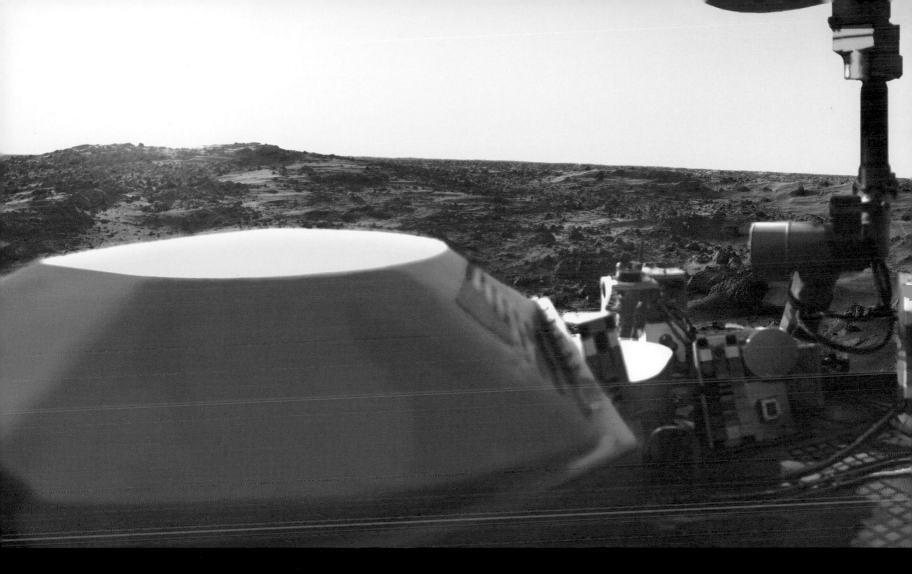

(1,500 m) across, is about 2,400 yards (2,200 m) south-east of the probe. A variety of rocks rich in quartz have been identified, such as andesite, a mineral containing more than 60 percent silica. On Earth, andesites are formed when continental drift causes pieces of the solid crust to sink into the mantle, where they are remelted. This second "cooking" distinguishes them from basalt rocks, formed when the magma from underground is cooled and hardened for the first time. As Mars lacks plate tectonics, the planet may have experienced a localized crust melt-

down early in its history, perhaps as a result of the great impacts that shaped its northern hemisphere.

At the *Spirit* site in the Gusev Crater, only 1 percent of the surface is covered with pebbles that are larger than half an inch (1 cm) across, and some of those are half buried in the sediment. Small pebbles 1.5 inches (4 cm) across bear witness to the passage of water. Most of the

Viking 1 site, 5:45 P.M. At the horizon, craters' rims viewed from the side (middle). In the foreground, the wind cover of nuclear generator no. 2. Right, the color calibration targets and antenna mast (*Viking*).

rocks are basalt. The microscope onboard *Spirit* made it possible to examine a volcanic rock named Humphrey, 23.6 inches (60 cm) high, where shiny crystallized minerals could be seen in the fissures, deposits from the water that had once flowed across the landscape and penetrated the rock. A water-signature mineral, called goethite, was identified inside another rock, named Clovis and located in the Columbia hills. The discoveries of goethite and of layered rocks imply that materials were formed in ponds or lakes or modified by flowing water inside the Gusev crater.

At the *Opportunity* site, on Meridiani Planum, the half of the crater where the probe landed appears to be surrounded by a wide, rocky substrate about 6 inches (15 cm) high. These rocks are outcroppings that jut out from the topmost of the sedimentary layers. They are stratified and very flat. Analysis of the rock called El Capitán showed that it was made of silicates, including magnesium, and iron sulfates

▲ Detail taken with *Opportunity*'s microscope of the Robert E. rock. Some tiny spherical concretions of hematite—named "blueberries"—measuring a few millimeters are still stuck to it (MER).

Viking 1, 3:15 P.M. The surface is sprinkled with stones. In the middle foreground, the Dutch Shoe rock, 13.8 inches (35 cm) across (*Viking*). ▶

Following double page. *Viking 2*, 6:50 A.M. on Utopia Planitia. The landscape, flat but deformed by the tilt of the lander, is covered with pitted rocks. In the middle, the meteorology boom holding the weather sensors (*Viking*).

such as jarosite, that were formed by the interaction of water, sulfur, and iron. Almost 40 percent by weight of the rock called Guadalupe is composed of sulfate salts.

These outcroppings are sedimentary rocks formed at the bottom of a huge, shallow salt lake by the continuous deposit of elements once suspended in the water. The level of the lake varied, allowing the wind to add a layer of dust before the water came back and deposited other sediment. Through slow evaporation, salts were concentrated in the rock matrix.

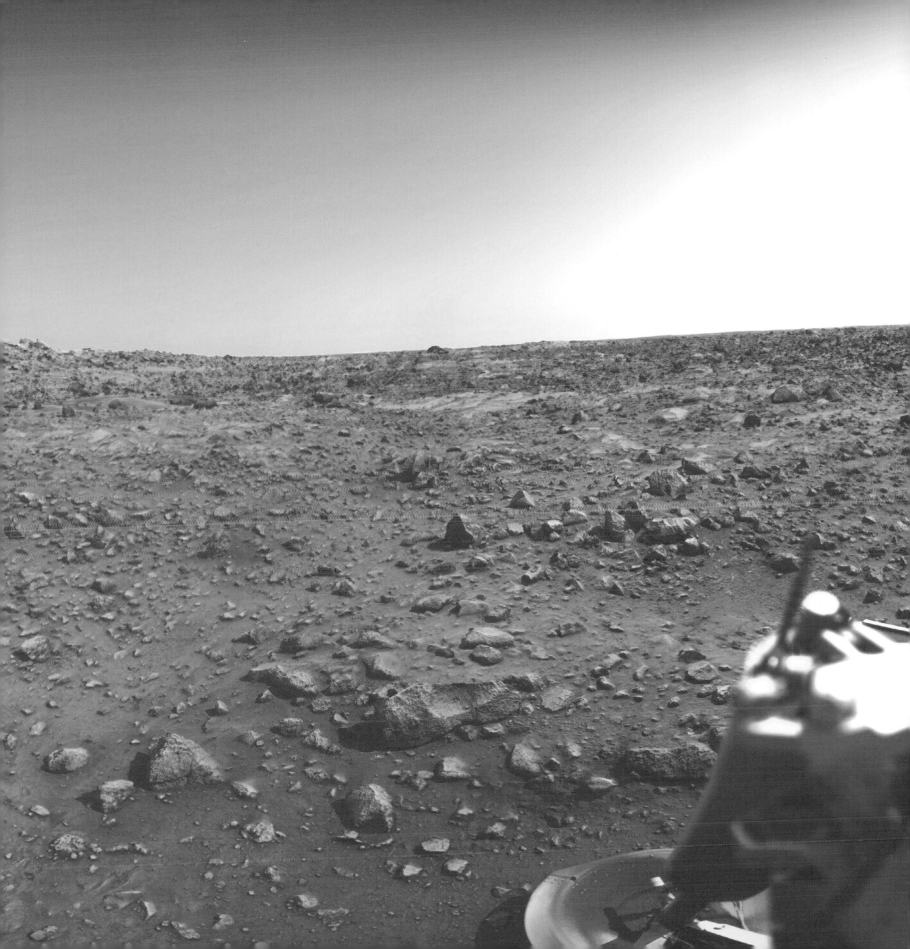

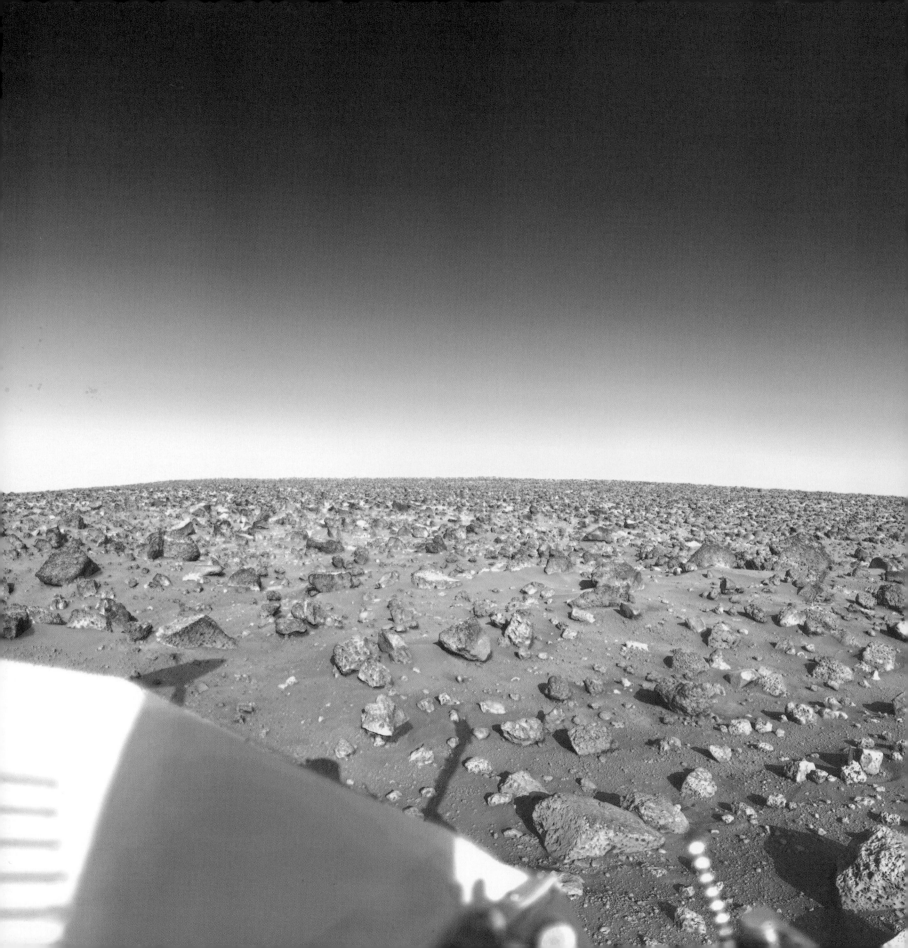

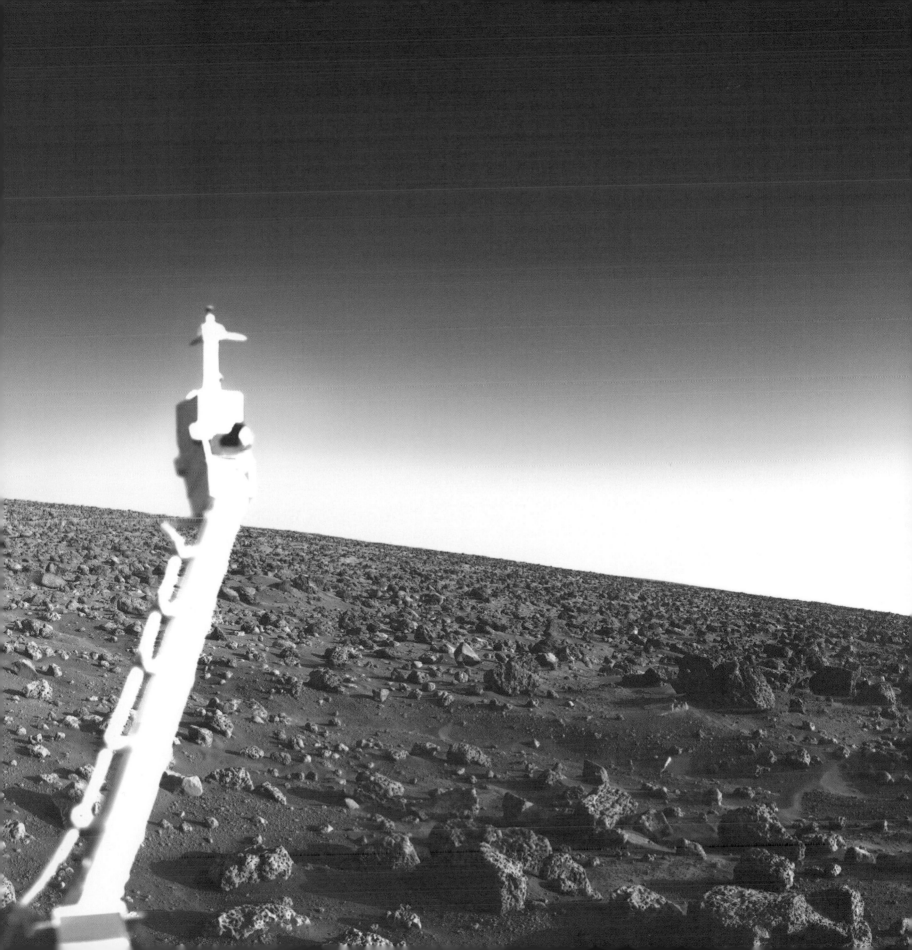

WATER

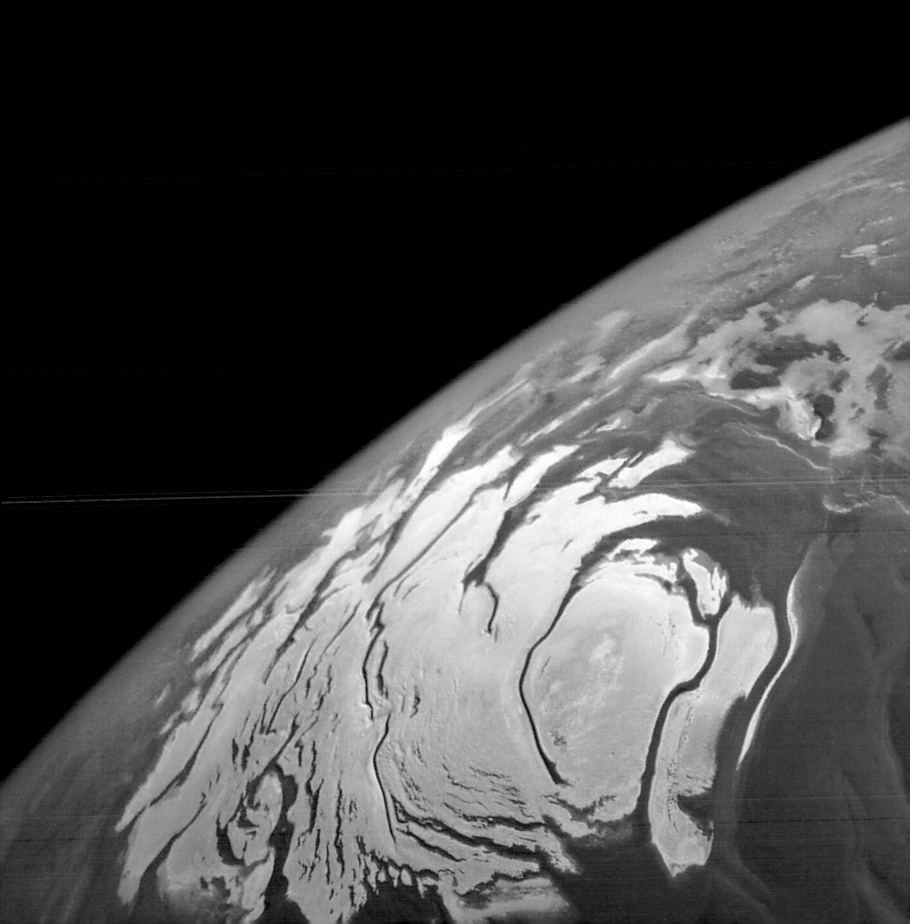

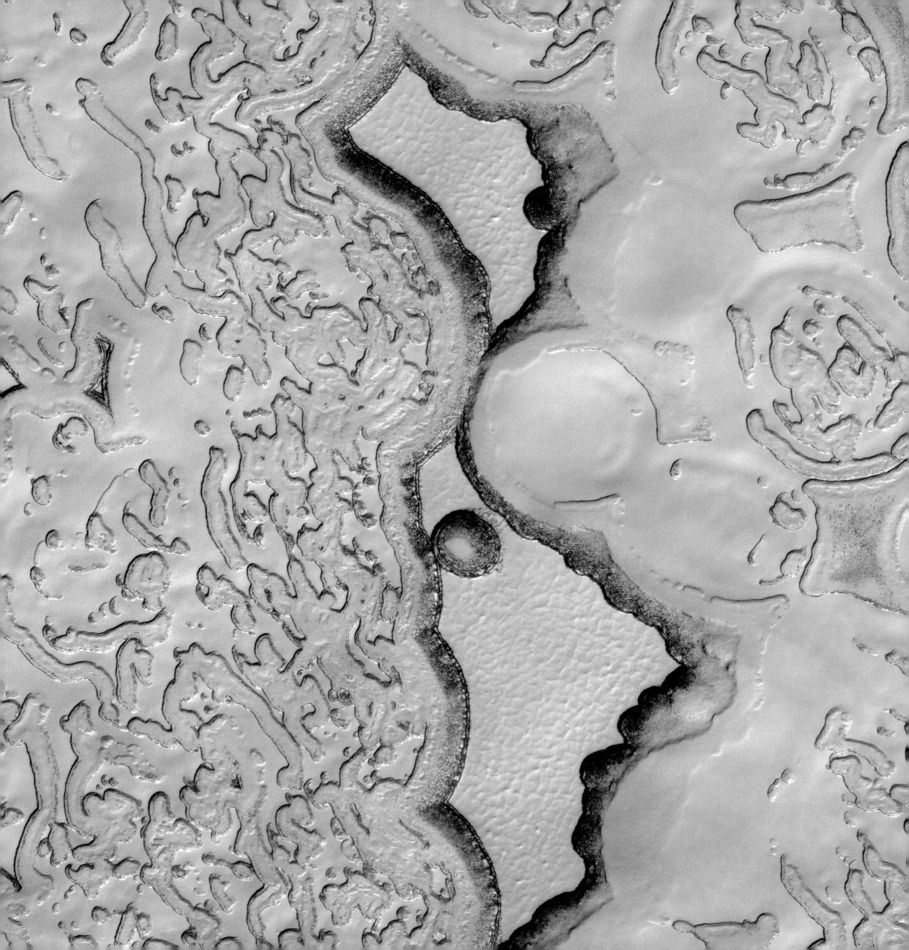

O N EARTH, WATER IS SOLID (ICE) AT 1,000 MILLIBARS OF PRESSURE AT SEA LEVEL. IT BECOMES LIQUID AT TEMPERATURES BETWEEN 32° F AND 212° F (0° C AND 100° C), AND AT HIGHER TEMPERATURES IT BECOMES VAPOR (STEAM). AT HIGH ALTITUDES, WHEN THE ATMOSPHERIC PRESSURE DECREASES, THE BOILING TEMPERATURE ALSO GOES DOWN. THE TRIPLE POINT OF WATER—A COMBINATION OF TEMPERATURE AND PRESSURE THAT LETS WATER TAKE THE FORM OF SOLID, LIQUID, AND GAS AT THE SAME TIME—IS AT 32.018° F (0.01° C) UNDER 6.1 MILLIBARS OF PRESSURE. THIS PRESSURE, 6.1 MILLIBARS, IS EXACTLY THAT FOUND ON MARS, WHERE IT IS ALWAYS VERY COLD, WITH AN AVERAGE TEMPERATURE OF −81° F (−63° C). ABOVE 32° F (0° C), WATER PASSES INSTANTANEOUSLY FROM THE SOLID INTO THE GASEOUS STATE WITHOUT BECOMING A LIQUID. MARS IS BLOCKED IN A "COLD TRAP." EVEN IF THE PRESSURE WERE HIGHER, CARBON DIOXIDE FROM THE AIR WOULD QUICKLY DISSOLVE IN THE WATER TO FORM CARBONATES. THIS WOULD GREATLY REDUCE THE ATMOSPHERIC VOLUME OF CARBON DIOXIDE: THE PRESSURE WOULD QUICKLY FALL AT THIS FAMOUS TRIPLE POINT.

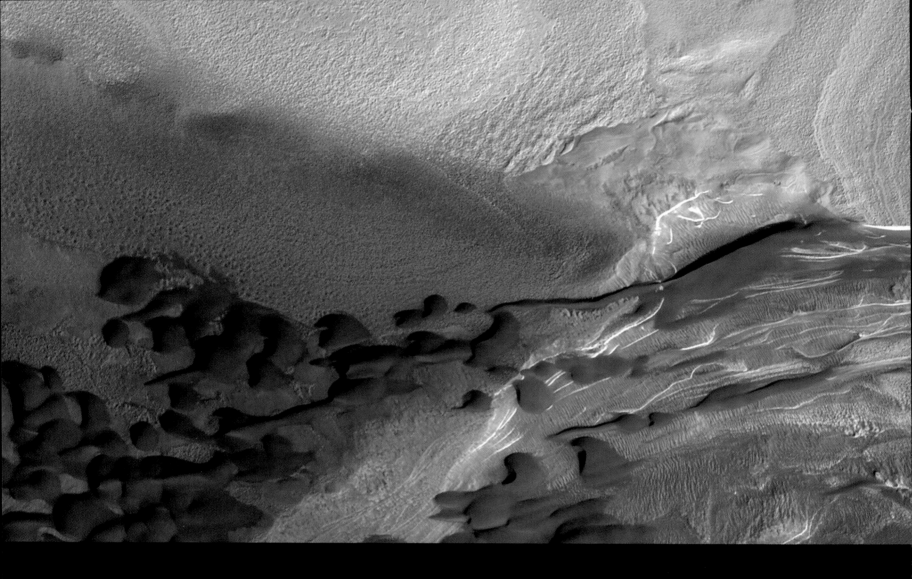

Poles Made of Water Ice

It is well known that Mars's polar caps expand and recede according to the seasons. In the summer, each pole retains only a small residual cap of water ice, about 85 percent as much ice as could be found in Greenland. Deep valleys cut into the caps, with horizontal layers sometimes a foot (30 cm) thick.

Because Mars follows an eccentric orbit around the sun, the southern winter is twenty-four Martian days—or "sols," with one sol equivalent to 24 hours 37 minutes—

longer than the same season in the northern hemisphere. A quarter of the Martian atmosphere is condensed at the planet's south pole as carbon dioxide or dry ice (frozen carbon dioxide), decreasing the pressure on the entire planet by 35 percent. A vast reservoir of carbon dioxide is also frozen in the southern cap.

Winter temperatures at the planet's north pole can drop to -220° F (-140° C). When the temperature drops to -193° F (-125° C), a layer of dry ice nearly 5 feet (1.5 m)

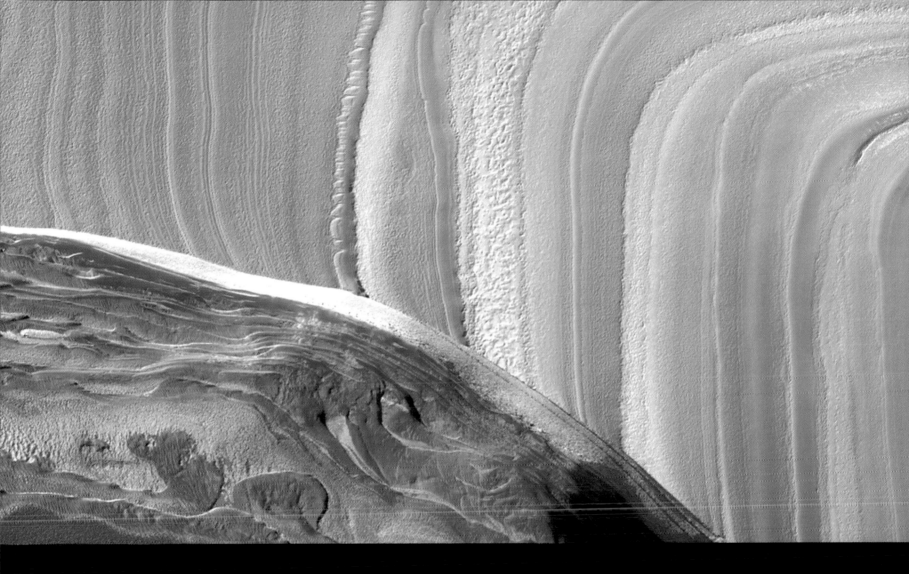

thick is formed. But the north cap has a negative altitude of about 6,230 feet (1,900 m) below the mean radius. In summer the air here is denser and warmer. The frozen carbon dioxide is sublimated, and there remains only a cap of water ice, 750 miles (1,200 km) across and 1.86 miles (3 km) thick.

The visible cap at the south pole, elevated 15,748 feet (4,800 m) above the planet's average altitude, does not reveal the enormous quantity of ice buried all around it. In

▲ View 6.2 miles (10 km) across (84° N and 239° W) showing a north pole layered scarp of dust and water ice about 984 feet (300 m) high, resting on frozen terrain (MOC).

Pp. 68–69. South polar cap in summer from orbit. Only water ice remains covered with a thin film of dry ice (CO_2) (MOC).

P. 70. Dry ice mesa 3,062 yards (2,800 m) long at 86° S and 358° W. The sublimation reveals alternating layers of ice and dust on its slopes about 33 feet (10 m) high (MOC).

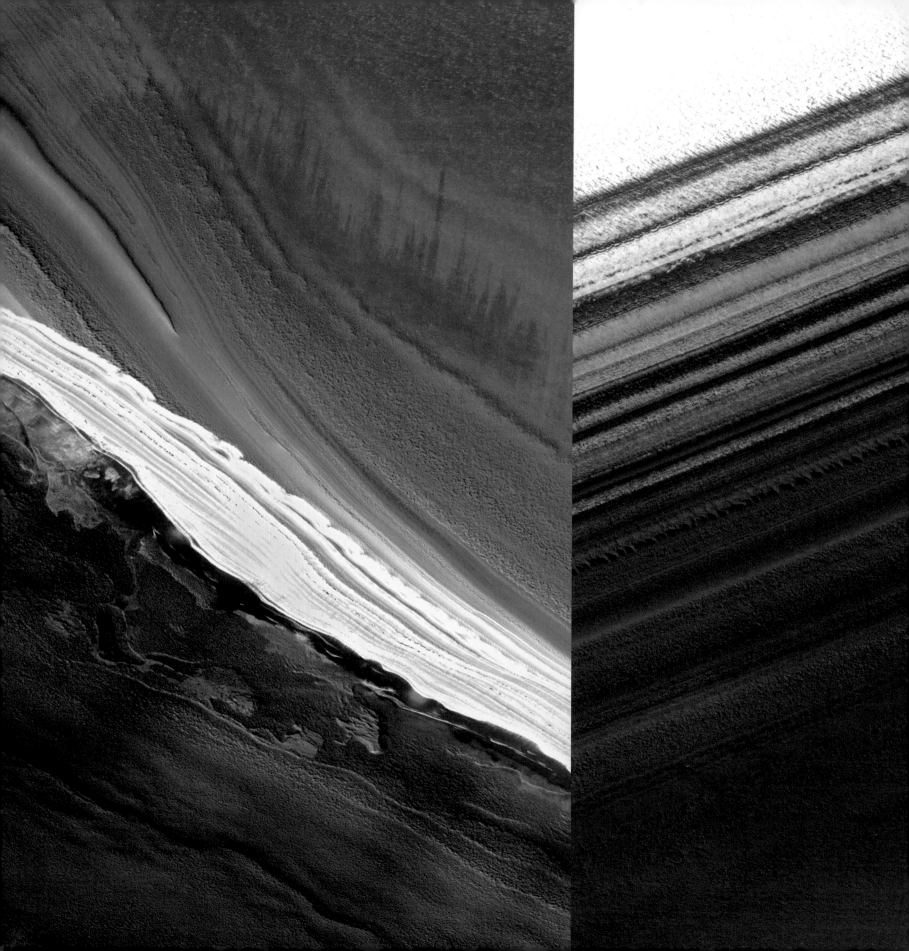

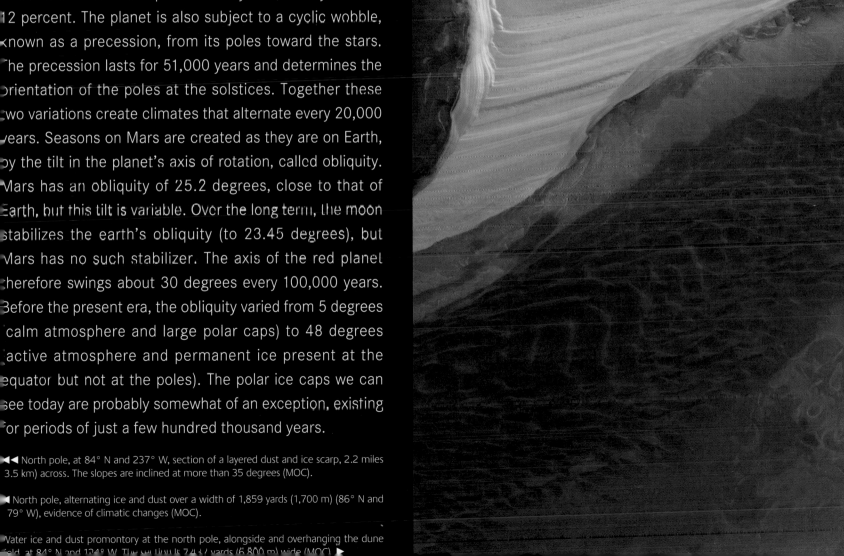

winter, dry ice forms in a layer about 35.4 inches (90 cm). In summer, temperatures remain cool as a result of the weak atmospheric pressure (4 millibars, on average) and the dry-ice layer is never completely sublimated. Despite this constant "winter," no one will be able to ski here—the dry-ice crust of frozen carbon dioxide never disappears and would stick to even the best-waxed skis.

Layers of sediment and ice bear witness to the planet's climatic cycles. The variation in the distance between Mars and the sun peaks every 95,000 years at 12 percent. The planet is also subject to a cyclic wobble, known as a precession, from its poles toward the stars. The precession lasts for 51,000 years and determines the orientation of the poles at the solstices. Together these two variations create climates that alternate every 20,000 years. Seasons on Mars are created as they are on Earth, by the tilt in the planet's axis of rotation, called obliquity. Mars has an obliquity of 25.2 degrees, close to that of Earth, but this tilt is variable. Over the long term, the moon stabilizes the earth's obliquity (to 23.45 degrees), but Mars has no such stabilizer. The axis of the red planet therefore swings about 30 degrees every 100,000 years. Before the present era, the obliquity varied from 5 degrees (calm atmosphere and large polar caps) to 48 degrees (active atmosphere and permanent ice present at the equator but not at the poles). The polar ice caps we can see today are probably somewhat of an exception, existing for periods of just a few hundred thousand years.

◄◄ North pole, at 84° N and 237° W, section of a layered dust and ice scarp, 2.2 miles (3.5 km) across. The slopes are inclined at more than 35 degrees (MOC).

◄ North pole, alternating ice and dust over a width of 1,859 yards (1,700 m) (86° N and 79° W), evidence of climatic changes (MOC).

Water ice and dust promontory at the north pole, alongside and overhanging the dune field, at 84° N and 124° W. The section is 7,437 yards (6,800 m) wide (MOC). ►

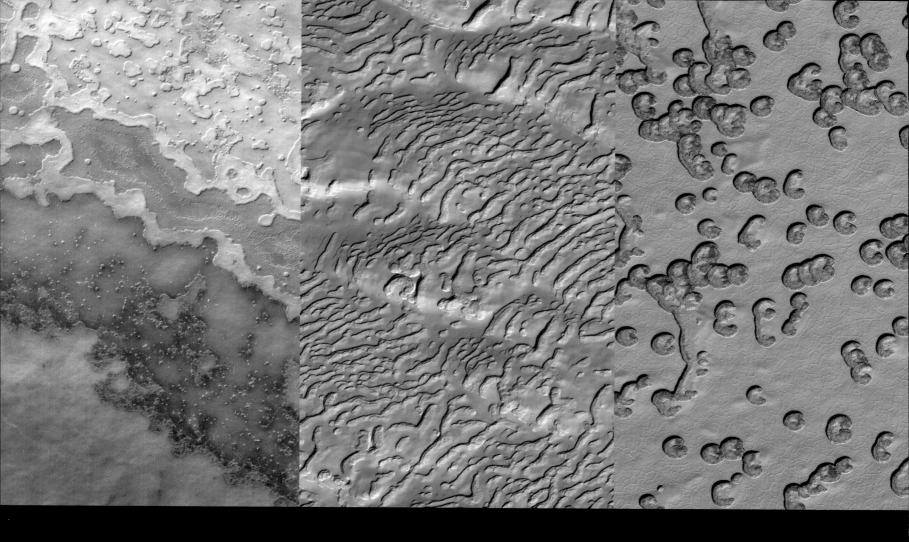

Strange Formations Unseen on Earth

The Martian poles feature unusual formations never seen on Earth, created over time by extreme climatic conditions.

The north cap is cut with cliffs of water ice, some reaching higher than 980 feet (300 m), which rest on a plateau composed of a thousand sheets of frozen ground with layers some 98 feet (30 m) thick. In summer, the rapid sublimation of the ice (at a rate of 0.19 inches or 5 mm per year) explains the steep 40-degree slopes of cliffs that date back tens of thousands of years. But it's the south cap's dry ice that is truly peculiar. In winter,

when temperatures drop to −193° F (−125° C), the carbon dioxide contained in the atmosphere freezes and forms plates of dry-ice frost on the warm ground. The frost catches small grains (2 microns) of dust in suspension in the atmosphere and settles down. Pockets of carbonic gas are created under the ice in the places where the frost comes into contact with warm soil. In spring, the sun heats up the grains of dust, creating tiny holes that tunnel all the way down to the bottom of the ice. In this way, the ice "self-cleans" and becomes transparent. Next the

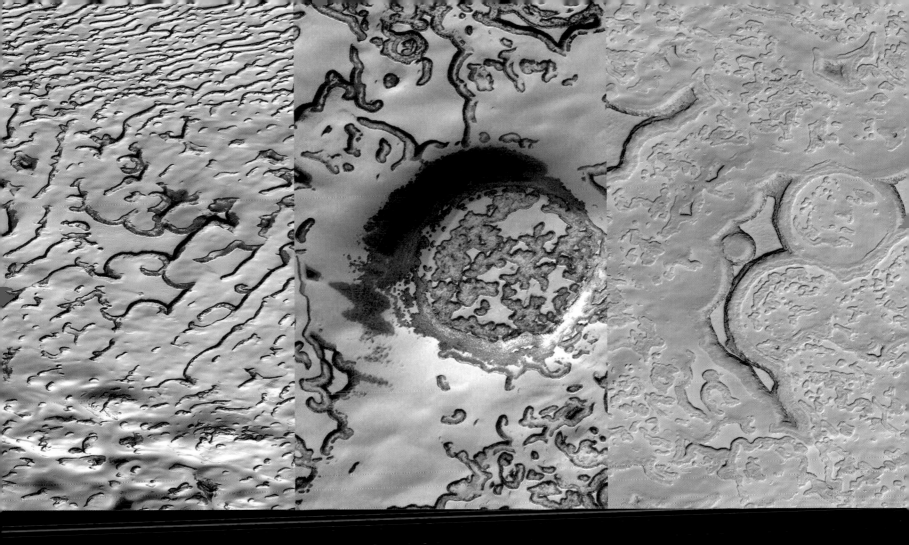

sunlight travels all the way through the frozen carbon dioxide. As the dark dust at the bottom is concentrated and heated, the trapped pockets of carbonic gas also get warmed. As it warms, the heated gas expands and begins to push up on the ice. Suddenly the ice bursts and the gas escapes at 164 ft/sec (50 m/sec). The dust it carries is deposited in fan-shape formations, according to the direction the wind blows.

When the plates of frozen carbon dioxide mix with the softer carbonic snow, gases pierce them like roots, which

▲ Pp. 76–77. Zoo of strange Martian dry-ice formations (MOC). From left to right, formations: in flat plates 3,062 yards (2,800 m) across at 87° S and 109° W; in "worms" 1.2 miles (2 km) across at 87° S and 29° W; in "hearts" (small "Swiss cheese" formations) 2,953 yards (2,700 m) across at 87° S and 7° W; in "worms" at the spring defrost 2,734 yards (2,500 m) across at 87° S and 47° W; at the bottom of a crater fossil, 1,859 yards (1,700 m) across at 87° S and 350° W; in very eroded "Swiss cheese" 2,515 yards (2,300 m) across at 87° S and 345° W.

Next page. Southern planisphere from latitude 67° S and centered on the south pole. Notice the small residual polar cap 249 miles by 186 miles (400 km by 300 km), which is not centered on the pole itself. The 0° meridian is at the top, 180° at the bottom, 90° on the left, and 270° on the right (USGS).

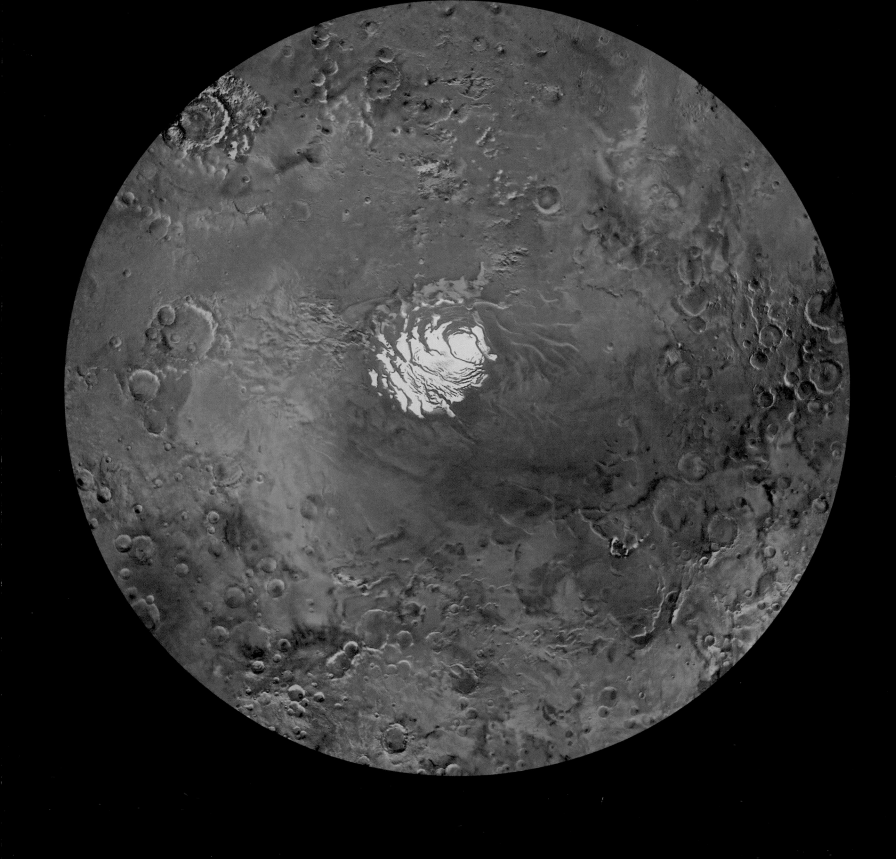

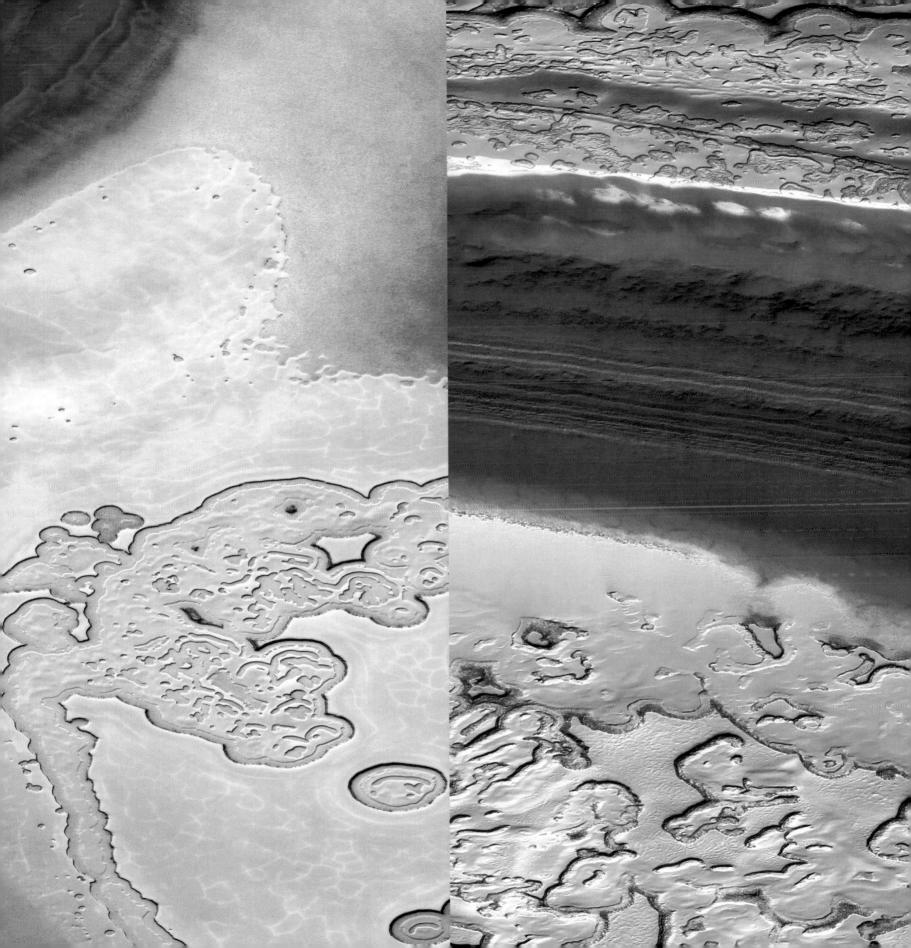

then grow into spectacular "bushes." When the ducts are blackened by dust, they are called "black spiders." If the gas and dust diffuse gently, small black dots form, called "Dalmatian spots." Sometimes they transform into "fried eggs" by surrounding themselves with a clearer halo.

On the other hand, "Swiss cheese" formations are actually holes in the dry ice. They may be heart-shape and measure over 100 yards or meters across, or they may be more circular in shape and 1.2 miles (2 km) wide. With a depth of over 33 feet (10 m), their walls alternate with layers of ice and dust. At the bottom, water ice is found. From one Martian year to the next, the depressions widen from 20 to 100 inches (50 to 250 cm). Calculating back to their birth dates, we see that they range in age from 400 to 15 years (213 to 8 Martian years). What causes these formations? One possible culprit might be a big historic dust storm, which would deposit a lot more dust than usual, which would then create an unusual degree of heating on the ice when warmed by the sun.

This fine superficial layer only makes up 5 percent of the total volume of atmospheric carbon dioxide. With the passing of climatic cycles, however, the cap will eventually disappear, along with its thousand sheets of carbonic and water, and its gases will dramatically increase atmospheric pressure.

MARTIAN "PLANTS"

Are those trees at the red planet's south pole? Could there be life on Mars? Actually, it's just an optical illusion! (MOC)
Below: Holes, created by dust that drills down in the dry ice, aligned like hedges (2,405 yards or meters across at 83° S and 45° W).

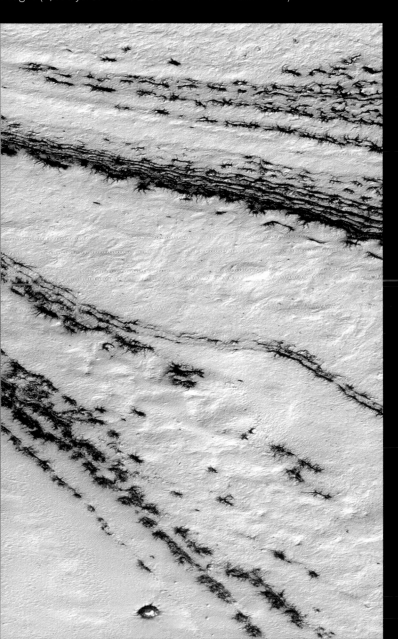

Above: Small longitudinal fractures shaped like trees allow the escape of pressurized carbon dioxide and dust, which is carried away by the wind (left, 1.8 miles [3 km] across at 84° S and 238° W; right, 1.5 miles [2.5 km] at 85° S and 238° W).
Below: Carbon dioxide ducts that look like bushes, measuring 546 yards (500 m) across (at 82° S and 294° W).

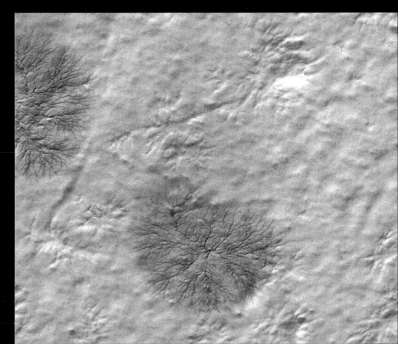

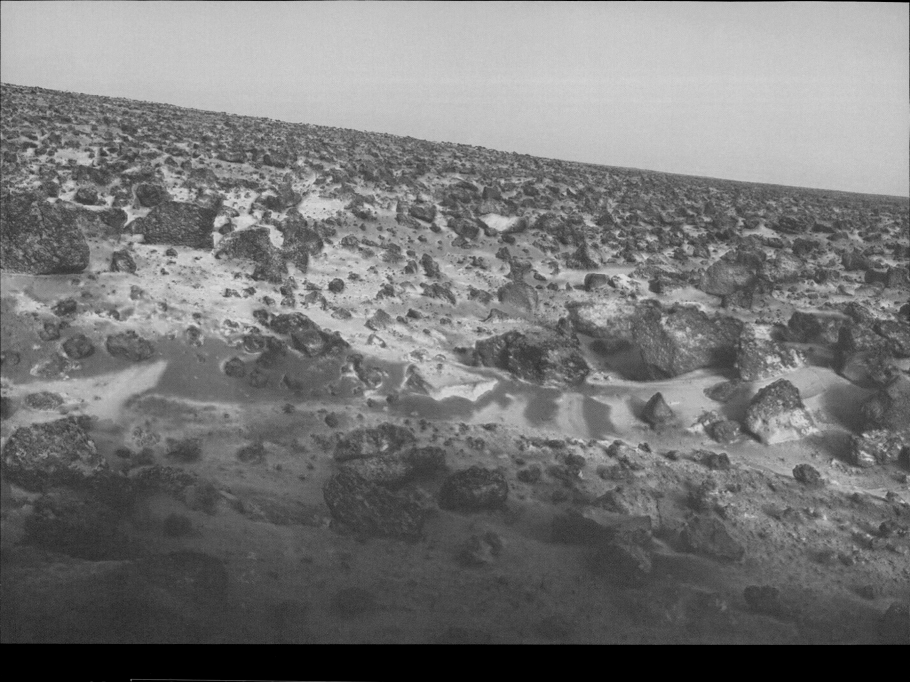

Evidence of Humidity in the Atmosphere

At night, when the temperatures are lowest, Mars's atmosphere becomes more humid. Around the north polar cap the air is always saturated with water vapor. Water vapor also seems to be homogeneously distributed in the atmosphere up to an altitude of 6.2 miles (10 km). In winter, water frost covers the planet's northern and southern regions. If all this atmospheric humidity condensed on the surface, it would form a 50-micron-deep cover of water—not much by Earth standards, but a lot for Mars.

The *Viking 2* lander has observed two consecutive Martian winters and the appearance and disappearance of water frost around it. How this frost is deposited is well

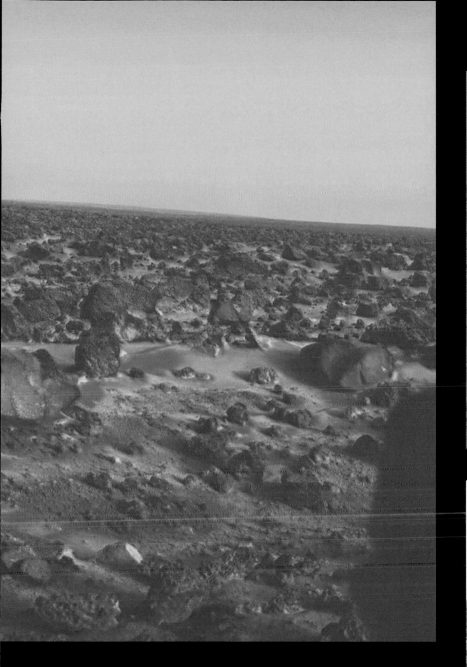

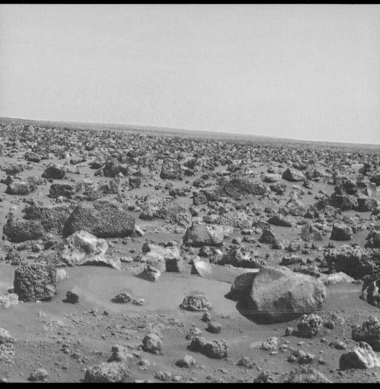

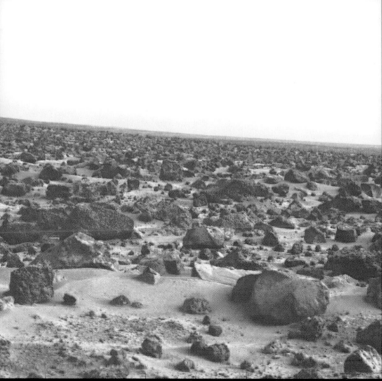

▲ 3:00 P.M. in the winter at the *Viking 2* site. The surface is still covered with white water frost (*Viking*).

Noon on Utopia Planitia (*Viking 2*). Top: Summer and it's "warm," with only −31° F (−35° C). Bottom: We are in the heart of winter: it's −139° F (−95° C), and the surface is uniformly covered with frost (*Viking*). ▶

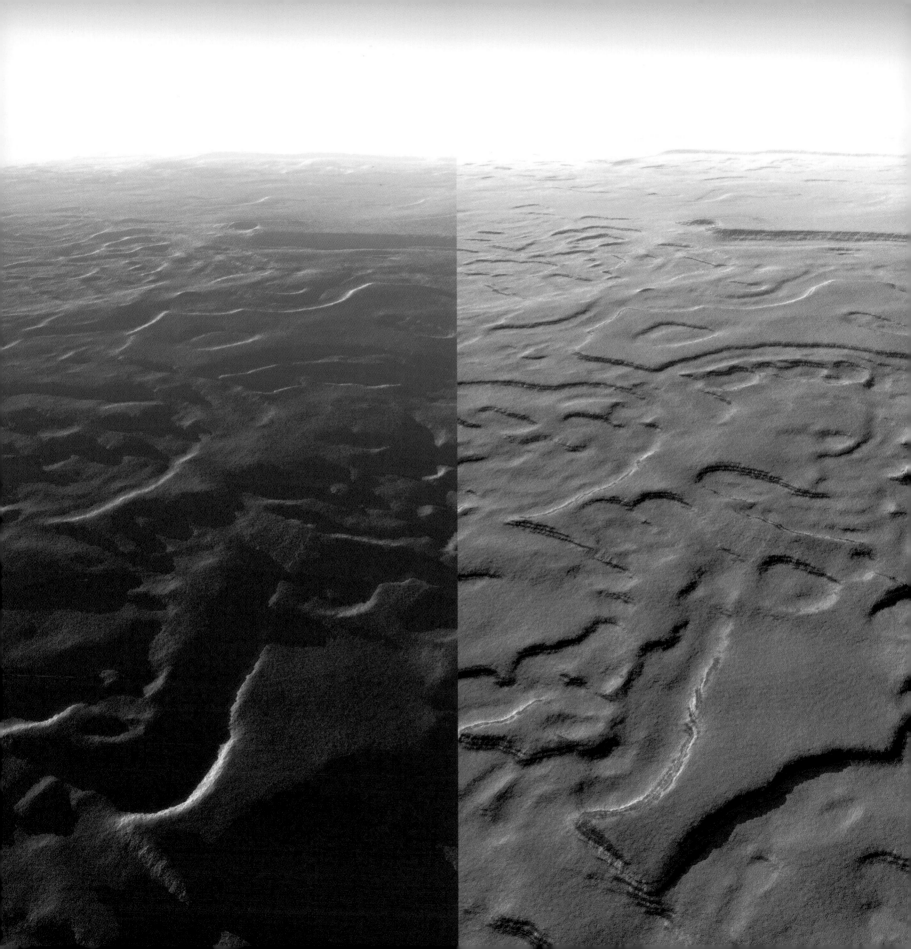

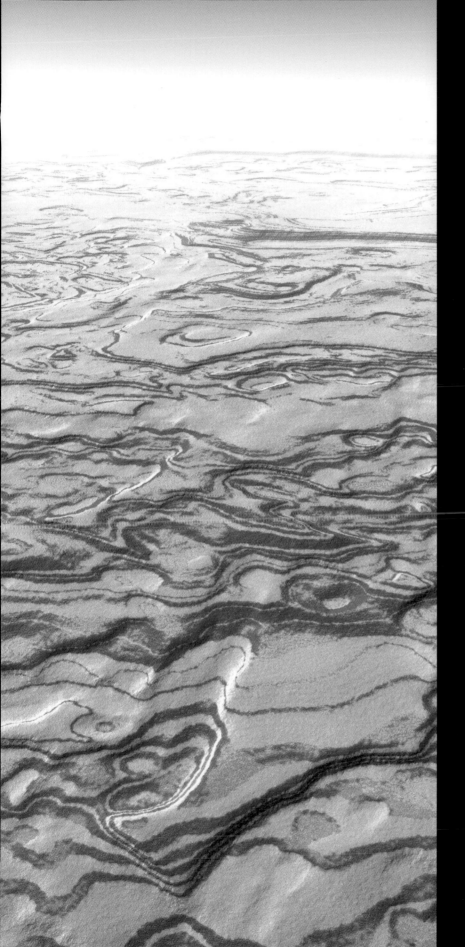

known. In the air the water vapor uses dust particles as a vector and freezes on them. In the northern regions it is cold enough for these grains to be covered with an additional film of dry ice. Weighed down, they are dropped on the surface at night and then reheated by the morning sun. The dry ice sublimates in the atmosphere, leaving the dust and white water frost on the ground. When spring comes, the white frost disappears. After the two hard winters experienced by *Viking 2,* it was clear by the end of spring that deposits of new dust had changed the color of the surface.

Fog has also been observed. As on Earth, it forms after midnight and disperses about forty-five minutes after sunrise. Some mornings it is so thick that the sun has trouble piercing it. White frost at the bottom of craters has even been observed to sublimate under the rays of the rising sun to form a thick fog.

Sublimation of carbon dioxide winter dry-ice slabs at the south pole. Left: It's winter and the surface is completely covered with frozen carbon dioxide. Middle: Spring, the slopes of hollows defrost. Right: At the end of spring, the winter dry ice has disappeared, leaving traces of frozen sediment and ice (USGS/MOLA).

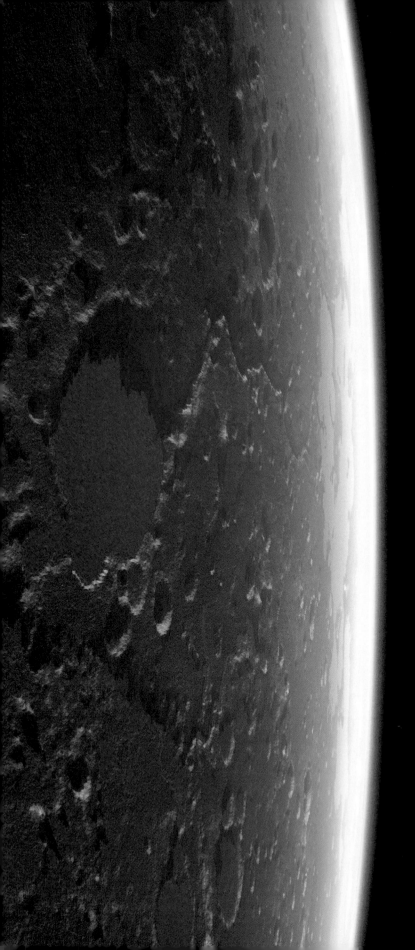

Millions of Lakes and a North Sea

Mars was a watery planet some 4.5 billion years ago. A hot period followed, lasting 700 million years. Asteroid impacts influenced the young climate: the water boiled, spurting up to form huge lakes. For some thousand years, the planet looked like the great Canadian North in the spring: a landscape dotted with a myriad of lakes. Then everything froze again until the next impact.

The great Tharsis Plateau was born 4 billion years ago, releasing enormous quantities of carbon dioxide and vapor into the atmosphere—enough to cover the planet with a sea 400 feet (120 m) deep. There were heavy rains. The water flowed through the landscape, causing severe erosion. A vast ocean was born, 3.8 to 4 billion years ago, at places 3 miles (5 km) deep, covering the northern hemisphere as well as the Argyre and Hellas basins in the south. Scientists now believe that the water that ran over Mars was slightly acidic. This water dissolved the rocks and hindered the formation of carbonates. After evaporation, salt minerals were left behind, such as magnesium sulfates, which are very abundant at the *Opportunity* landing site on Meridiani Planum. Could life have evolved in this environment? The answer is yes. On Earth there are places where a rich biosphere blossomed under such conditions.

◄ Gusev crater: 3.7 billion years ago, the Ma'adim Vallis channel filled it with water. *Spirit* landed here (MOLA).

Above the Becquerel crater (22° N and 8° W) looking to the west toward Chryse Planitia, opposite, from 3.6 to 4.3 billion years ago, when the planet was temperate with a vast northern ocean (right). ►

P. 88: from 2.9 to 3.6 billion years ago, when Mars was cold but crossed with flood channels (in the background) created by a second northern ocean that quickly froze (right). P. 89: Mars today. The ancient oceans have been replaced by vast plains of frozen terrain and sediment (MOLA).

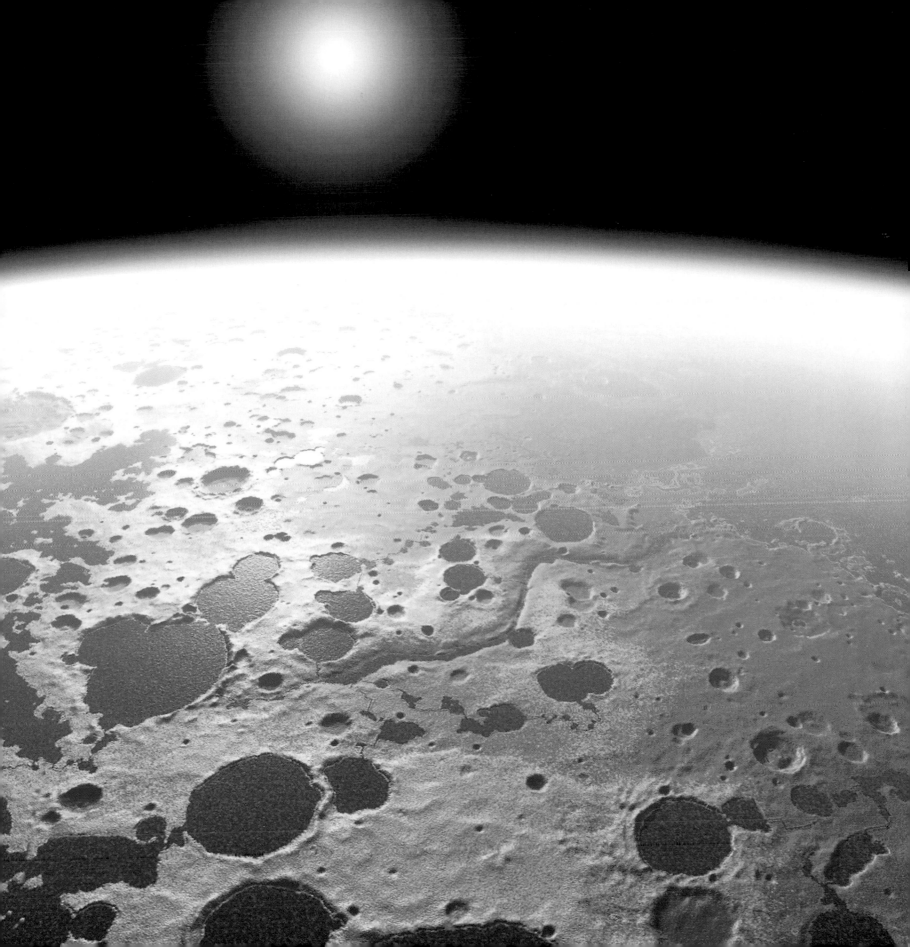

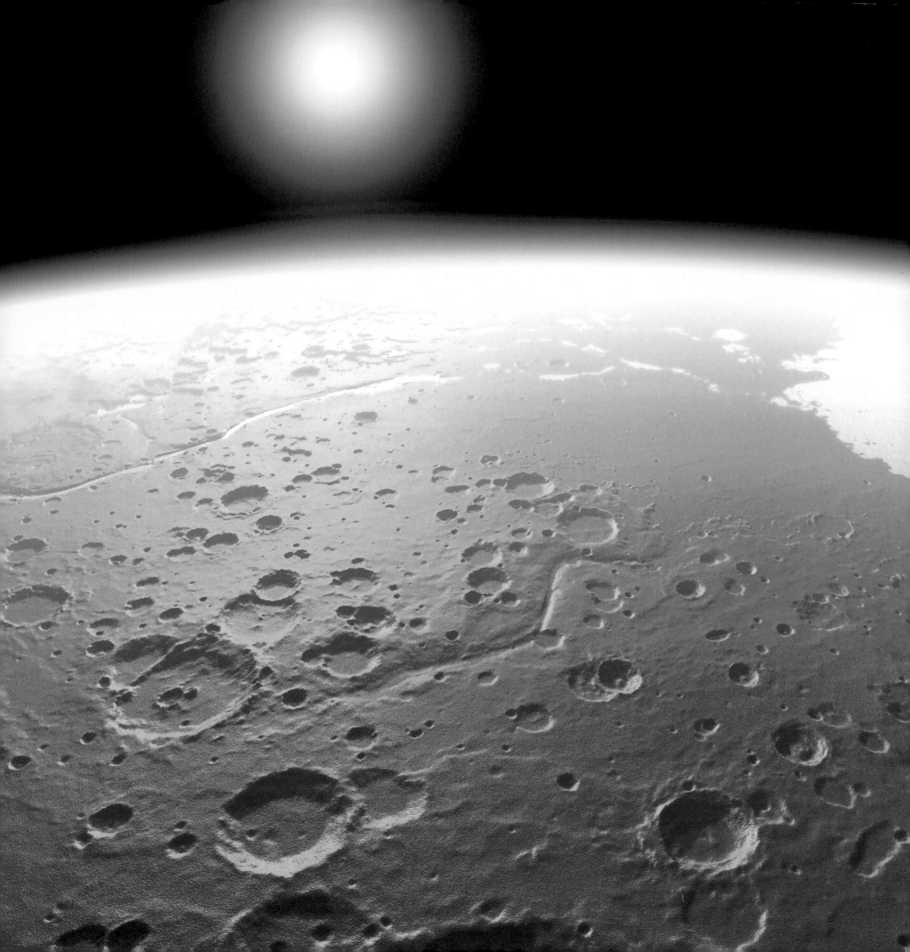

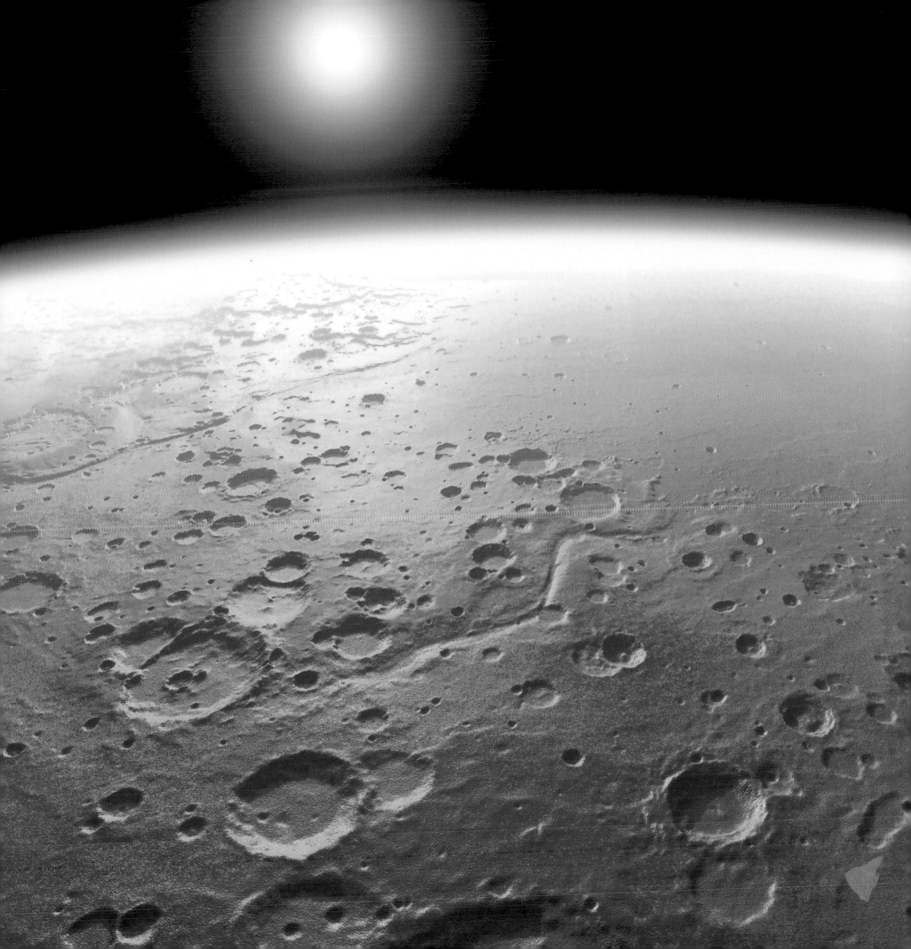

After this period, the planet cooled quickly. Broken down by solar rays, water vapor released its hydrogen into space. Surface water retreated into the ground and froze, and Mars became the cold world we know today. But volcanic activity continued to heat the crust, causing huge floods, and thus were born the great Martian channels.

The flooding events, which happened 2.9 to 3.6 billion years ago, were episodic. A huge northern sea was created again, though not as great as the first ocean. Salt water like our seawater formed a warm sea. Huge convective movements brought hot water to the surface and forced cold water to the bottom, distributing suspended sediment. But

the Martian air was very cold, and under its low pressure the sea was steaming as it evaporated. The humidity in the atmosphere fell down as snow, and ten years later a large ice floe had formed and quickly thickened. The ocean had not been liquid long enough for carbon dioxide in the atmosphere to dissolve in the water and form calcium carbonate deposits; in addition, the water was slightly acidic, containing iron and dissolved sulfur.

Another peculiar thing that happened on Mars was that its seas froze from the bottom up. The water covered ancient frozen ground, which accelerated the encroachment of the ice floe. Over a period of 33,000 years, the

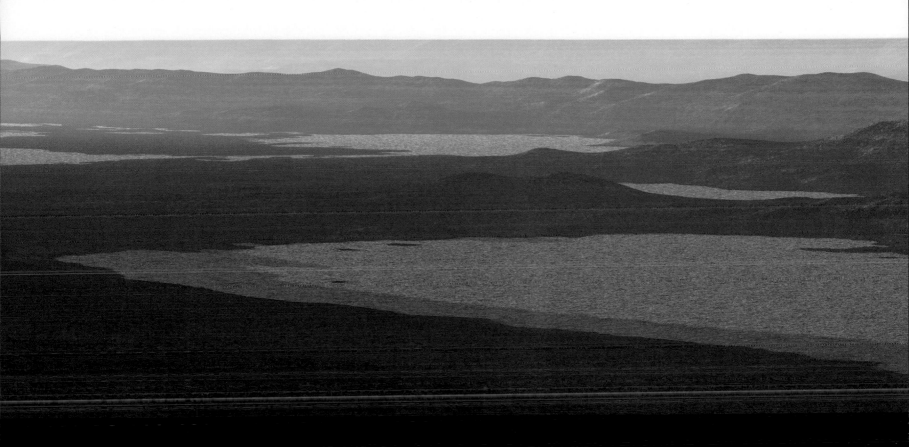

ocean froze to a depth of 1.24 miles (2 km). Under the combined action of sun and dry air, the ice then began to evaporate. This process of sublimation continued for more than a million years, as flood after flood continued to cover the ice with new sediment. This is how the frozen landscapes covering the northern plains were formed. It is estimated that the floods dispersed water to a depth of about 490 feet (150 m) over the Martian planet surface. The equivalent of a depth of 165 feet (50 m) evaporated and was released into space, and 100 feet (30 m) are still stored at the poles. But where are the remaining 230 feet (70 m) of water? Could it really have disappeared?

No. Information gathered by orbital probes tells us that some terrains in the north and south are so waterlogged that it would be more apt to call them dirty ice than frozen ground. In the far north (80° N), the surface thin top layer is dry. Just below, in the next 20 inches (50 cm), however, water ice can represent up to 80 percent of the landmass. An astronaut who filled a bucket with polar soil and heated it would find it more than half filled with water. The Martian sea is buried right under his feet.

In the Coprates Chasma (Valles Marineris) formed 3 billion years ago, on a promontory beside the plateau (10° S and 68° W). The canyon floor is filled with large frozen lakes (MOLA).

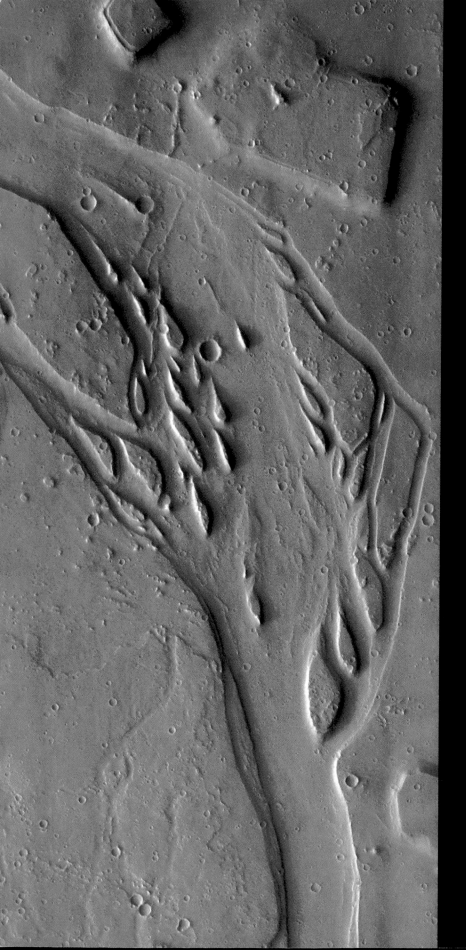

◄ Southwest of the Elysium Mons volcano, at 19° N and 233° W. Outflow channel made by water released from troughs (Themis).

Global view of all the outflow channels, 1,802 miles (2,900 km) across, including those from Valles Marineris (bottom) and Kasei Valles (top), which converge into the Chryse basin (top; USGS). ▶

Rivers: Proof of a Once-Favorable Climate

As seen from orbit, the Martian landscape is sculpted with meandering tracks that run for thousands of miles (several thousand kilometers). They are the remnants of dried-up rivers (or channels), which were formed in a long-ago past when enormous volumes of underground water were released in catastrophic outflows. After the planet's surface features collapsed, the torrential flow of mud tumbled down slopes, tearing down everything in its way.

The huge lakes formed in this manner were covered with ice after underground volcanic activity heated up the frozen ground in Valles Marineris. When the natural barriers gave way, masses of water flooded the Chryse basin below. Fresh channels dating back only some tens of millions of years are found southeast of the Elysium Planitia volcanoes. Here 144 cubic miles (600 km³) of water gullied the landscape in only a few weeks. All these channels have craters shaped like teardrops with eroded rims. Water percolating to the surface from underground water tables has also dug out smaller river valleys, some taking hundreds of thousands of years to form.

On Mars we also find traces of slow environmental change, similar to the passages glaciers have made on Earth. These are found at high altitude on the slopes of big

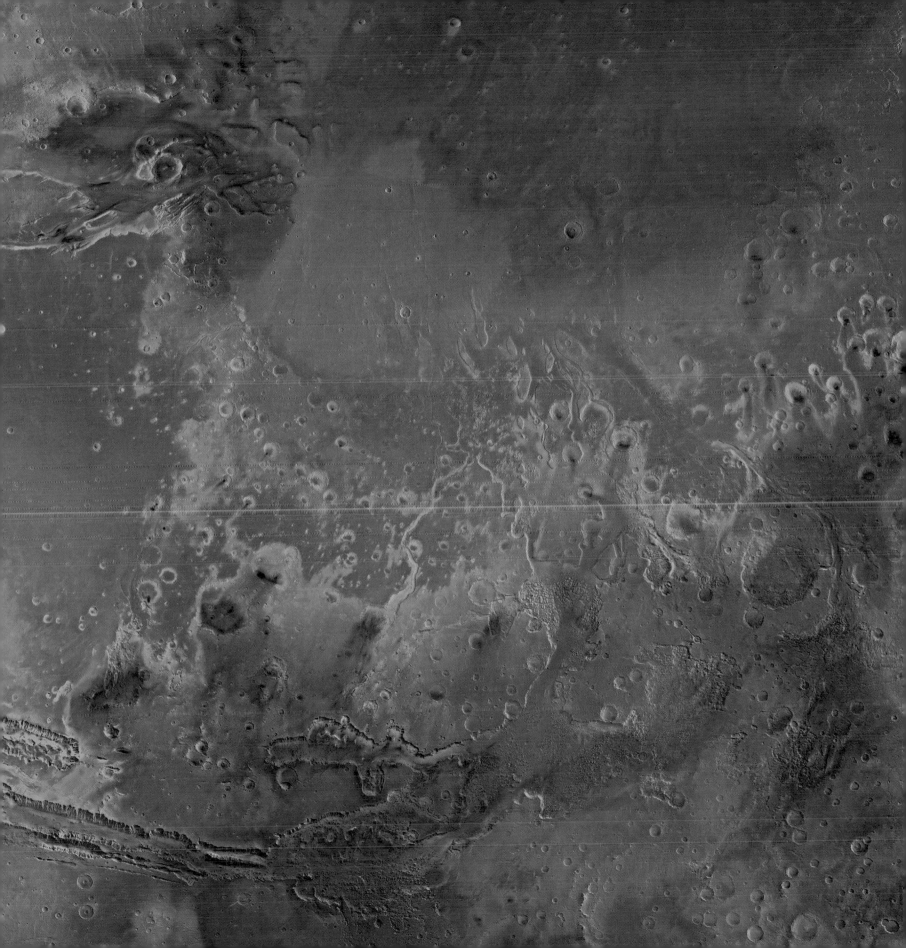

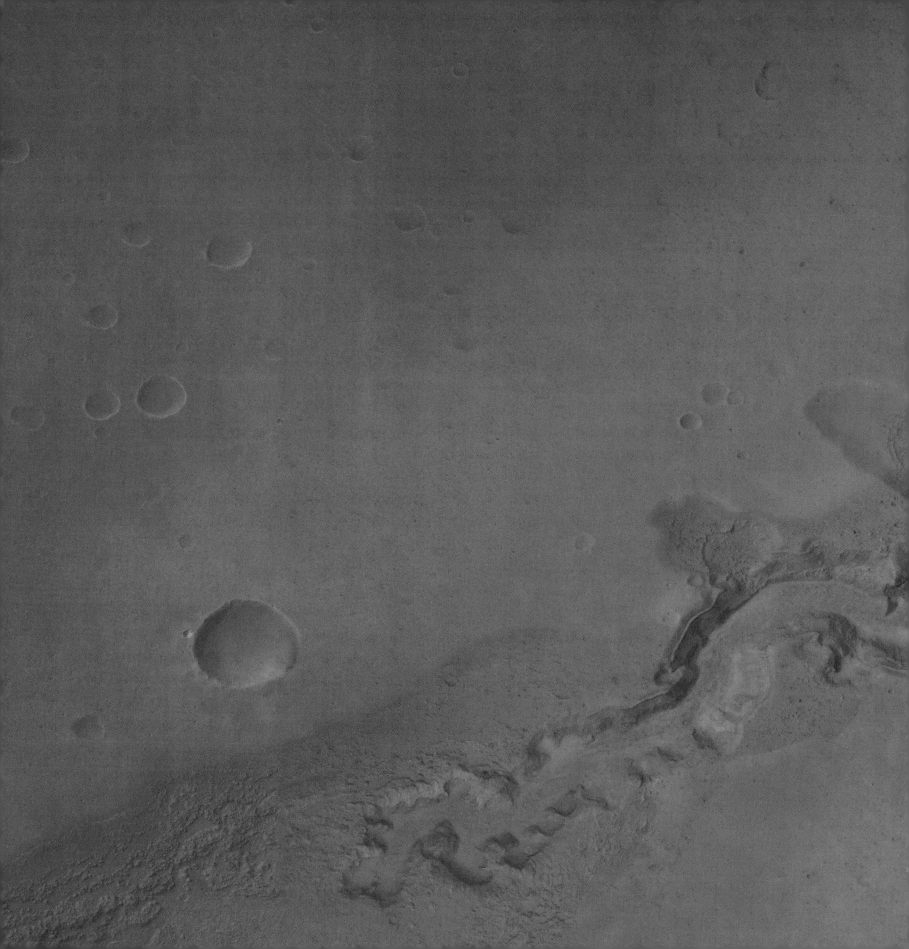

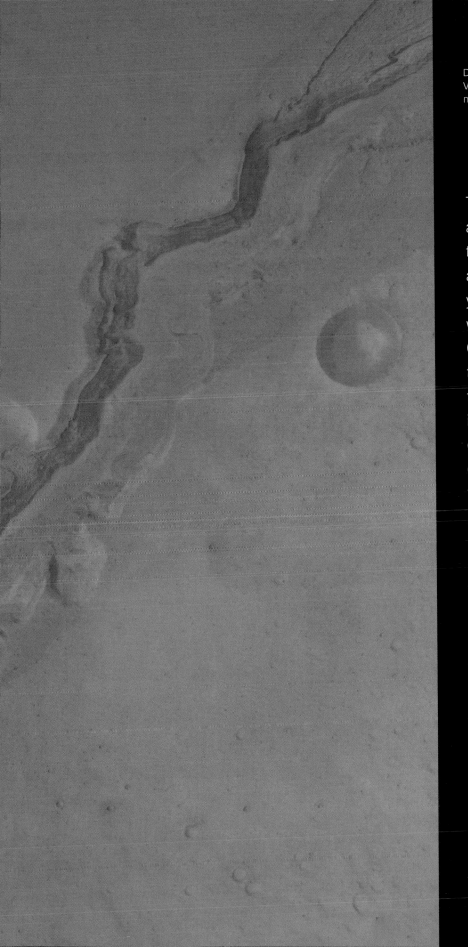

Diagonal section 11.2 miles (18 km) long showing the central residual channel in Kasei Valles, at 21° N and 73° W. The water flowed from the southwest (bottom left) to the northeast (top right) (MOC).

Tharsis volcanoes such as Olympus Mons. The ice (actually a mixture of ice and dust) is protected from sublimation by a layer of dust. The buried ice may be sublimating at a slow pace and thus remaining stable over millions of years. Glaciers are seen also in Reull Vallis and Dao Vallis, where these channels open into the great Hellas basin. Crevasselike wrinkles run parallel and perpendicular to the channel slopes. These surface ripples are evidence of the slow stretching of a sedimentary layer—as by the incremental passage of a huge mass of ice—which descends and mixes at the bottom of the channel with other floes coming from upstream as in the highest mountains on Earth (such as the Himalayas, Andes, Rocky Mountains, or the Alps). Mars must have known very mild temperatures not long ago, as the planet's glaciers could not have formed without snow: snow can only fall in a temperate and humid climate, where water evaporates from the lakes and seas and then falls elsewhere. These snowfalls could have happened at times of high obliquity *(see pages 75 and 153)*. It is estimated that glaciers could have formed on Mars in only 3,000 years.

In Antarctica's Beacon Valley, an 8-million-year-old glacier is protected under 20 inches (50 cm) of sediment. It sublimates at a rate of 0.0001 mm per year. The climatic conditions found on Mars, including the low atmospheric pressure, are indeed close to those recorded at Russia's Vostok base in Antarctica, where the average temperature is 70.6° F (or –57° C).

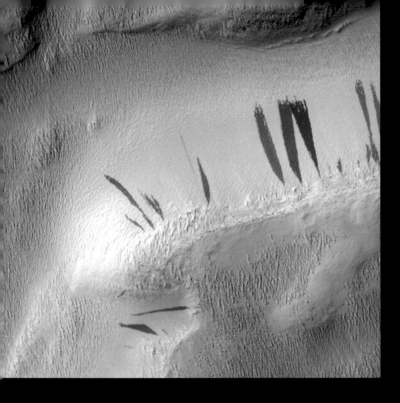

Is There Still Liquid Water on Mars?

Liquid water could exist on the surface of Mars, but only in certain places. For example, at the bottom of the Hellas basin—26,240 feet (8,000 m) below the average altitude—atmospheric pressure varies according to seasons, changing from 12 millibars in summer to 17 millibars in winter. Water could be liquid here from 32° F to 50° F (0° C to 10° C), in summer about 2:00 P.M.

Moreover, in places where the pressure is greater than 7 millibars and the atmosphere is very humid, water could be liquid for a short period of time. At night water frost forms on the surface between individual grains of sand. The frost melts in the heat of the morning sun, and the water becomes liquid. Because the layer of air just above is still cold, the water is prevented from turning to vapor and disappearing into the atmosphere. Instead, the liquid water runs between the grains of sand and dissolves the salts there to form brine. In the meantime, the sun continues to heat the surface. The layer of cold air rises, and the water vapor finally escapes. The accumulation of salts cements the grains of sand together to form a brittle crust: a "duricrust" with a high sulfate content. Could there be life here?

On-site analysis has shown that the Martian soil has a salt content between 10 and 20 percent. Saltwater does not freeze at water's usual temperature (32° F or 0° C). The red planet may well still experience flowing saltwater evidenced as the famous "Martian gullies."

Nine-tenths of the observed floes are in the southern hemisphere, on a band located between −30° S and −60° S latitude, where water ice is found in abundance. At the equator, on the other hand, the ice has disappeared as the surrounding environment has dried out. During the last great climatic variation, when the planet's obliquity was more than 31 degrees, these places experienced mild temperatures. Here the ground filled with ice or snow that melted in summer. The water ran to form ravines (also called "alcoves") with a talus apron below. These runoffs are young: they have not been covered over with lighter-colored sediment. The volume of water ejected by each of those runoffs was sometimes 32,700 cubic yards (250,000 m³). That means that there is enough underground water to support colonists in the future—or even bacteria today. A correlation was found to exist between the ice table (with its probable groundwater), the presence and distribution of water vapor, and the production o

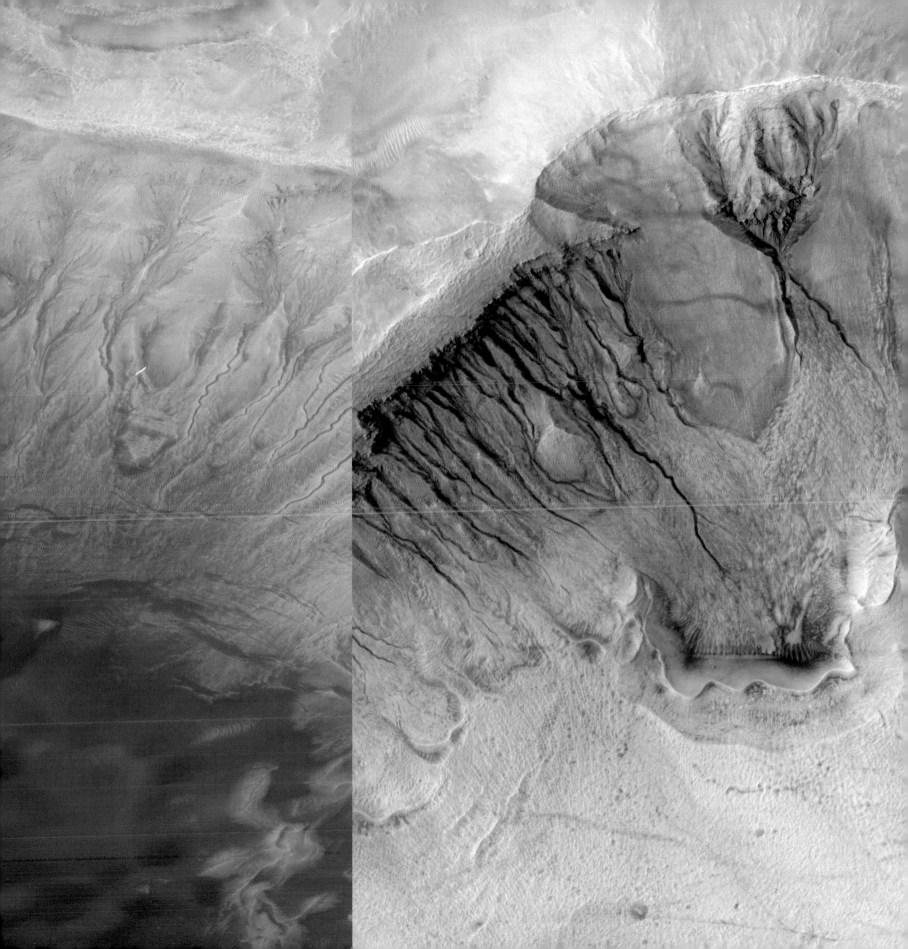

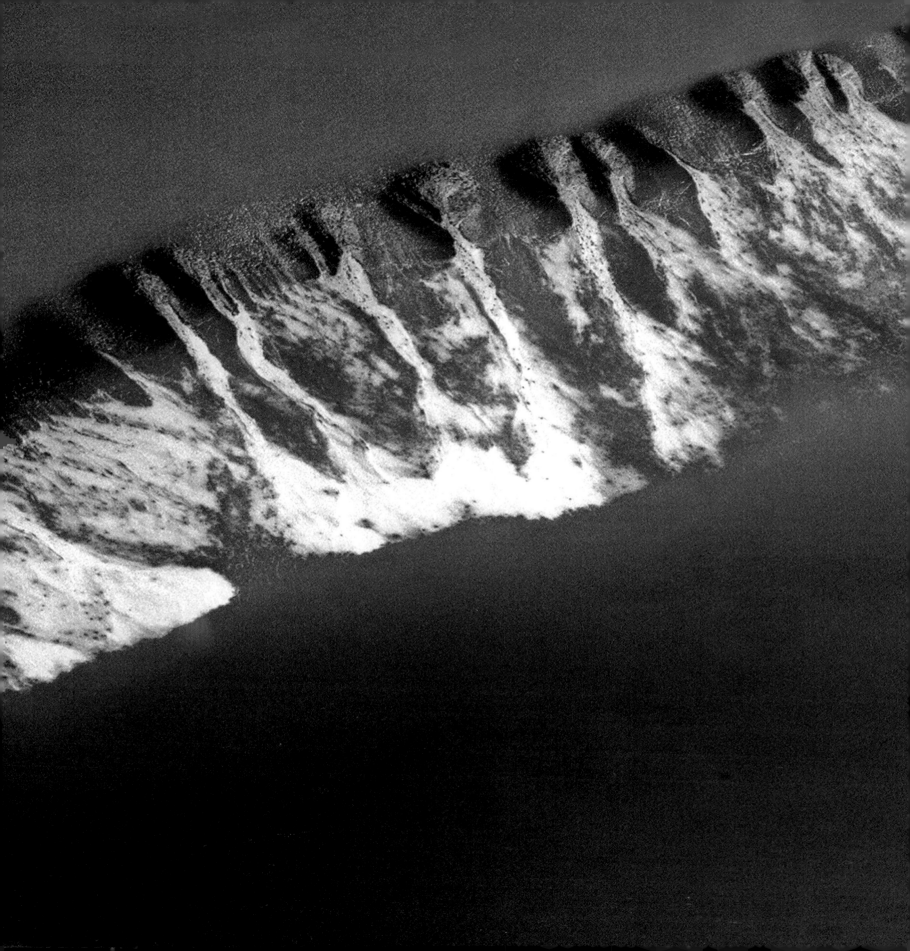

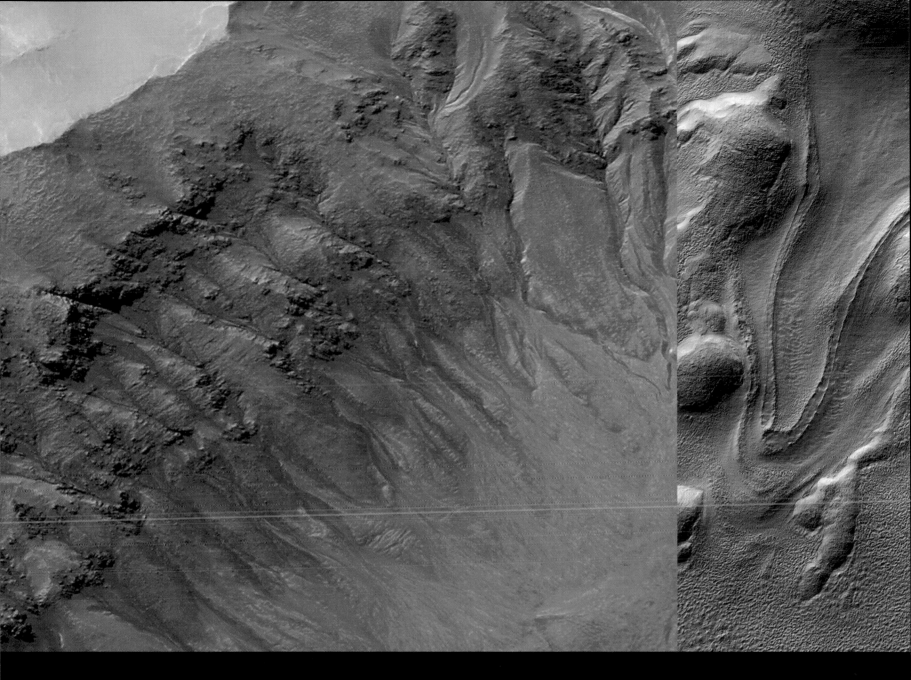

▲ Detail of the side of a crater at 37° S and 168° W, 1.2 miles (2 km) across, showing gullies considered "fresh" because their color is darker than the surrounding terrain and not yet covered over with lighter dust (MOC). To the right, side of a crater (39° S and 247° W) with a glacier covered with dust, 5,249 yards (4,800 m) in length, shaped like a tongue (MOC).

◄ Sisyphi Cavi (71° S and 356° W). Side of the valley 3,062 yards (2,800 m) long. The frost that remains on the ancient gullies is evidence of terrain saturated with ice because it is colder than the surroundings (MOC).

methane in the atmosphere. There might now be some geothermal processes at work that bring water vapor to some methanogenic bacteria, which can survive and in return feed the Martian atmosphere with between 170 and 3000 tons per year of methane. It implies that Mars may be globally sterile, except for some small oases of Martian bacterial life. By mapping methane, the scientists found that at the high latitudes only discrete sources of methane exist. But in Syrtis Major Planitia and toward Hellas basin (24° S to 30° S) a maximum of concentration is seen: perhaps bigger oases of bacteria are surviving there.

AIR

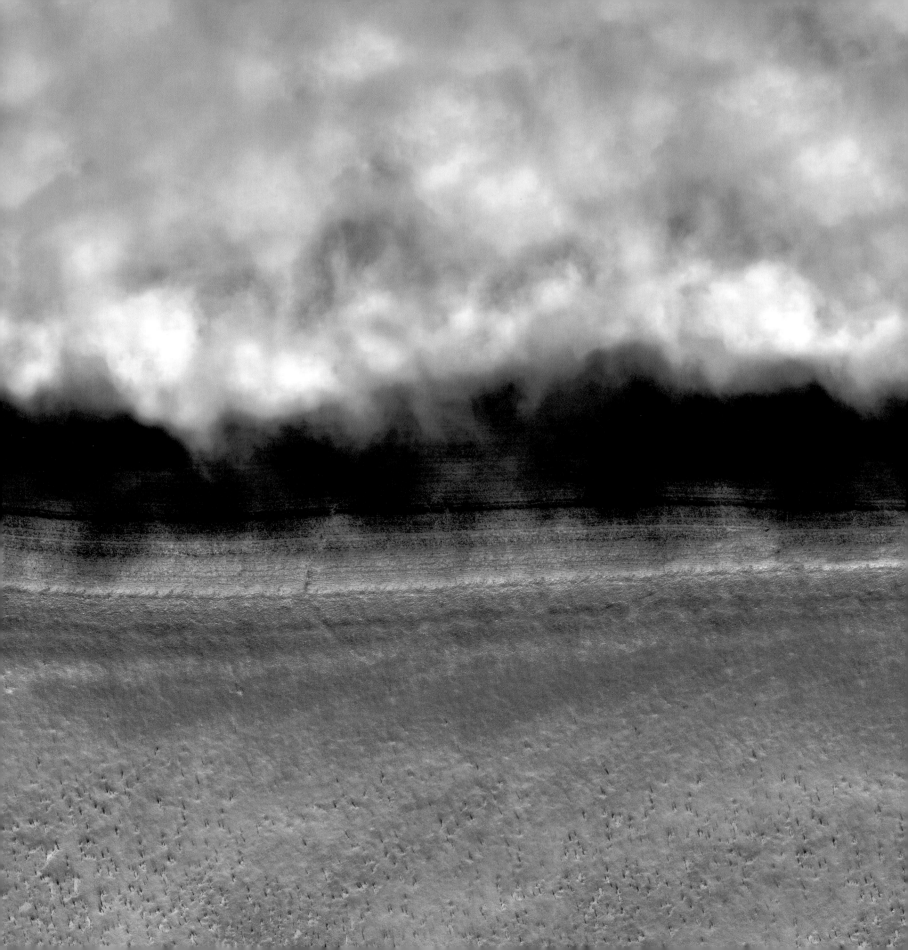

THE ATMOSPHERE ON MARS IS MORE THAN 95 PERCENT CARBON DIOXIDE (CO_2), A GAS THAT MAN CANNOT BREATHE. MARS HAS AN IONOSPHERE, AS DOES THE EARTH, LOCATED ON THE PLANET AT AN ALTITUDE OVER 68 MILES (110 KM). AT ALTITUDES BELOW 56 MILES (90 KM) ABOVE THE PLANET, THE PRESSURE INCREASES REGULARLY WITH PROXIMITY TO THE SURFACE. ON EARTH WE ARE PROTECTED AGAINST HARMFUL ULTRAVIOLET RAYS BY THE OZONE LAYER, WHICH FORMS PART OF THE STRATOSPHERE AT ALTITUDES RANGING FROM 6 TO 25 MILES (10 TO 40 KM). MARS DOES NOT HAVE THE SAME COMFORT. THERE OZONE EXISTS ONLY IN MINUTE QUANTITIES. IT IS UNIFORMLY DISPERSED IN THE LOWER ATMOSPHERE, FROM THE SURFACE TO AN ALTITUDE OF ABOUT 5 MILES (8 KM). AN UNPROTECTED ASTRONAUT WOULD GET A GREAT TAN IN RECORD TIME ON MARS.

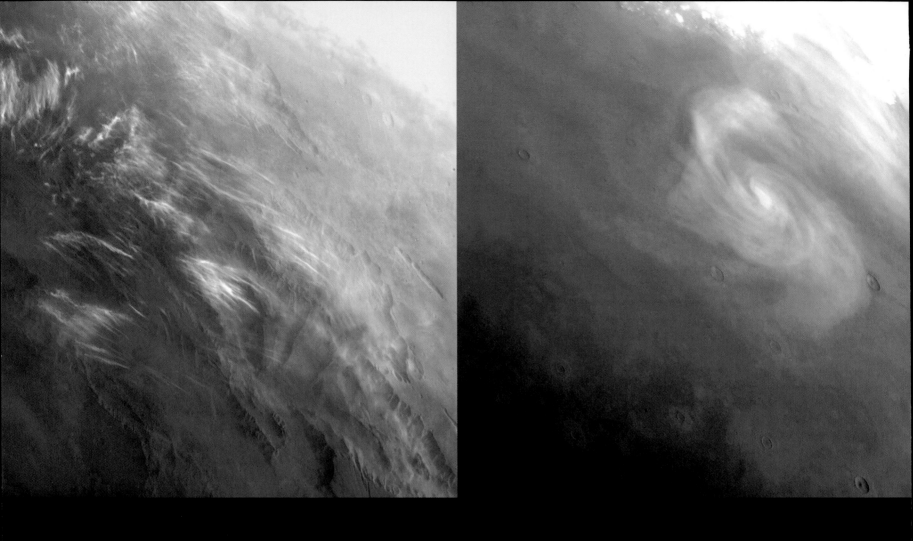

▲ Left: At sunrise, a group of cirrus clouds drifts above the center of the Valles Marineris giant canyon (*Viking*). Right: Low-pressure cell at 65° N in the middle of the summer. It is located at the intersection of a polar cold front and warm air coming from temperate latitudes (*Viking*).

Pp. 100–101. From left to right, the evolution of a dust storm in 2001. Beginning of June: The atmosphere is still clear. End of July: The storm, which began at the south pole on July 8, is already raging: the dust has mounted so high that it has almost covered the large Tharsis volcanoes (black spots). End of September: The storm continues. It will dissipate in mid-November. Notice the decrease in the size of the south polar cap as summer approaches (MOC).

P. 102. At 83° S and 258° W, section 4.3 miles (7 km) across along the Chasma Australe valley. The stratocumulus clouds just lap against the rim of the depression, making it look like a sea of clouds (top) visible from the high plateau (bottom) (MOC).

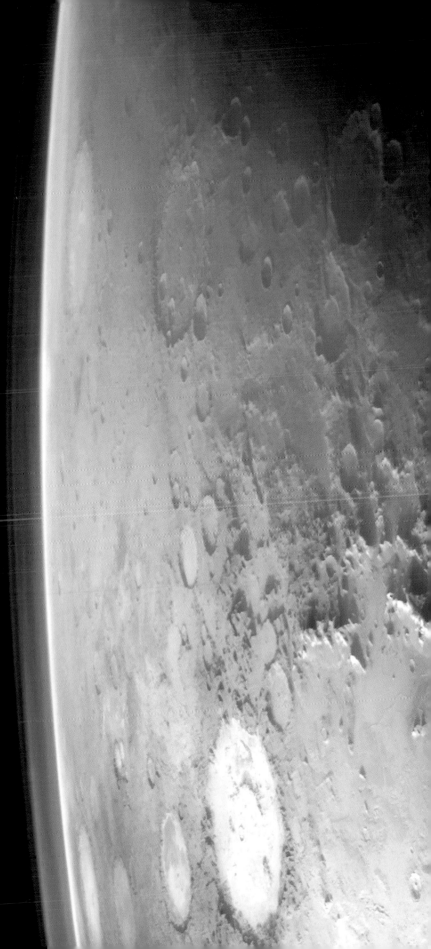

Many Types of Clouds

We have known for more than a century that there are clouds in the Martian atmosphere. With their powerful telescopes, astronomers have been able to see them at the edge of the planet. The probes have captured excellent images that have allowed us to characterize these cloud formations. Although cirrocumulus clouds have been observed, most Martian clouds are fine ice-crystal cirrus that form at about 22 miles (35 km) above the surface. Some are formed from crystallized carbon dioxide (dry-ice crystals). Dispersed around the poles during the winter, these clouds move toward the equatorial latitudes in the spring.

Large spiral clouds have been observed from space; they only develop around the planet's north pole during periods of calm weather. Stratocumulus clouds sometimes glide above equatorial latitudes when warm air rises vertically from the surface and the water vapor condenses in the air. From the planet's surface, ice-crystal cirrus clouds can also be observed just before sunrise or in the morning, drifting at an altitude of about 10 to 12.5 miles (16 to 20 km).

Atmospheric shot flying over Argyre Planitia and looking toward the eastern horizon (*Viking*).

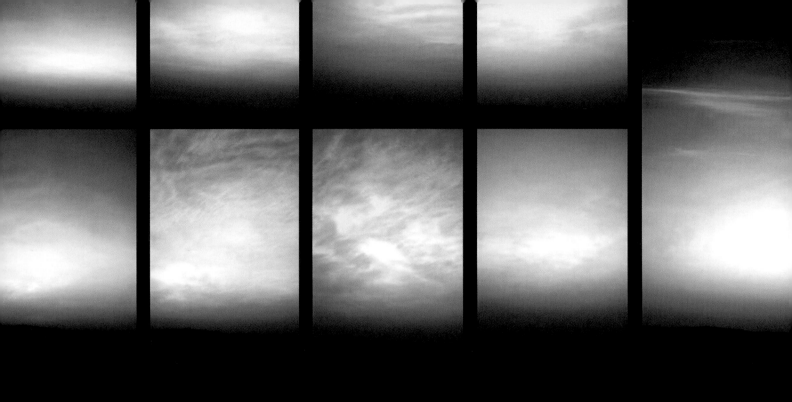

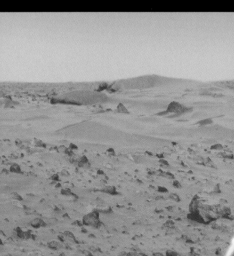

▲ Early in the morning, before sunrise, in the Martian sky o
Pathfinder lander: the cirrus clouds drift at 15.5 mph (25 km/h)
at an altitude of about 10 miles (16 km). Right: Light refraction
from the water ice colors them blue (MPF).

◄ Mars at 6-year intervals at the *Viking 1* site. Left: August 15
1976. Right: September 6, 1982. After a violent dust storm
June 14, 1981, the wind has revealed a sublayer of darker sedi
ment on the drifts (background left, *Viking*).

Localized dust clouds being lifted from the surface at the south
pole (87° S and 175° W). The view shows a section 1.86 mile
(3 km) across (MOC). ▶

Section about 230 miles (370 km) across, at 38° S and 332° W
in Noachis Terra, showing clouds of dust pushed by the wind

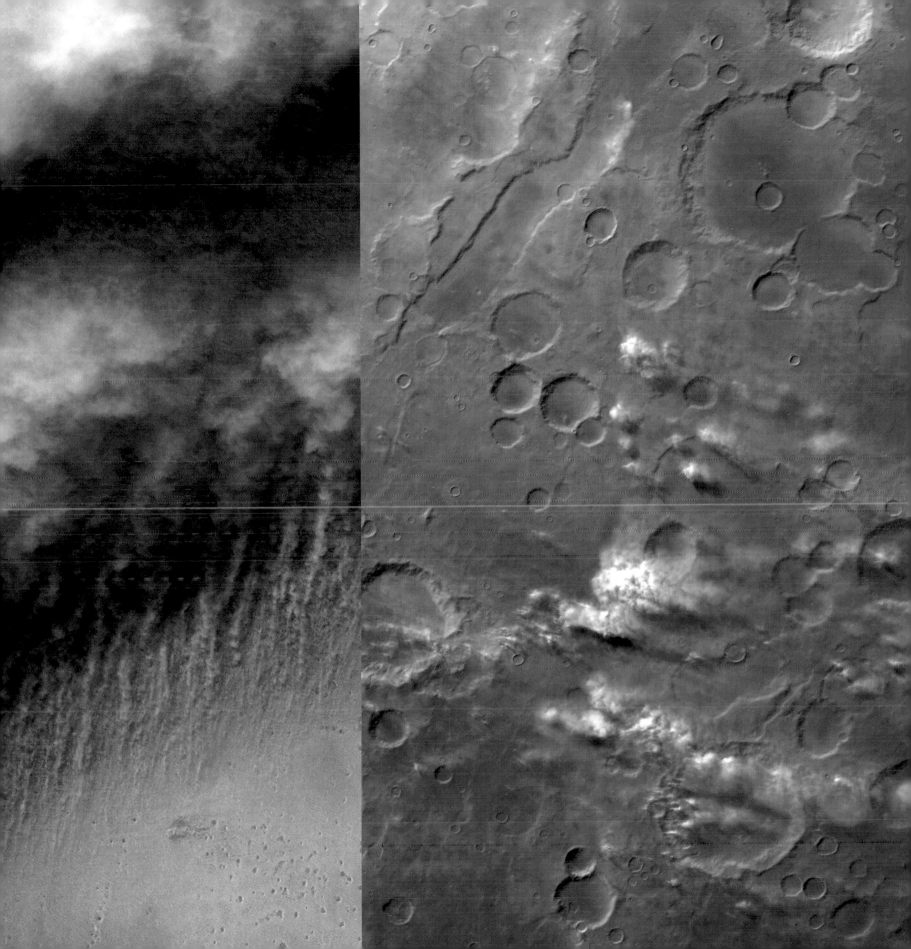

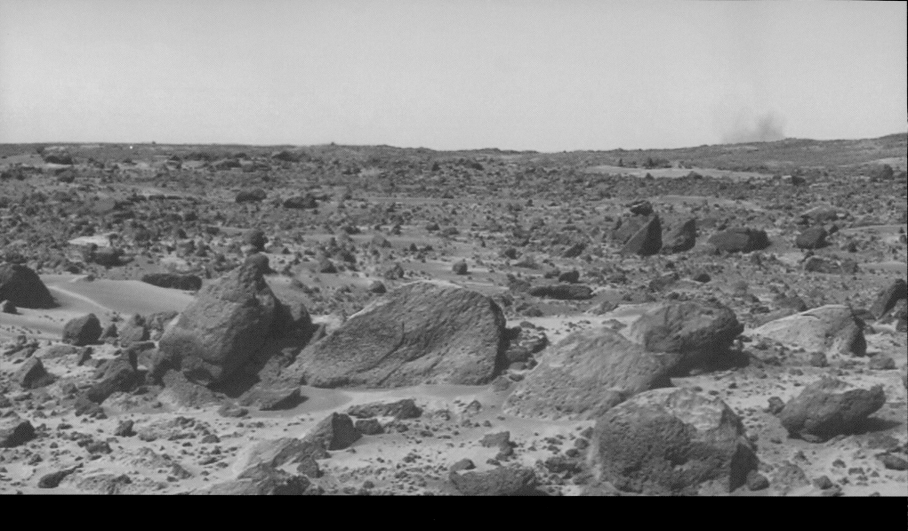

▲ Base of a dust devil near the horizon 984 feet (300 m) high that disappears into the surrounding light (MPF).

Evolution of the transparency and color of the atmosphere during 1.5 Martian years (3 terrestrial years) at 2:30 P.M. at the *Viking 1* site. Notice day (or "sol") 1742; the inversion of the sky brightness is due to a dust storm (*Viking*). ▼

sol 1150 sol 1187 sol 1261 sol 1291 sol 1298 sol 1335 sol 1372 sol 1409 sol 1520 sol 1557 sol 1594 sol 1705 sol 1742 sol 1853 sol 1890 sol 1950 sol 1957 sol 1964 sol 2001 sol 2075 sol 2149

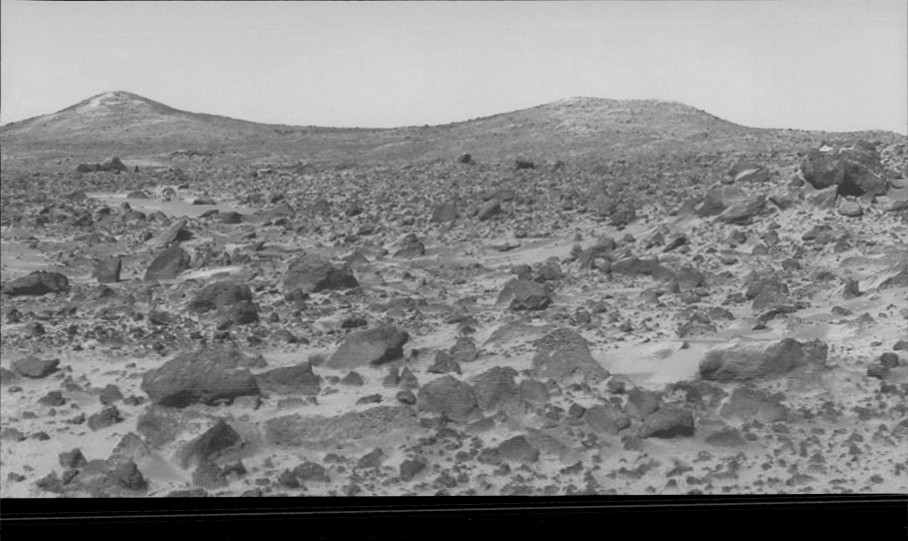

Giant Dust Storms

The Martian atmosphere is extremely dusty. The lower layers—to an altitude of about 5 miles (8 km)—contain a suspension of tiny particles, 6 percent of which is made of maghemite. These rusty granules turn the Martian sky color into a lovely, luminous salmon pink up to 30 degrees above the horizon. When the sky is not very dusty, it loses this pink tone and becomes pale yellowish-gray. Distant features (25 miles or 40 km away) on the surface are blurred by the dust. In clear weather, topographical features can be seen from up to 50 miles (80 km) away, though they appear shadowy. At the oppo-

site extreme, a dust storm might obliterate the sun completely, making the landscape as dark as a rainy day on Earth.

The probes have detected dust devils on the Martian surface. On average these have measured from 160 to 330 feet (50 to 100 m) in diameter and from 1,600 feet to 1.5 miles (500 m to 2.5 km) in height. The dust-devil tracks are visible from orbit as fine straight streaks that run along the ground for dozens of miles. The dust devils lift and stir up light materials from the surface, while the infamous Martian dust storms have more dramatic effects.

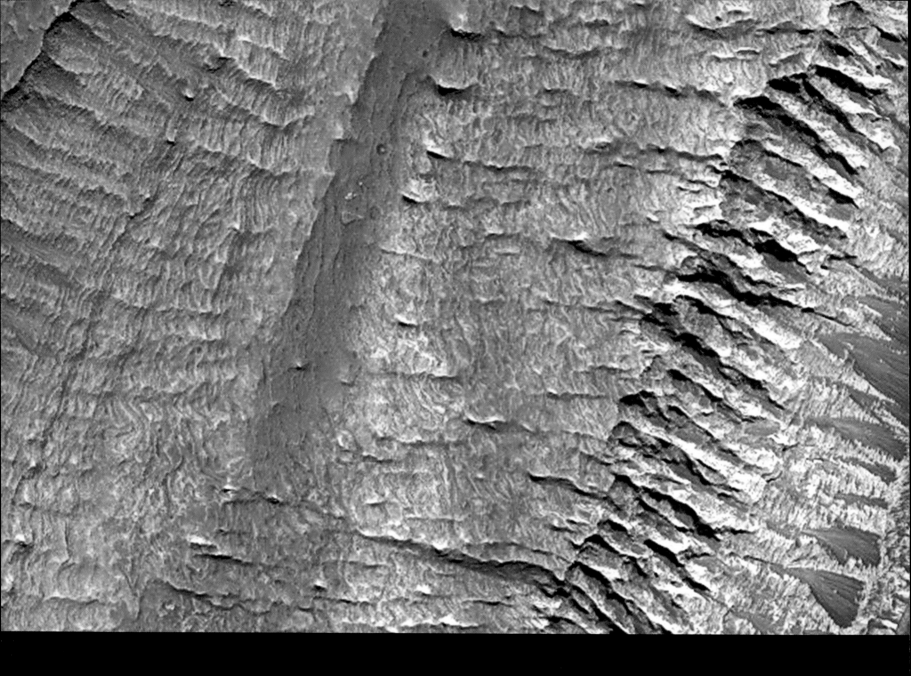

Dust storms often begin in the southern hemisphere. In spring, the sudden heating of the south polar cap causes the rapid sublimation of dry ice into the atmosphere. This creates significant local variations in pressure and temperature between the polar cap and the area surrounding it, where there is no ice and the atmosphere is humid. The air is then subjected to brutal changes. The winds make sudden changes of direction, thus sweeping up the fine dust deposited on the surface. Powerful storms then arise: they can engulf the entire planet as dust is lifted up to 25 miles (40 km) into the atmosphere. Some strong storms have generated wind speeds of 93 mph (150 km/h) and reached all the way to the high northern latitudes in only a few days.

During the lengthy *Viking 1* mission (1976 to 1982), five dust storms were observed at the landing site. Winds were

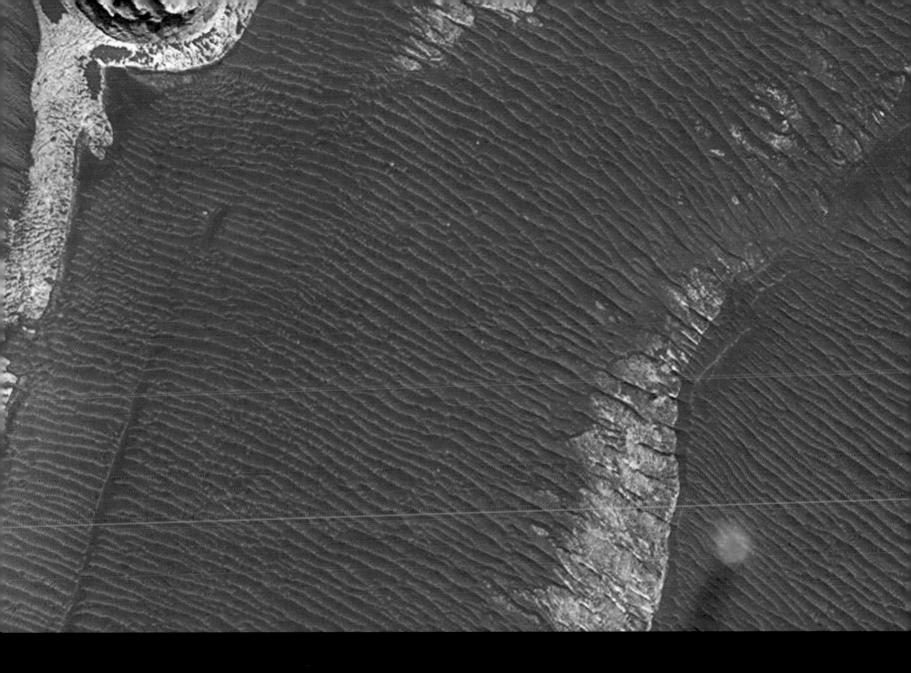

usually strong, about 59 mph (95 km/h), with gusts of up to 68 mph (110 km/h). The first three storms created no observable change in the landscape. However, the fourth was strong enough to darken the surface around the probe. Violent gusts between 90 and 190 mph (140 and 300 km/h) removed a fine layer of dust in places (some tens of millimeters), revealing a darker sublayer. Small pebbles were even moved and piles of dust eroded.

At 10° S and 75° W, small dust devil (bottom right) leisurely travels along the bottom of Valles Marineris. The image shows a section of terrain (top) 2,843 yards (2,600 m) across. The dust devil is 131 yards (120 m) wide (MOC).

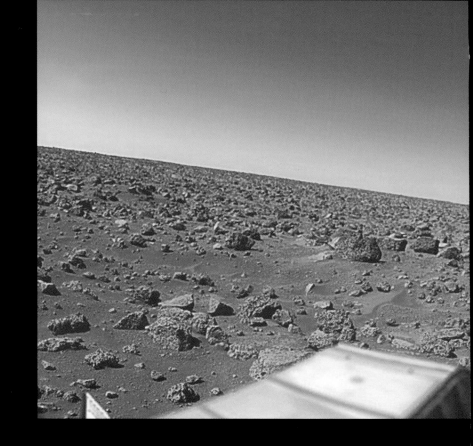

Weather More Uniform Than Earth's

The *Viking* and *Pathfinder* missions have provided us with precise measurements of conditions such as temperature, pressure, and wind speed in Mars's lower atmosphere. From *Viking 1,* we have data gathered over a period of three consecutive Martian years (with a Martian year corresponding to 687 Earth days).

Temperatures on Mars vary depending on how much heat the surface accumulates and on the quantity of dust in the atmosphere. Temperatures change gradually all over the planet as each season advances. In the summer, when Mars is closest to the sun, temperatures south of the equator are very mild—an average of 50° F (10° C) at

2:00 P.M. In winter on the other hand, when the planet is farthest from the sun, nighttime temperatures at the south pole can plunge below -202° F (-130° C). Violent dust storms also have an effect on temperatures. When the sun is completely hidden, normal daily high and low temperatures vary only by 50° F (10° C) instead of the average 140° F (60° C).

Variations in atmospheric pressure depend on the wintertime condensation of atmospheric carbon dioxide into frost at the poles, especially on the south polar cap. Up to 25 percent of the Martian atmosphere condenses there, and since the Martian air is 95 percent carbon

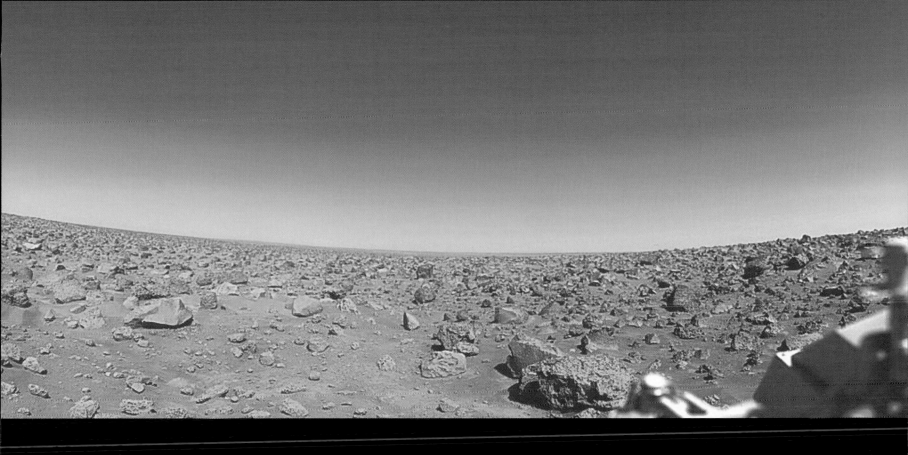

dioxide, the pressure varies by more than 35 percent over the entire planet. Pressure also varies according to altitude. For example, near the summit of Olympus Mons, at an altitude of 69,882 feet (21,300 m), it is just under a millibar. But at a depth of -26,240 feet (-8,000 m) at the great Hellas basin, it is 12 millibars in summer and can reach 17 millibars in winter.

In short, even though dust storms subject the Martian climate to extreme variations, temperatures change slowly, day to day and according to the rhythm of the seasons. Mars is a planet for which weather forecasts could be made several months in advance without much risk.

▲ Martian sky in the heart of summer. It is 3:00 P.M. at the *Viking 2* site. The color of the sky quickly turns dark purple at the zenith (*Viking*).

Following double page. Noon on Utopia Planitia (*Viking 2*). The sun is 60° above the horizon. The shadows are very sharp: a minimum of dust is suspended in the atmosphere. The "can" on the surface in the foreground is the protective shroud of the soil sampler that was ejected shortly after landing (*Viking*).

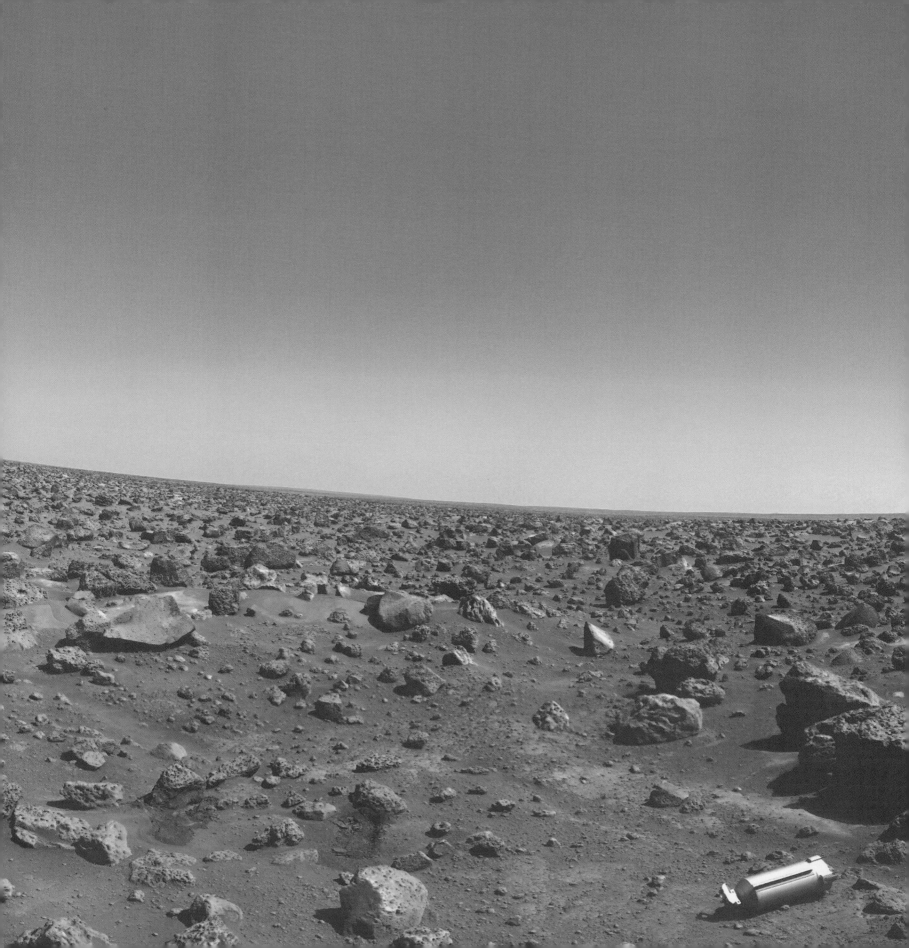

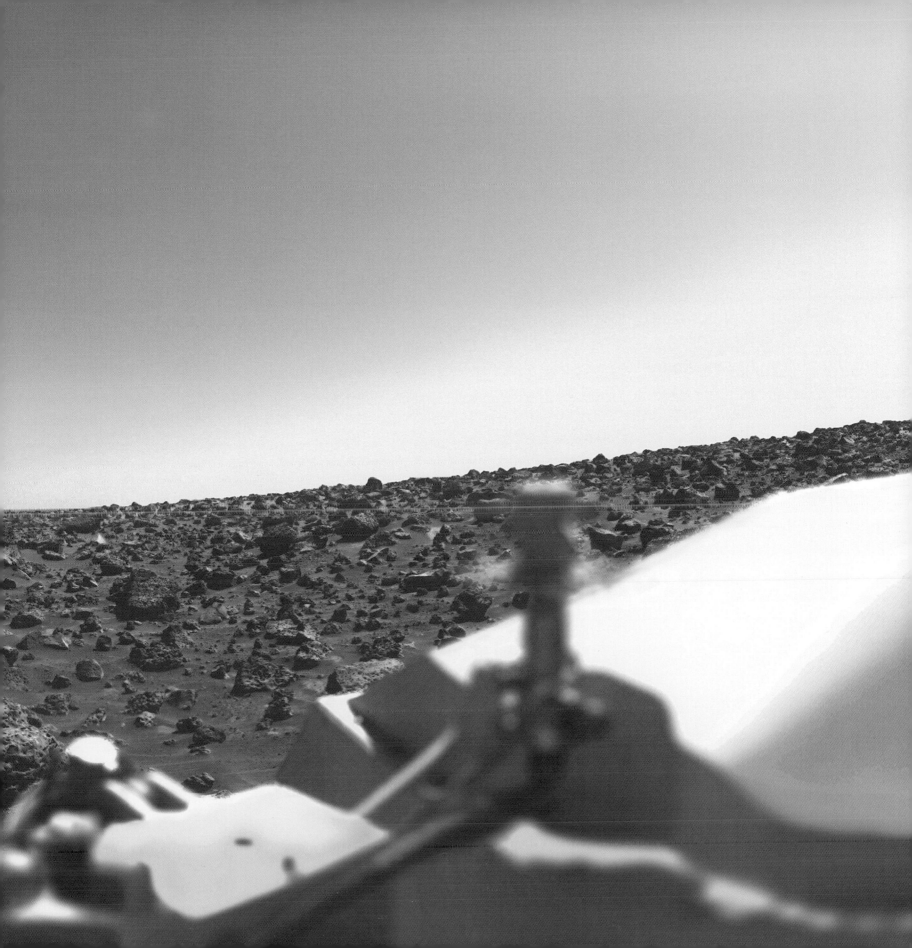

The Dramatic Colors of Morning and Evening

On Mars, everything starts very early in the morning, an hour before sunrise. Overhead, at an altitude of more than 6.2 miles (10 km), fine blue-tinted water-ice cirrus clouds rise over the landscape. A pale blue oval appears in the eastern sky, with amber all around it. In the foreground, the surface remains a very dark brown. Then the oval becomes brighter and a deeper blue. The landscape begins to take on a rusty glow. The sky along the horizon is darkened by the suspended dust particles, and sometimes by fog like we have on Earth. Then the sun, a small yellowish ball, suddenly rises. The halo above it is very

grow shorter. The surface gradually takes on its lovely copper color. The halo has already disappeared, dissipated in the surrounding light. Now the day is well underway. Discrete cirrus are no longer visible, overtaken by the sky's luminosity. Clouds can only be seen during the day when there is a minimum of dust in the atmosphere. The Martian sky now takes on its beautiful salmon pink color, deep violet at the zenith overhead.

About noon in summer, the light merges the tones into a uniform color: a strong yellowish brown. Basalt rocks, which are really gray, look blue. This optical illusion is well

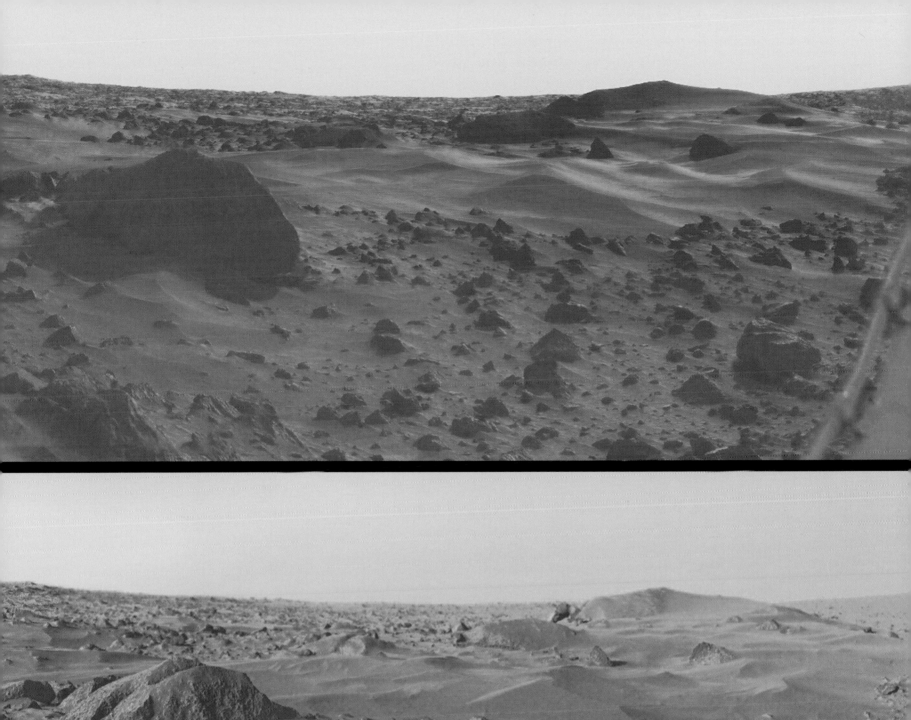
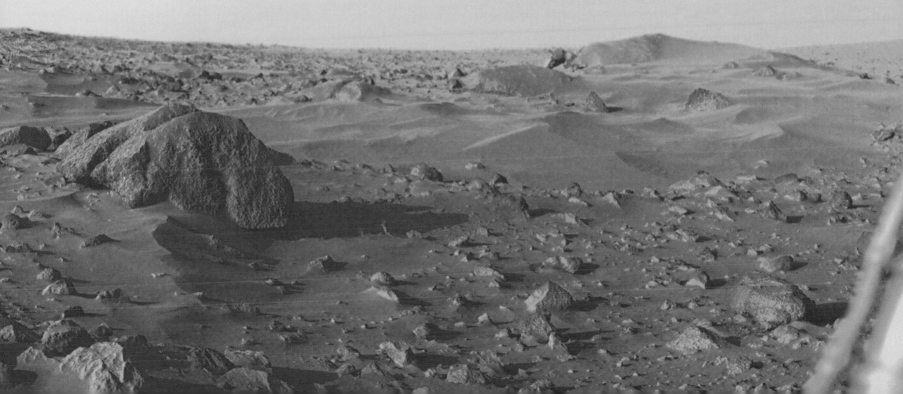

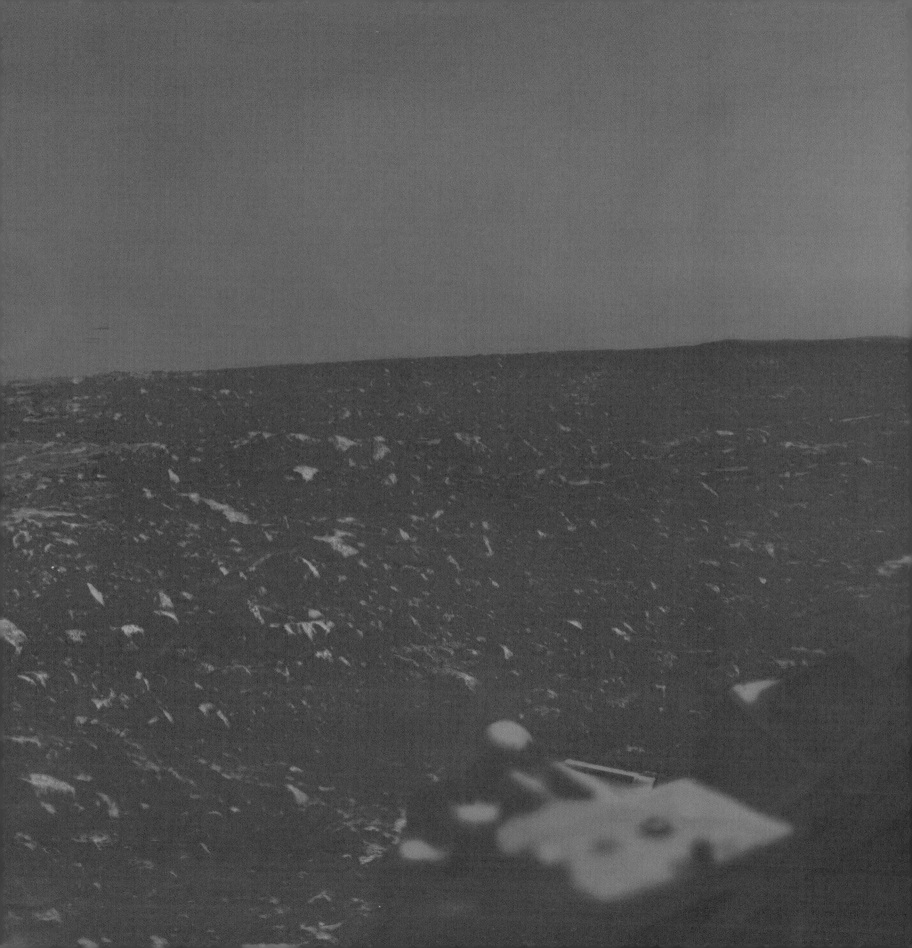

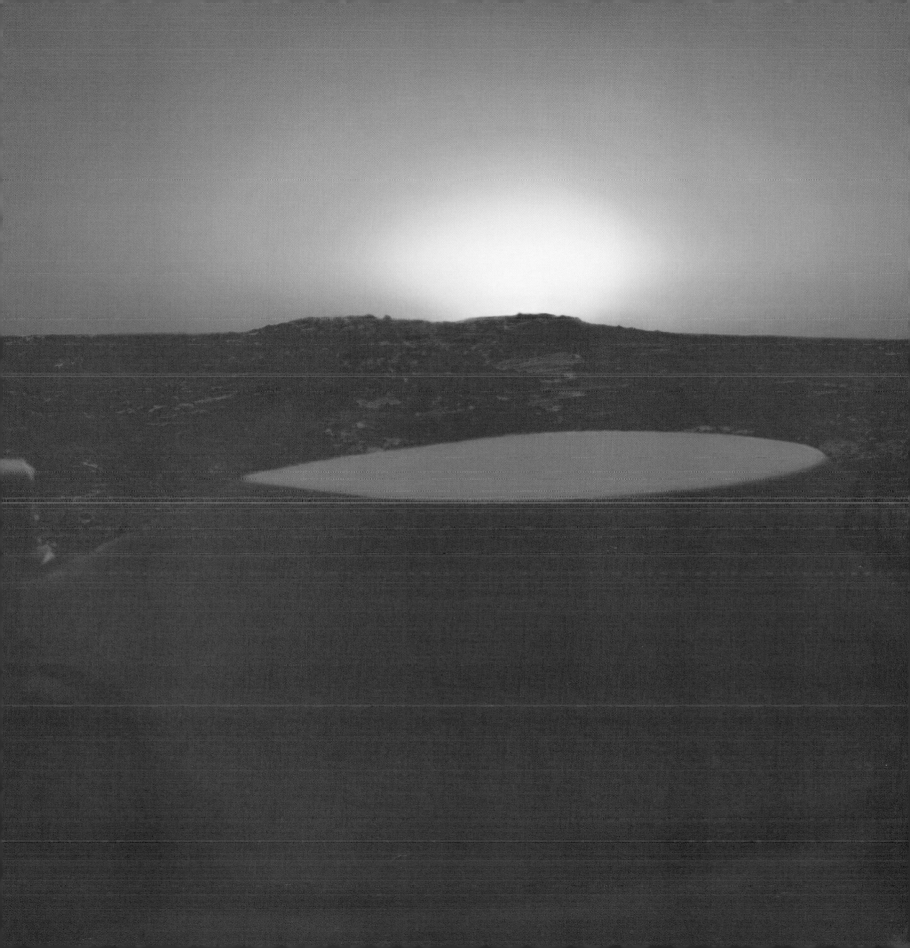

late afternoon. The sunlight pierces the dust of the lower atmosphere and turns a deep yellow. When the sun is about to sink beneath the horizon, the blue halo reappears above it. All around, the sky turns from salmon pink back to light amber. Once the sun has disappeared, the blue halo remains for a few more minutes then fades away.

Lights appear in the sky. First the two small moons, Phobos and Deimos, shine like stars. Phobos turns so quickly and so close to Mars that it can be observed with the naked eye to be slowly moving in the sky. Next, other planets show themselves. When Mars is in the proper position on its orbit around the sun, Jupiter shines very brightly. Depending on the time of year, another large "star," our Earth, reigns over some portion of the sky: it may set in the evening toward the west, or rise in the morning to the east.

From Mars, Earth looks like the classic image of the Christmas star that appeared overhead to the shepherds in their fields. Through a telescope, the tiny light of our moon sparkles right beside it. At high magnification, our globe is a beautiful orb of blue sprinkled with white clouds. The continents are sometimes visible as areas of brown.

Soon the sky fills with stars. Since the Martian air is not very dense, their light is brighter than on Earth, and they don't twinkle much. At about two in the morning, when the fog begins to rise, they fade away.

▲ Sunset from *Opportunity*. The sequence begins at 5:52 P.M., with a one-minute interval between images (MER).

8:15 A.M. *Viking 1* in the fog. The sun rose at 7:50 A.M. but still looks veiled in mist (*Viking*).
▼

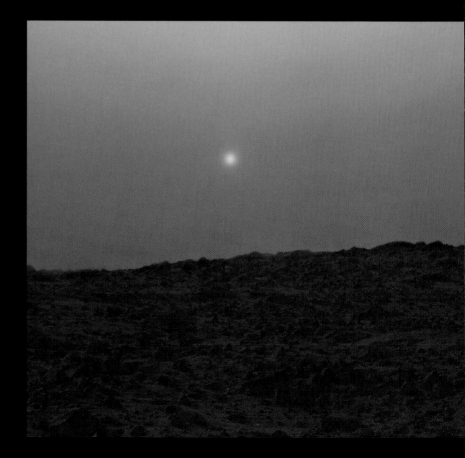

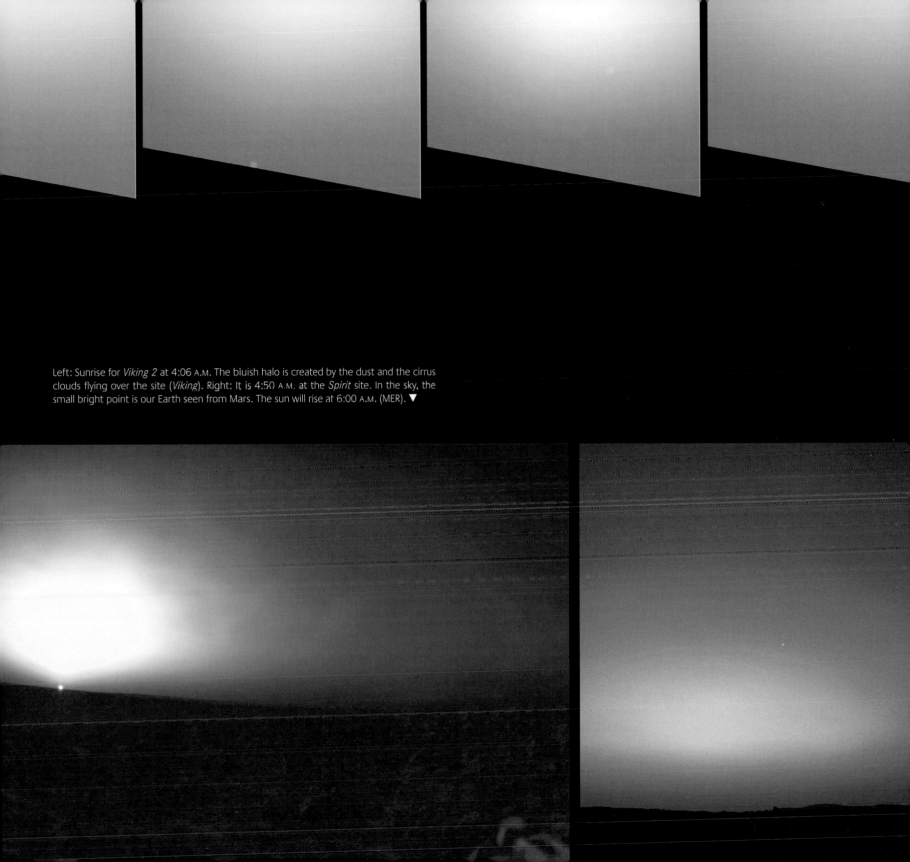

Left: Sunrise for *Viking 2* at 4:06 A.M. The bluish halo is created by the dust and the cirrus clouds flying over the site (*Viking*). Right: It is 4:50 A.M. at the *Spirit* site. In the sky, the small bright point is our Earth seen from Mars. The sun will rise at 6:00 A.M. (MER). ▼

MAN

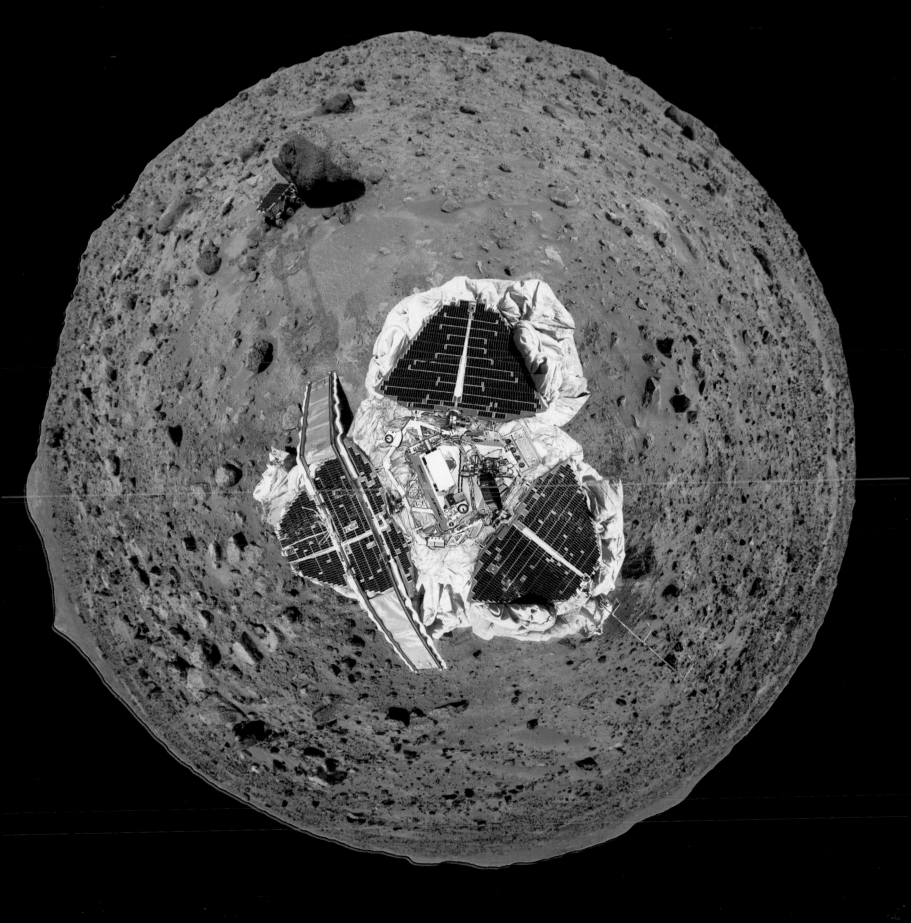

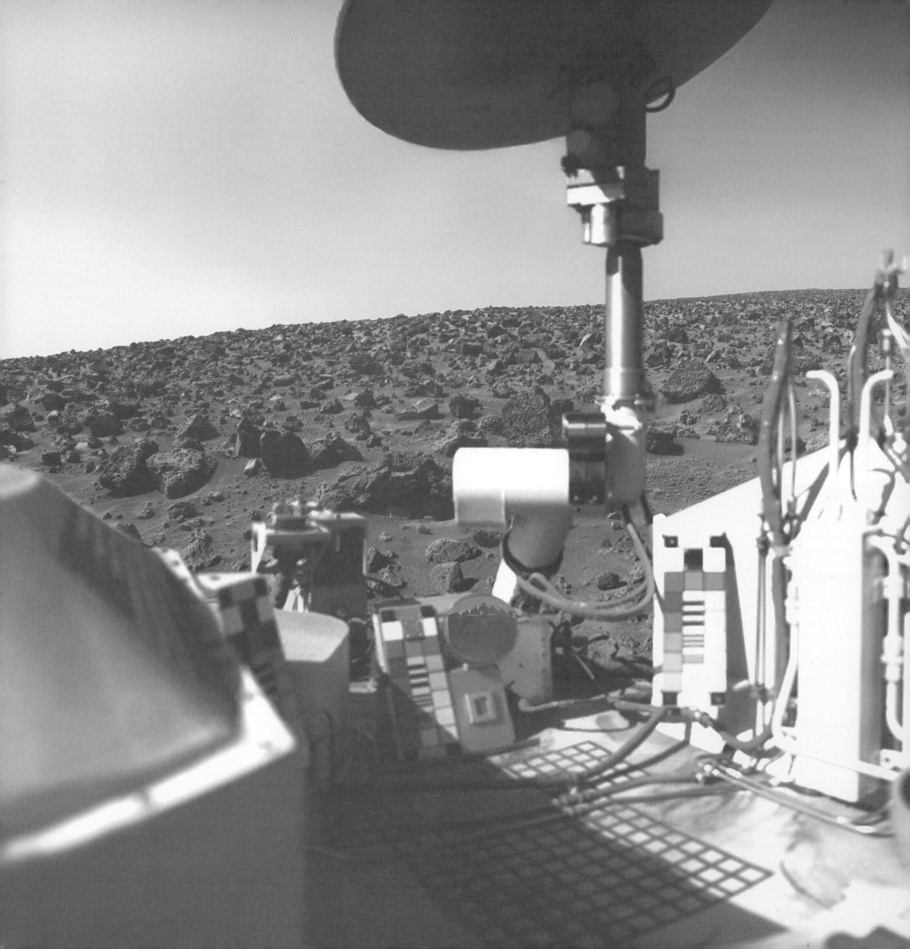

THE MARTIAN PROBES WERE DESIGNED TO SIMULATE OUR FIVE HUMAN SENSES: SIGHT, HEARING, TOUCH, TASTE, AND SMELL. THESE ROBOTS ARE CONSTRUCTED WITH EXTENSIONS SO THAT THEIR OPERATORS CAN "FEEL" THE MARTIAN ENVIRONMENT, ALMOST AS THOUGH THESE HUMAN BEINGS WERE THERE IN THE FLESH. CAMERAS, CONTINUOUSLY PERFECTED, CAPTURE DETAILS ALMOST AS SHARPLY AS THE HUMAN EYE. A MICROPHONE ACTS AS AN EAR. IN SPITE OF ITS LOW DENSITY, THE MARTIAN AIR CAN STILL CARRY SOUNDS, THOUGH THEY ARE MUFFLED. WE CAN LISTEN TO NOISES FROM EXPERIMENTS TAKING PLACE OR FROM THE MARTIAN ENVIRONMENT, SUCH AS THE SOUNDS OF THE WIND AND OF FLYING PARTICLES DURING STORMS. WE ARE GIVEN THE SENSE OF TOUCH THROUGH THE FOOTPADS, SHOVEL, AND WHEELS IN CONTACT WITH THE SURFACE. AS FOR TASTE AND SMELL, THEY ARE BROUGHT TO US VIA THE MANY SOPHISTICATED EXPERIMENTS THAT ANALYZE THE SURFACE. ROBOTS MAY HAVE BEEN FIRST, BUT MEN ARE SOON TO FOLLOW.

How to Find Your Way on Mars

It is hard to find your bearings on the Martian surface. The horizon is closer than it is on Earth: 2.50 miles (4 km) instead of 3.70 miles (6 km). Moreover, the suspended dust in the atmosphere tones down the contrasts of land-scapes more than about 25 miles (40 km) distant. It is difficult to interpret a map drawn from orbital views, and the rim of a crater a few yards high could block the view of another feature.

Therefore, it has been impossible to accurately locate the *Viking* probes after their landing. Scientists first tried to triangulate them through listening to them with orbital probes and with giant telecommunications antennas on Earth. But the results were accurate only up to about a couple of miles (a few kilometers). Attempts to locate them from orbit have failed—the probes have no big, bright components to contrast with the landscape. In fact, the protuberances of the instruments create shadows like the small rocks found in the surrounding environment. The two possible sites for *Viking 1* are 3.7 miles (5.9 km) away from each other. All that was seen was the small "V"-shape dark ejecta made by the impact of its heat shield. *Viking 2* was not located for a long time, since its site was so flat and without protruding topographical features. Thanks to a clever idea (described in the following section), *Viking 2* was finally found. *Pathfinder* had better luck and touched down in a distinctive spot, where many topographical features enabled us to pinpoint it on the same day it landed. As for *Spirit* and *Opportunity,* after many attempts to pin them down through telecommuni-cations, it was high-resolution cameras on orbital probes that spotted their white airbags.

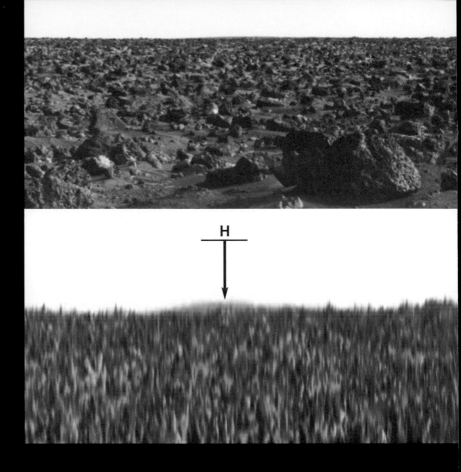

P. 123. *Pathfinder* seen from above with its retracted airbags and ramps deployed. The *Sojourner* microrover has just come down the ramp (left) and takes up position beside the large rock Yogi (MPF).

P. 124. The rear of the *Viking 2* probe. On both sides, the wind cover of the nuclear gener-ators. At right, the coolant tubes and the red connecting wires that were cut at the sepa-ration of the lander from its orbiter before landing (right). In the center, the calibration targets and the magnifying mirror showing the shovel's round magnetic test charts. In the middle, the mast of the high-gain antenna pointed toward Earth (*Viking*).

Goldstone

The Search for Viking 2

On the vast plains that include Utopia Planitia, there are no features that stand out against the horizon and make it possible to use reference points to locate *Viking 2.* East of the site, however, a lobe of lighter material ejected by the large Mie crater can be observed. In 1976 scientists were only able to approximate the spot by triangulating its radio broadcasts. Orbital views show that the entire region is dotted with craters that rise slightly above the surface, as though they were perched on platforms ("pedestal craters"). They are formed when the terrain inside the crater, compressed by the force of the impact, remains intact while the wind blows away the softer soil all around. When viewed from the side, the residual platform looks like a flat pancake that barely rises above the surrounding

▲ Top: The ultraflat plains of Utopia. Bottom: The clever imagery idea discovered by Philip Stooke (University of Western Ontario): stretching the shot vertically. The hill "H" and the Goldstone crater, located respectively at 14.3 miles (23 km) and 10.6 miles (17 km) away, become visible. Triangulating the position is finally possible (*Viking*).

Following double page. Vision of the future: astronauts examine *Viking 2,* silent for decades, relic of the "golden age" of space exploration (Pat Rawlings/SAIC).

landscape. To locate *Viking 2,* a scientist finally had the idea to "compress" a 360-degree panorama by increasing its verticality several times while preserving its width. The result showed two surprising "bumps." They were two ancient pedestal craters, very exaggerated in height, whose summits were visible above the horizon. After twenty-eight years, it was thus possible to find the spot where *Viking 2* had landed.

Pat Rawlings '7

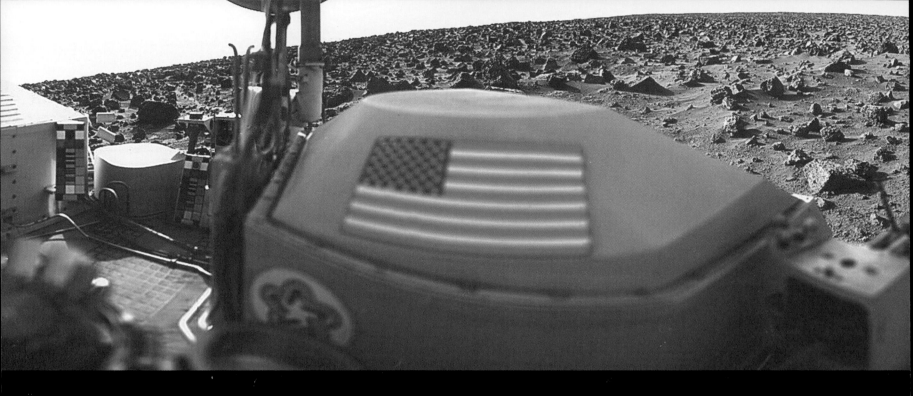

Familiar Shapes in an Unknown World

When the first probe touched down on Mars, it gave us pictures not only of an unknown world but also of itself. What useless information, you might say. Why send something such a long way only to have it show you what you already knew—pictures of a familiar machine that had, after all, been made on Earth? Early engineers saw the same images hundreds of times over as they tested their cameras on the ground: a foreground filled with *Viking*'s landing footpads or antennas, and a background that showed nothing of much greater interest—the assembly room with its computers, test benches, and calibration targets. Now, though we scan this same panorama, there is a big difference: the background has changed. We discover the landscape of another planet and suddenly, thanks to the familiar shape seen in the foreground, as though looking through a car window, we are now transported to this new world.

The design of the probes influences the perception the scientists have of their new environment. The American *Viking 1* and *2,* the first probes to land successfully on Mars, had no means of locomotion, which meant we were also stuck in the same spot. It was very frustrating not to be able to see beyond the horizon. The next probes, *Pathfinder, Spirit,* and *Opportunity,* provided a new perspective: a landscape that changed as the vehicles moved. Science also had to adapt to this new situation.

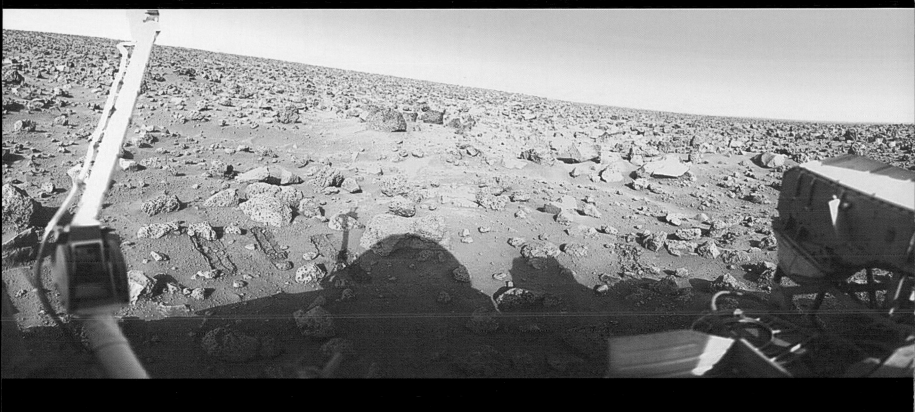

Fast analyses and results were needed so the probes could set off as quickly as possible to examine another site. The probes got their energy from solar panels. This was a disadvantage. The camera and other instruments consumed a lot of energy and could only be used during the day, when the sun was high in the sky and giving the strongest light, in order to conserve power in the batteries at night. Most images were thus taken with the sun at the zenith, suppressing shadows and contours.

Paradoxically, the *Viking* probes gave scientists more freedom to meditate on the probes' surroundings. Big nuclear generators provided abundant power that lasted several years, and images could be taken at will from sunrise to sunset. Researchers had time to examine the probes' environment under different lighting. The colors of the landscape burst forth at sunrise and blazed at sunset; sand and rocks turned white under the winter frost. Clearly, the future belongs to mobile probes like rovers, but supplied with nuclear energy.

▲ Complete panorama taken by camera no. 1 of *Viking 2* at 1:15 P.M. Left to right: The wind cover of nuclear generator no. 2; the rear of the lander with its calibration targets, mast of the high-gain antenna; the the wind cover of nuclear generator no. 1, bearing the American flag; the meteorology boom; and the hood housing the soil sampler boom (*Viking*).

Following double page. *The* Spirit *rover has just left its lander, called the Columbia Memorial Station.* A now-inert structure with three wide-open panels, it holds the deflated airbags. Notice the yellow flexible ramps, called batwings by the engineers: the one in the foreground enables *Spirit* to get down to the surface (MER).

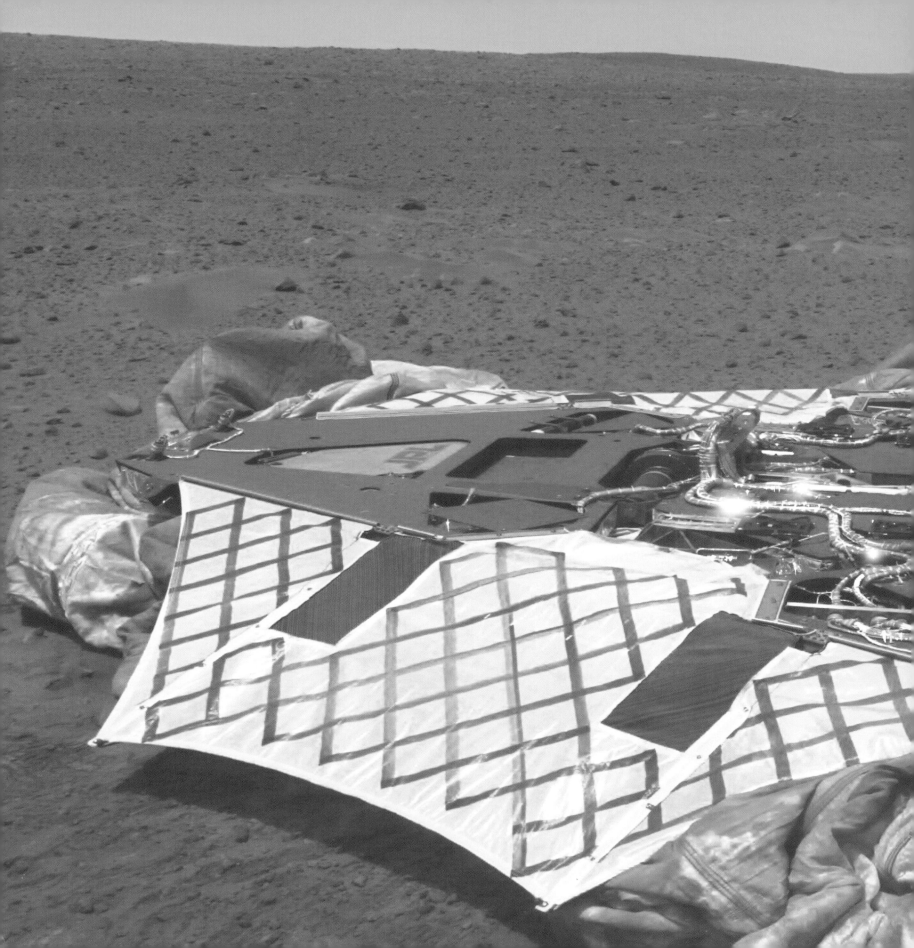

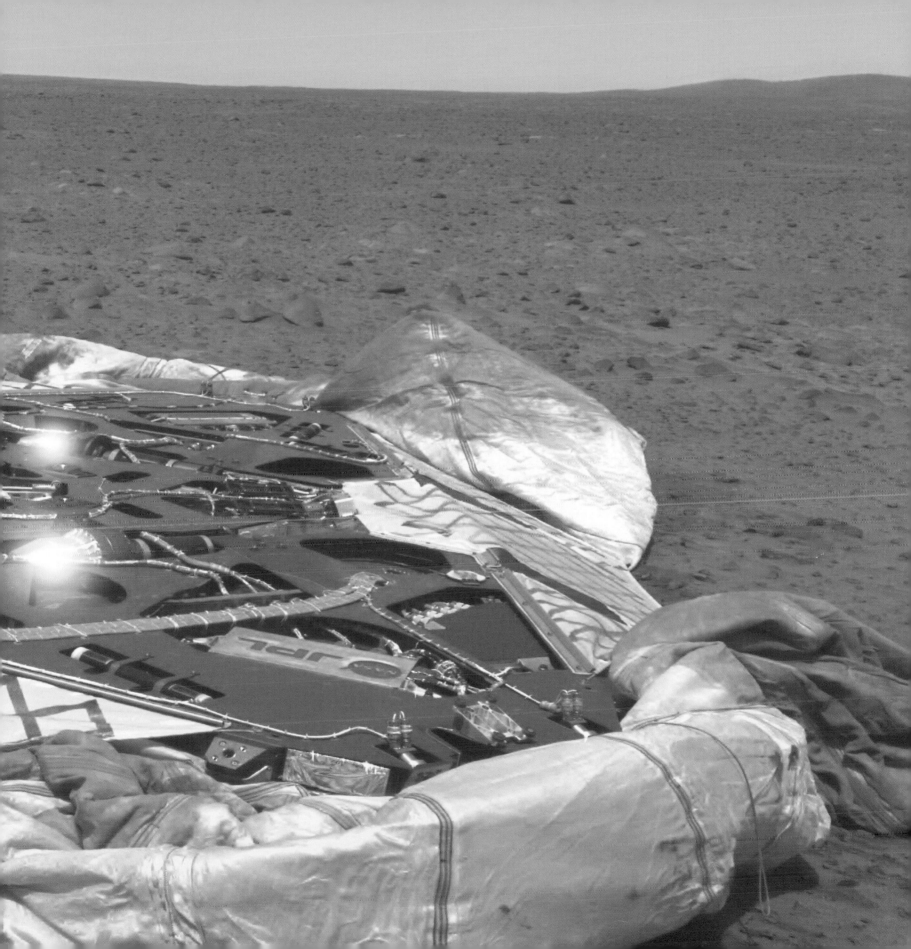

◀ Imprints of the airbags in the fine hematite dust at the *Opportunity* site. By straight-
ening the perspective to reconstitute a view from above, you can even see the stitching of
the airbags imprinted on the surface (bottom) (MER).

Early in the morning on Chryse Planitia. In the foreground, one of *Viking 1*'s three titanium
landing footpads (*Viking*). ▶

Feet: Symbols of Exploration

"When you disembark, what do you look at first? Your
feet!" This is how scientists decided on the first image
Viking 1 should capture when it landed on Mars in 1976.
When it was received on Earth, the picture astonished
everyone with the sharpness of its details and, most of all,
by the fidelity with which the rivets of the probe's footpads
were displayed. It was the star of this first day. Immedi-
ately after, a panorama was sent that showed the land-
scape to the horizon. It has become a tradition of Martian
exploration for the probe to photograph its immediate
environment first. *Pathfinder, Spirit,* and *Opportunity* did
not break the rule: their first images showed the folded
fabric of their airbags. Images like these allow engineers
to evaluate the condition of the probe after landing. They
have also proved useful to science. For instance, an image
of a *Viking 1* footpad sinking into the Martian soil made it
possible to measure the physical properties of the sedi-
ment. During the following missions, small rocks were
dislodged when the airbags under the probes retracted,
scraping over the surface and even carving into it at times.
In this way the cohesion of the terrain around the landers
could be inferred.

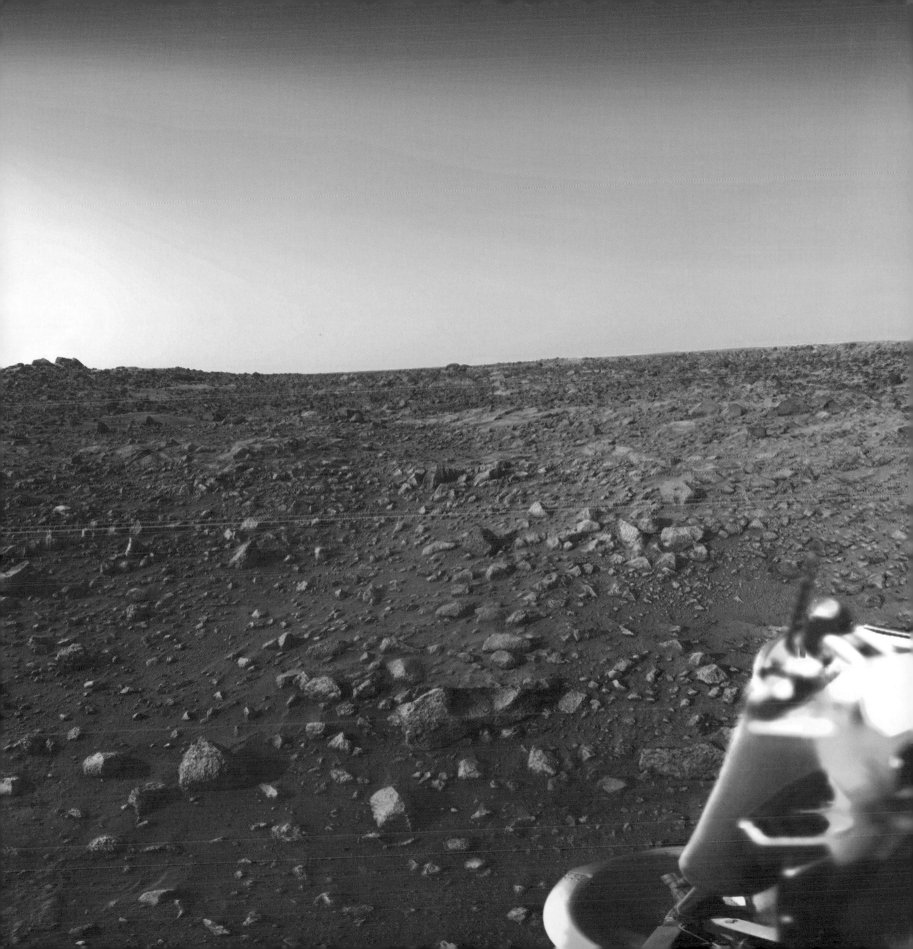

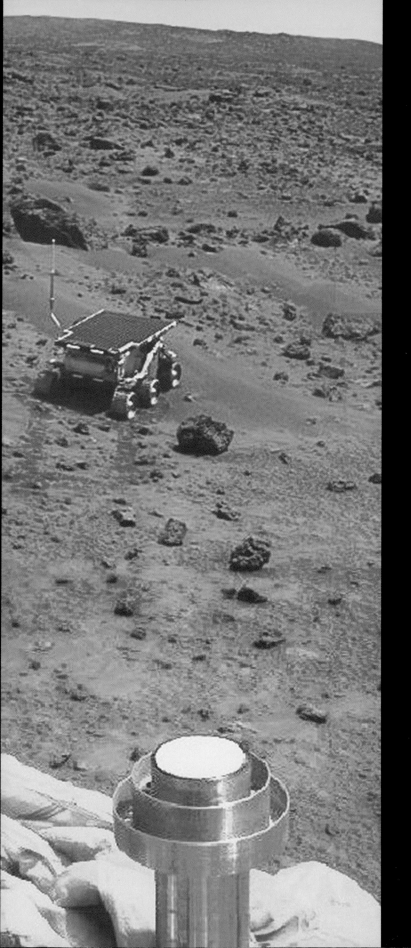

Wheels: Imprints of Civilization

During the first *Apollo* lunar missions, we quickly came to understand the limitations of space exploration on foot. The astronauts of *Apollo 14* were provided with a hand-cart, a two-wheeled vehicle called "Modular Equipment Transporter" or MET, for hauling some of the equipment to enable them to go farther. Transportation improved even more during the three following missions, when the astronauts were able to go several miles in their Lunar Roving Vehicle.

The sequence was the same for the Martian probes. Landers first went "on foot" (the immobile *Viking 1* and *Viking 2*), then had limited movement with a small rover (the *Sojourner* rover of the *Pathfinder* lander), and were finally completely mobile with the *Spirit* and *Opportunity* rovers. The wheel is now an essential element of Martian exploration. The image of the wheels and their tracks in the ground are concrete proof of our progress in exploration. Nor have the researchers been forgotten. Through their movement, the vehicles disturb the surface and dislodge sediment. This allows them to gather data on the Martian soil's cohesion, whose magnetic properties cause it to act like wet sand.

◄ In the foreground, the top of *Pathfinder*'s omnidirectional antenna. In the background, the *Sojourner* microrover explores the Mermaid dune (MPF).

Progress of *Spirit,* which is now 109 yards (100 m) from its base (near the horizon). It travels over the Laguna Hollow where it will stay for three days digging the surface (*see p. 139*). Notice its direction changes when detecting the relief and its in-place rotations (MER). ►

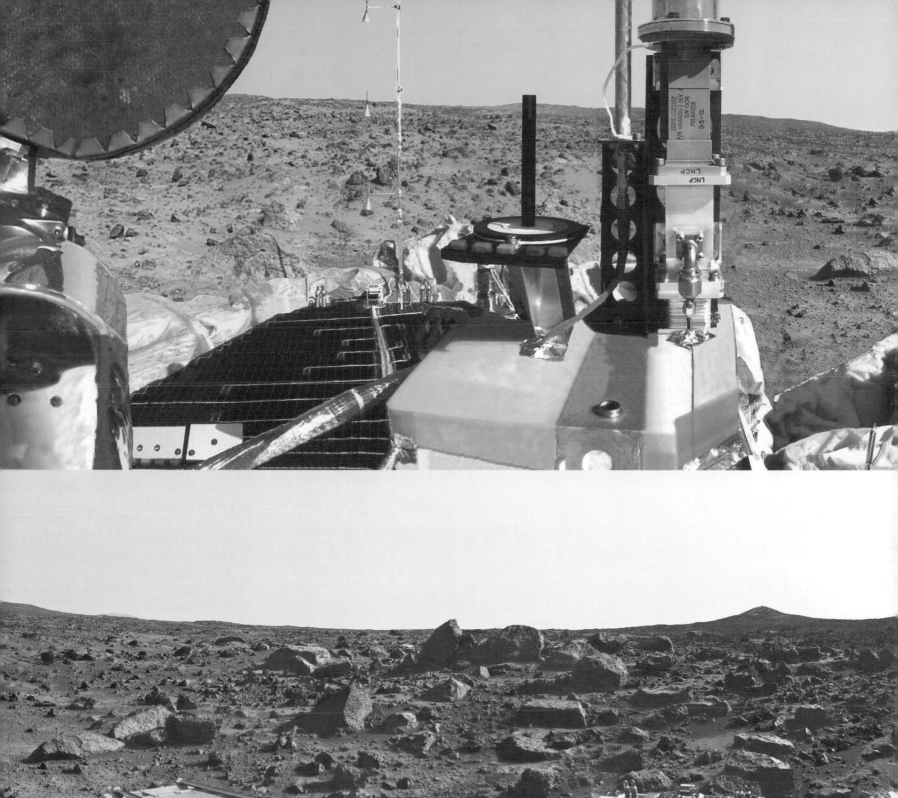
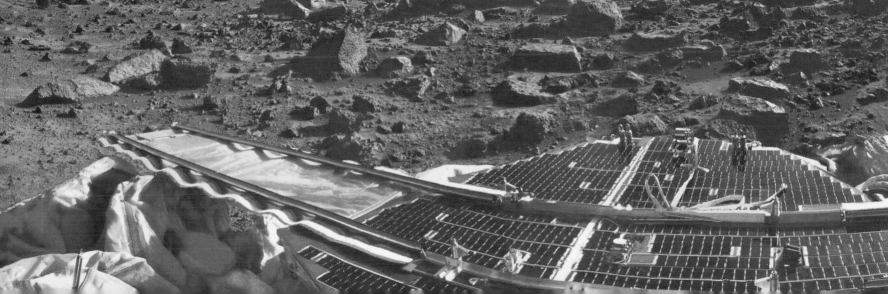

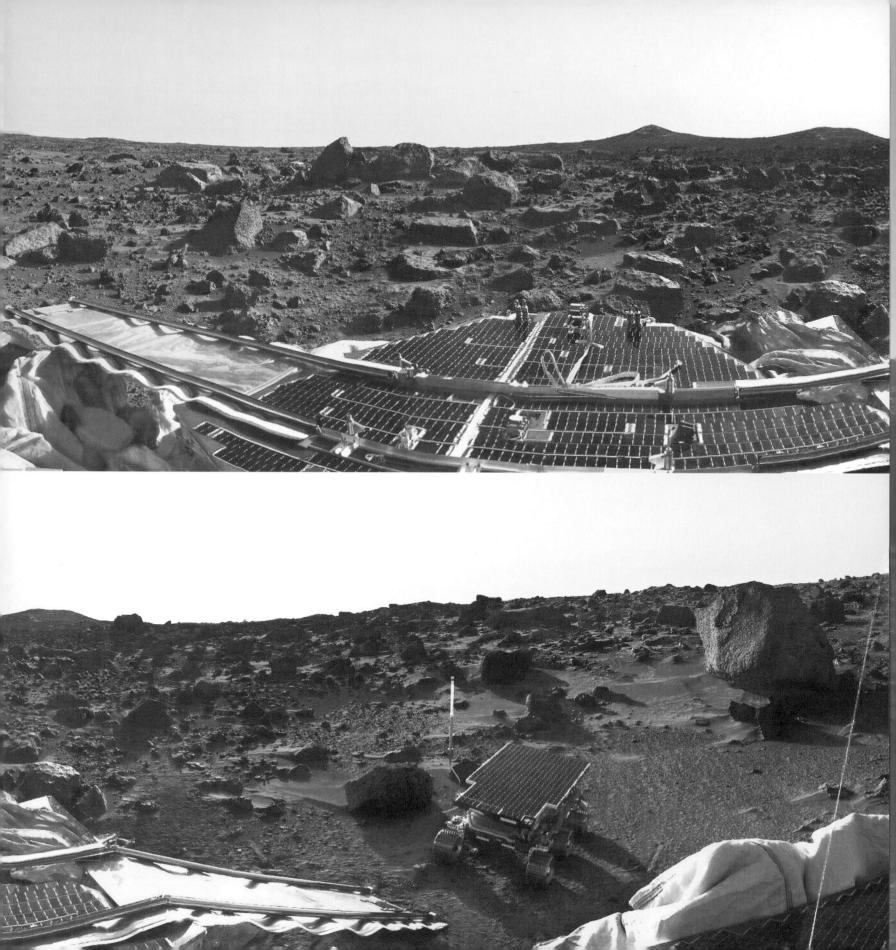

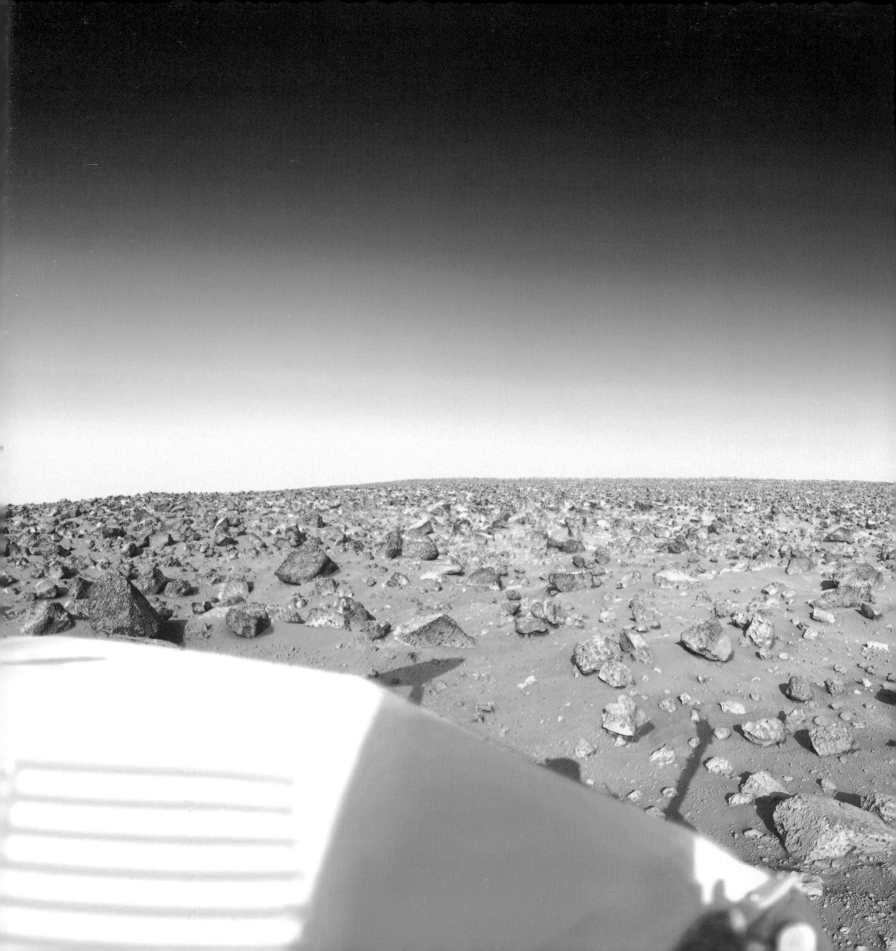

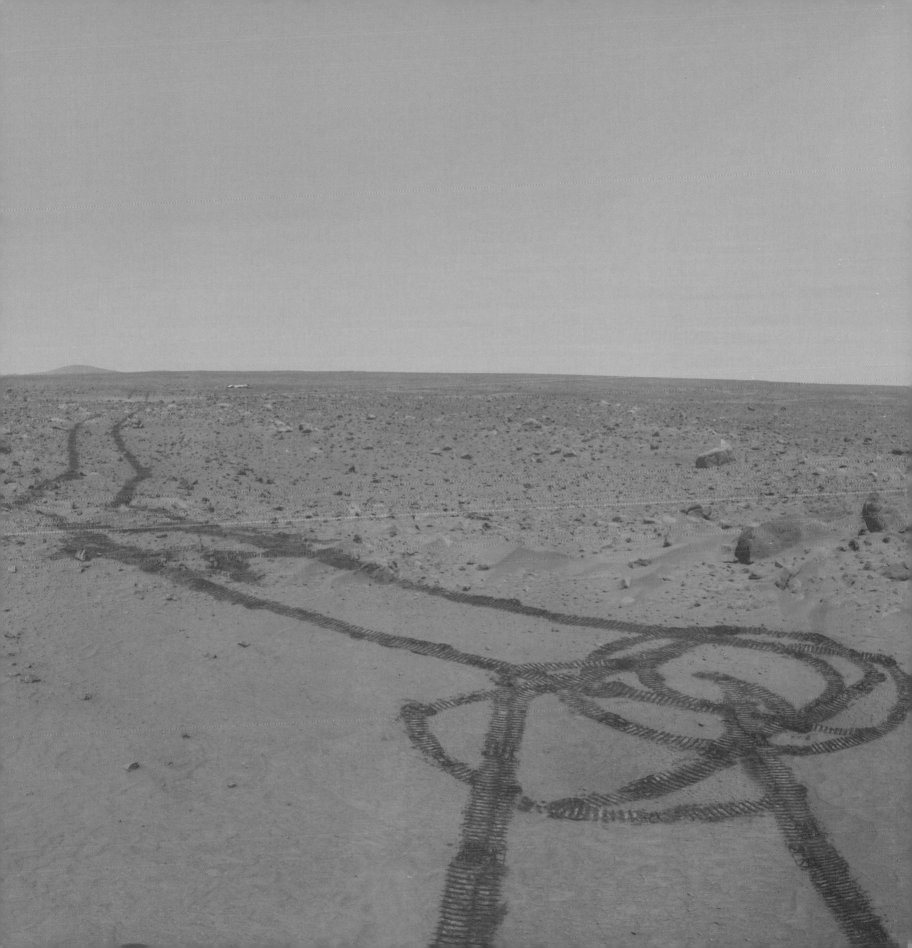

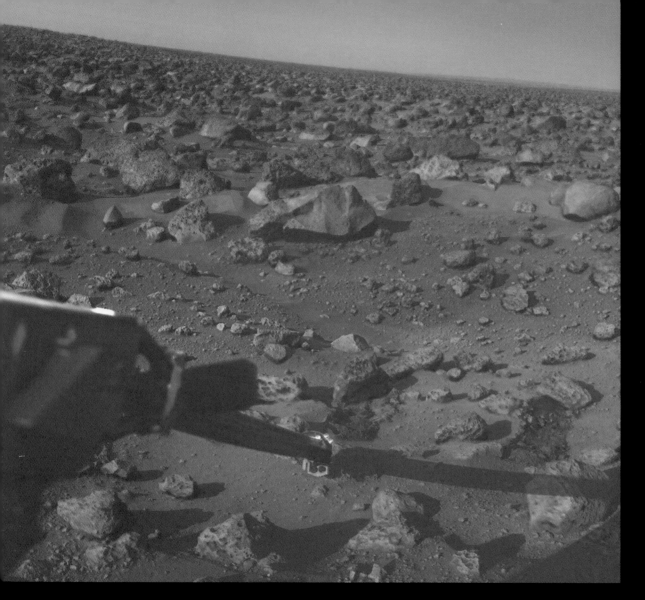

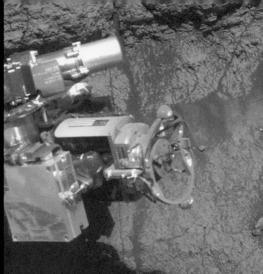

Arms: Extending Our Human Senses

▲ Left: soil-sampler boom of *Viking 2* digging a trench (*Viking*). Top right: The Rock Abrasion Tool (RAT) has just cleaned the Guadalupe rock. It is covered with a fine dust. Bottom right: The results of dry-grinding a thickness of 5 mm (details p. 27). The rock is now ready for analysis (MER).

The *Viking* probes were equipped with a soil-sampler boom that stretched to about 4 yards or 3.7 meters, with a shovel that dug to a depth of 7.8 inches (20 cm). The boom then retracted and provided the samples to the chosen experiment.

The *Sojourner* small rover acted as *Pathfinder*'s extended arm, moving over some hundred yards or 91 meters. A small instrument (alpha-proton and x-ray spectrometer, or

APXS) could detect the elements in the rocks. Its six notched wheels also allowed it to scratch the surface and reveal the upper layers of the subsoil. The *Spirit* and *Opportunity* rovers each had a robotic arm with several articulations. On the end, a cross-shape cylinder carried three experiments and a Rock Abrasion Tool (RAT) capable of

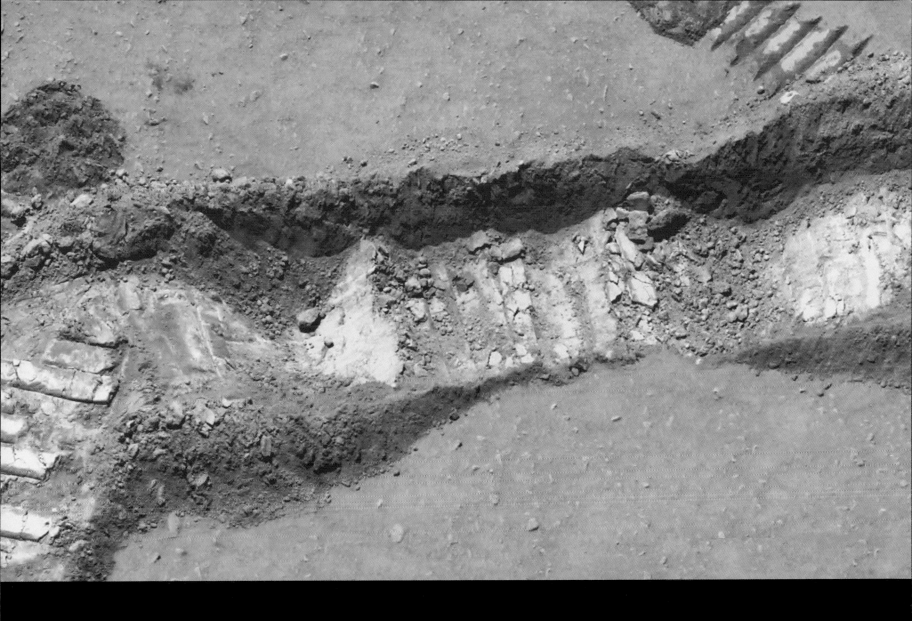

Trench dug in the sediment of Laguna Hollow by *Spirit*. Eleven round trips were necessary for the wheels to dig to a depth of 2.75 inches (7 cm) (MER).

grinding a thickness of 5 mm of rock. In this way, scientists could access material that hadn't been polluted by airborne dust. In addition to an APXS spectrometer, a microscope captured very sharp images (at a resolution of 30 microns per pixel). A Mössbauer spectrometer detected minerals and determined their state of oxidation. Like *Sojourner,*

Spirit and *Opportunity* could put the brakes on five of their wheels and make the sixth one turn in place to dig into the surface to a depth of some 4 inches (10 cm). Still, it took *Opportunity* and *Spirit* one full day to do what a geologist could accomplish in less than a minute. This is why it is essential for astronauts to be sent to Mars.

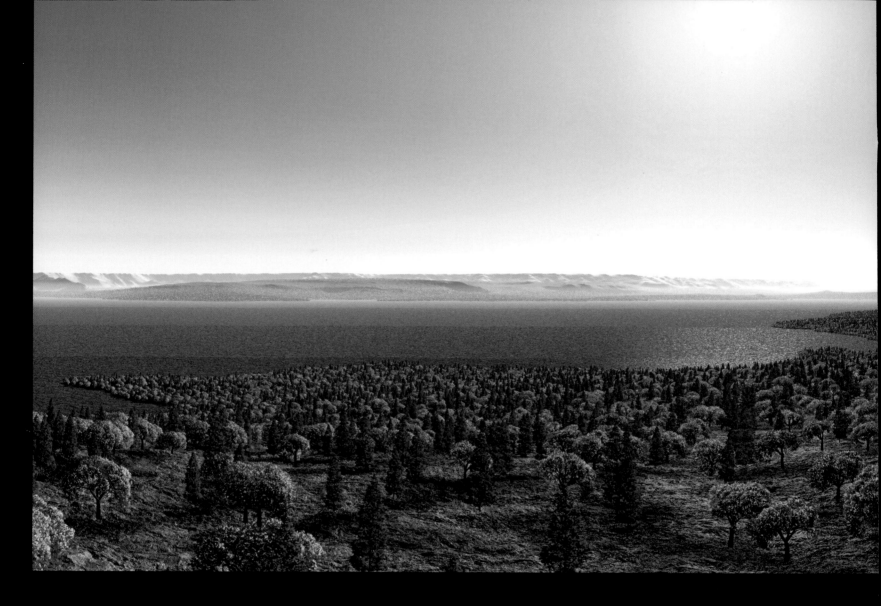

"Terraforming" the Martian Environment

We can conceive of colonizing Mars. But how could we make it habitable, "terraform" it, to make the red planet home to a diversified flora and fauna?

Some scientists think about creating ecological "niches" by scattering bacteria inside the planet's depressions. Others want to dig it up more by crashing huge asteroids into it. This would create depths great enough to maintain an atmospheric pressure of 25 millibars, favorable to cold-resistant plants like lichens. Most Earth plants, however,

grow at a pressure of 140 millibars. These limited interventions aside, a real terraformation requires a global change.

The first step would be to trigger the greenhouse effect. Mars has a great asset in its carbon dioxide, which comprises 95.3 percent of its atmosphere, as this gas is capable of trapping heat. It is stored in the ice at the south pole and in rocks. The process would begin in the southern polar cap, which would have to be heated to make a thicker atmosphere and to capture solar

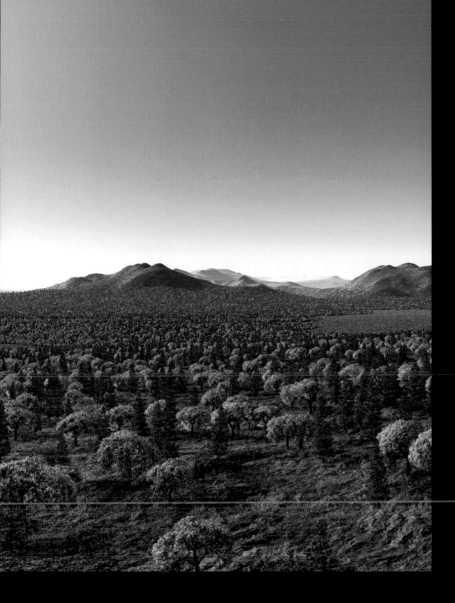

◄ Year 3400: the bottom of the Valles Marineris is filled with a large lake surrounded by forests (MOLA).

Following double page. From top to bottom: Valles Marineris (see pp. 90–91) today, and then 3,000 years in the future, after the terraformation processes that began with the filling of hollows with water, and, finally, at the end of 3,400 years when Mars resembles Earth (MOLA).

pressure to reach 100 millibars. At that point, the heat would penetrate deeper into the ground, and the atmospheric pressure would consequently rise 5 millibars per year. Another point of equilibrium would be reached at 500 millibars. At this pressure, the temperature from equator to tropics would not exceed freezing (32° F, or 0° C), and the frozen subsoil in high latitudes would not be subject to a massive thaw.

The planet could be heated even more with the use of greenhouse gases, such as the infamous CFCs (or chlorofluorocarbons). Not all of these are destructive to the ozone layer, and they could be mass produced in small factories right on Mars. Next the permafrost would thaw, and water would run on the surface of Mars. In this thicker atmosphere, colonists would be able to walk on the surface without spacesuits, though they would still need supplemental oxygen.

For higher plant and animal life to evolve on the planet surface, the atmosphere must be rich in oxygen. Man, for instance, needs at least the equivalent of 120 millibars of oxygen, without counting nitrogen. It might be possible to create oxygen "easily" by "seeding" the surface with genetically modified plants and bacteria. Even then, a full millennium might pass before human beings were able to walk in the open air without oxygen masks.

It is impossible to imagine the terraformation of Mars until we know whether life exists there already, even if in a very primitive form. If it does, we would have to arrange niches that would enable it to survive.

heat more effectively. A giant orbital mirror has been suggested, along with a "sprinkling" of the almost-black debris of comets or asteroids to absorb solar heat.

It would take a minimum of twenty years for the dry ice of the south pole to sublimate. The Martian temperature would then rise a few degrees, and the carbon dioxide would escape from the subsoil. The greenhouse effect would take over, and more carbon dioxide would be released. Still it would take a century for the atmospheric

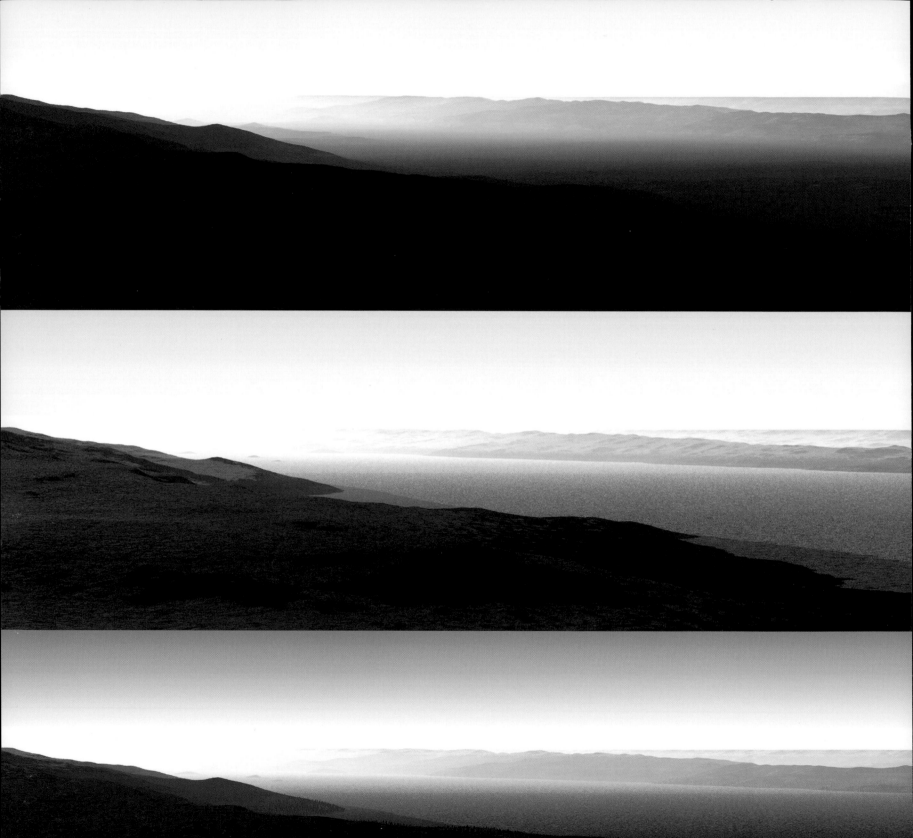

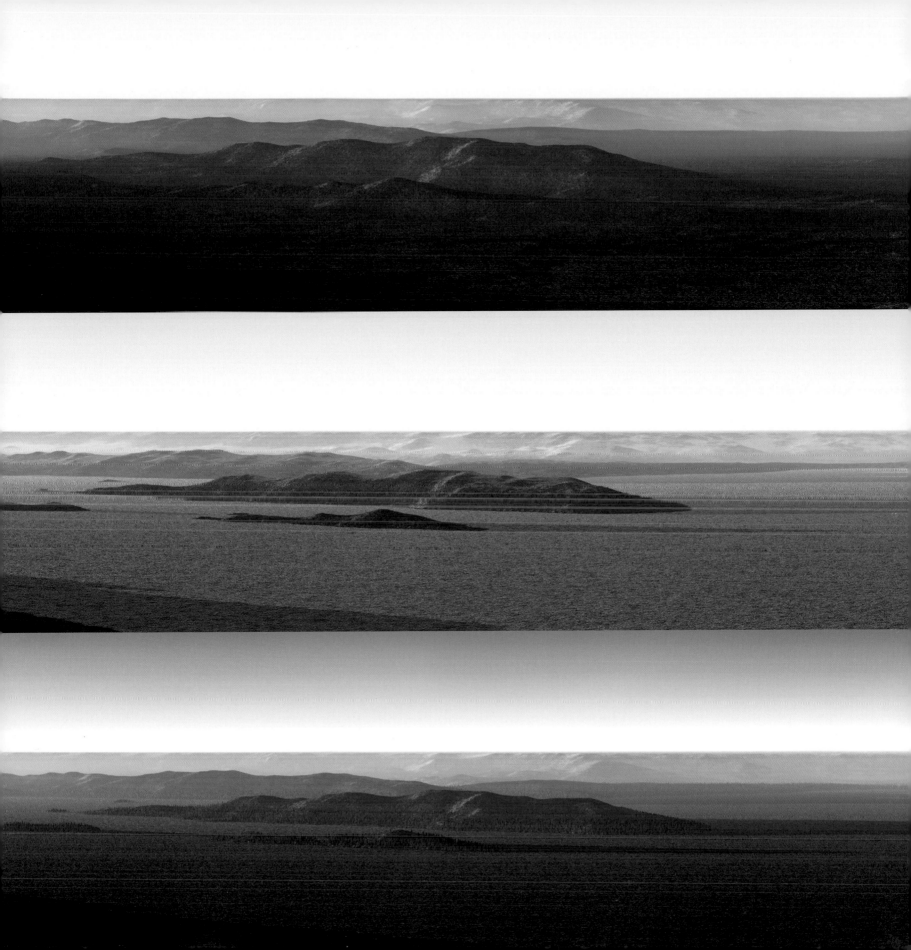

APPENDIX

Visions of Mars Deciphered: The Imaging Processes

Mars, Just As If You Were There!

The aim of this book is to let you see Mars as though you were on the planet. Its origin dates back in 1978, when NASA published *The Martian Landscape*. Looking at one black-and-white image of a crater's rim seen from the surface (below right), I dreamed of being able to see it in color and explore it. Now, using computers, we can see the real colors of the rocks.

Special attention was given to the artistic quality of the images presented here. Pictures taken from orbit or on the surface were carefully selected from all the images that have been transmitted to Earth. Any segments that were missing (as a result of a communications failure, for instance) were re-created from low-resolution and/or adjacent images. Some surface shots were completed using another method. Some black-and-white images (shot in so-called panchromatic mode) were colorized using pictures of spacecraft parts taken inside assembly rooms on earth. Each image was reworked with care, and imperfections were corrected to the nearest pixel: hundreds of hours of meticulous work were invested.

But what are the real colors of Mars? In 1982, when as a trainee I was working at NASA's Jet Propulsion Laboratory (JPL), processing the images captured by the *Viking* landers, I soon realized that the colors made popular in the press were too saturated. I set out to find the true colors by correcting for color shifts caused by the camera filters : the soil was no longer orange but a more realistic yellowish brown. It also became obvious that the seasonal variation in the color of the sky, usually yellow-orange, also depended on the amount of dust in the lower atmosphere (as illustrated in the sequence at the bottom of p. 108). Cold fronts passing over the site were also accompanied by a retinue of cirrostratus clouds, which diminished luminosity and thus reduced contrast and color saturation. Any given landscape may change in appearance from one month to the next. The variations in sunlight during a Martian day (or "sol," which lasts twenty-four hours, thirty-seven minutes) also changes the color of the sediments from a lovely copper brown to a brighter brownish yellow.

Often I am asked, "But are your colors the real ones?" In answer I say they are an interpretation. They match the tones in the calibration targets positioned on the probes. They are close to what an astronaut would see on Mars with a brain that has already intensified the light and contrasts of the landscape. Future colonists will develop a greater acuity than ours when it comes to perceiving the red planet's subtle shades.

The images in this book that have been processed belong to each of four categories: orbital images that have been colorized; shots from the *Viking* landers now seen in high-resolution color; high-resolution color images from *Pathfinder, Spirit,* and *Opportunity*; and synthetic images built from laser-altimeter data.

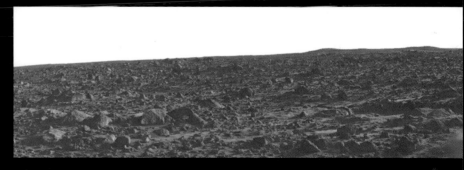

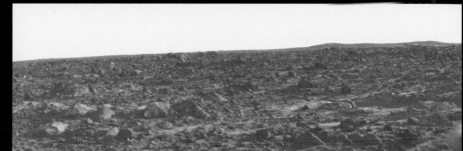

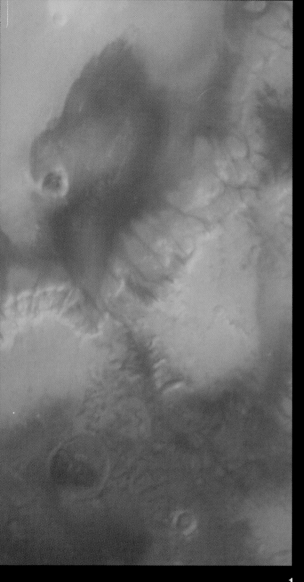

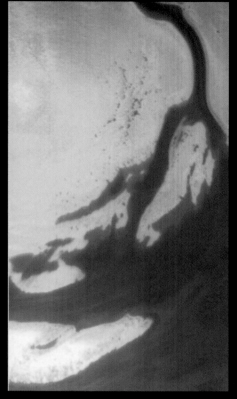

2

4

1

3

These five shots have been reconstituted from blue and red wide-angle images taken by the Mars Global Surveyor's MOC camera. The darkest areas of images 1 and 2 are not blue but gray, with colors that are not very saturated. Image 3 shows a segment of the north polar cap: the water ice is slightly pinkish because of atmospheric dust deposited there. Images 4 and 5 were taken above the south polar cap: notice that the frost is slightly pinkish.

Orbital Images

Most shots from the American probes are taken through color filters and transmitted in panchromatic mode (black-and-white). When taken through a clear filter (i.e., a transparent noncolored glass), these images are brought into color by sampling low-resolution shots taken under different filters and reconstituted in full color—some of which were captured at different Martian locations than the black-and-white originals. One by one, tens of colors are layered onto the high-resolution image in a process very similar to serigraphy (silkscreen printing). Some images needed nearly a hundred individual selections. The colors were then mixed together to produce natural tones.

5

2 **3** **4**

5 **6**

7

High-Resolution Color Images from the Viking Landers

The cameras of the *Viking* landers worked in two modes: high-resolution panchromatic (that is, in real black-and-white taken through a clear filter) and low-resolution color (through three filters: blue, green, and red). The high-resolution images (1 through 4) are patiently pieced together to create complete panoramas (5) in black-and-white. Next they are accurately merged with reconstituted low-resolution color shots (6). The results are spectacular: Now, for the first time, you can look at a *Viking* lander picture in high-resolution color (7). Twenty panoramas were produced in this manner, of which some are published in this book.

Color Images from the Pathfinder, Spirit, and Opportunity Landers

The images in this category are made by combining three high-resolution images, each taken with either a blue, red, or green filter. Occasionally one of the three images would include missing data—a problem usually caused by communications failures that show up in the shots as black bands or squares—and these gaps had to be filled in with data taken under different filters and then compensated for. Parallax defects, the result of camera movement between shots, also required correction. In addition the choice of using a near-infrared filter in place of a red filter by the *Spirit* and *Opportunity* cameras oversaturated the red hues, which then had to be balanced with green and blue tones. Opposite right: this mosaic of raw images was taken by *Spirit*. (The final image, with all corrections integrated, is shown on p. 137.)

The panorama below was taken on Mars on July 6, 1997 between 3:00 and 5:00 P.M. local time with the Mars *Pathfinder*'s camera. As it rotated, the camera calculated the contrast and luminosity for each shot. The result (top) is not homogeneous. Moreover, communication failures created black bands on some images.

Some corrections are needed (diagram p. 148). First of all, the reconstitution of missing data like the green, for example, whose absence creates the pink bands. A synthetic green, re-created from the blue and red, enables us to get back the original colors. Other corrections consist of recentering the blue signal (a), shifted a few pixels to the right when the shot was taken, on originally red (b) and green (c) images. Superimposing them without recentering gives a blurry image (d). A new recentered blue image is created (e), which gives a sharp image when superimposed on the blue and red images (f). The chromatic corrections have to be done using the color-test charts on the probes. Now we have a good color image (g).

After correcting the parallax and putting all the images together, we get the final panorama (bottom).

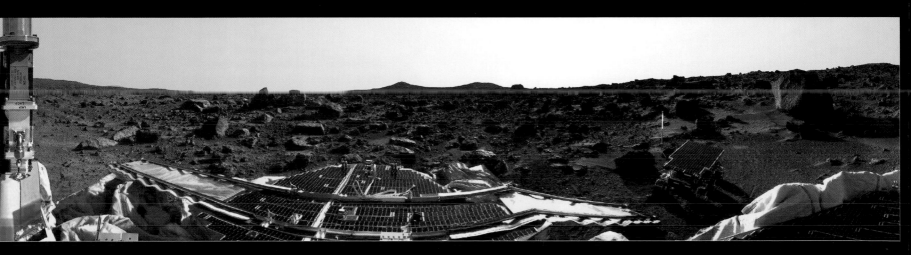

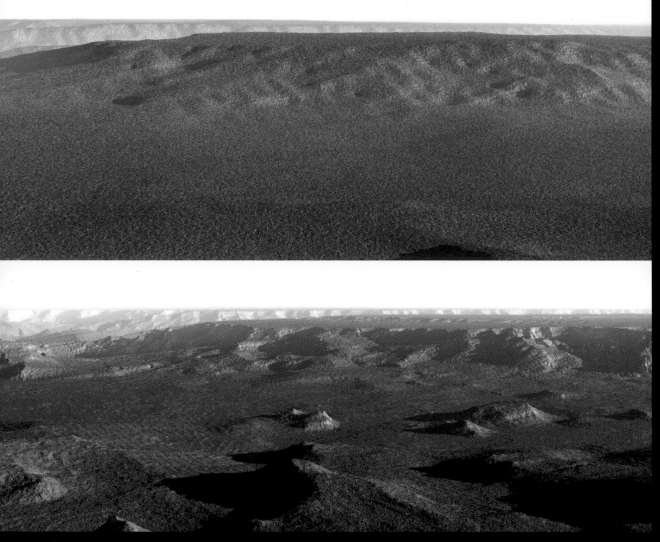

Synthetic Altimetric Images

These images are re-created using the laser-altimeter data from the MOLA instrument of the Mars Global Surveyor (MGS) in collaboration with the NASA/GSFC team. Since September 1997, when MGS went into orbit, the probe's laser altimeter has made 640 million measurements of the Martian topography. Its short-duration lasers (of 8 nanoseconds) are beamed continuously from an orbit 250 miles (400 km) above Mars, illuminating a circle on the planet surface. Light reflects from surface features and is picked up by a telescope. Each signal is precisely timed, from emission to its bounce-back to the tele-scope: the longer the time, the farther the surface is from the probe. A short response time indicates an elevated relief. MGS retraces its path every seven Martian days, thus making an increasingly finer measurement and creating an ever-more-accurate grid of the planet. From these images, maps with a very fine resolution—of 1/256th degree at the equator—are made with an altimetric accuracy close to 16 inches (40 cm). Texture is then layered onto the map like plaster spread on a wire mesh. The shadows are calculated, the dusty lower atmos-phere is reproduced, and there we are—on Mars!

Mars: Identity Card

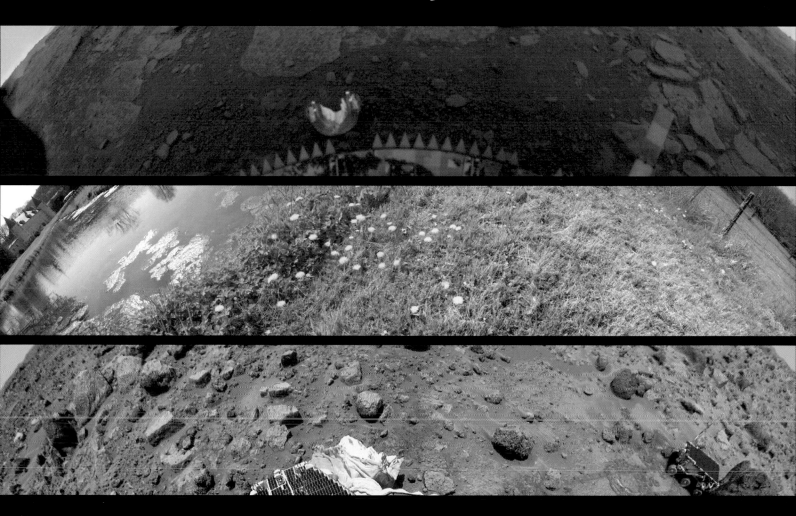

Mars's Orbits

Mars is positioned in the solar system nearest the sun after Earth. Because it has a greater distance to cover on its orbit, and because it revolves more slowly around the sun, the Martian year is nearly twice as long as ours (687 days compared to 365). Every 780 days (on average), the orbits of Earth and Mars coincide so that Earth stands directly between Mars and the sun, with these two bodies on opposite sides of our plane. Of these times we say that Mars is "in opposition" to Earth. The cycle continues when the orbits of both planets put them on opposite sides of the sun. Mars is invisible to us at these times, and we say it is "in conjunction" with the sun.

Mars does not have a circular orbit, but rather an eccentric one. Its distance from the sun varies from 128 million miles (206 million km) at its closest point (perihelion) to about 155 million miles (249 millions km) at its farthest point (aphelion). When Mars is in opposition to Earth, its position varies considerably, depending on the distance its orbit takes it from the sun. During an aphelic opposition (when Mars is farthest from the sun on its orbit), the red planet is 62.7 million miles (101 million km)

Three worlds, one sun. Venus (top): A planet with conditions of extreme heat (480° C), where daylight is no brighter than a stormy day on Earth. Earth (in the middle): One fine spring day in Burgundy, where life abounds. Mars (bottom, MPF) an Earth-like world but cold: at noon it is −22° F (−30° C).

from us. During a perihelic opposition (when Mars is nearest to the sun on its orbit), the planet barely brushes by at a distance of 34.2 million miles (55.09 million km)—just 150 times the distance from Earth to the moon. In the sky Mars then appears as a big reddish star, as bright as an airplane making its initial high approach. On August 27, 2003, the Martian opposition was calculated at a distance of 34.6 million miles (55.76 million km), a passage, at the closest, that almost coincided with its perihelion.

Surrounding any star exists a zone where it is physically possible for water to exist in liquid form. Called the ecosphere, this area is considered capable of supporting life; in the illustration below, it is indicated by a ring of gray. In our solar system, the ecosphere's inner boundary lies just inside the earth's orbit, at 0.95 astronomical units (AU) from the sun (87.6 million miles, or 141 million km), where the solar flux is no more than 1.1 times that measured on Earth. The ecosphere's outer boundary falls at 1.60 AU, just inside the outer limit of Mars's orbit (1.66 AU). Here

the red planet receives only 0.5 times the light that shines on Earth. Venus, which is closer to the sun than the Earth, is bathed in 1.9 times more light. If life existed on Venus, it could not have maintained itself for long. Our Earth is located very close to the ecosphere's lower boundary. With a constant 1-percent increase in sunlight on average every 100 million years, the earth's average surface temperature will be close to 122° F (50° C) in a billion years, instead of the mild 59° F (15° C) it is today. Survival would be difficult. As for Mars, the current eccentricity of its orbit (9 percent) briefly takes it out of the ecosphere when the planet is farthest from the sun. On the other hand, when the sun becomes hotter, Mars will become a world with a more temperate climate.

We know today that if a planet the size of Earth were revolving on a Martian orbit, it would have a thick atmosphere of carbon dioxide and surface temperatures mild enough to keep its oceans from freezing. Though human beings could not breathe this air, it would be perfectly capable of supporting

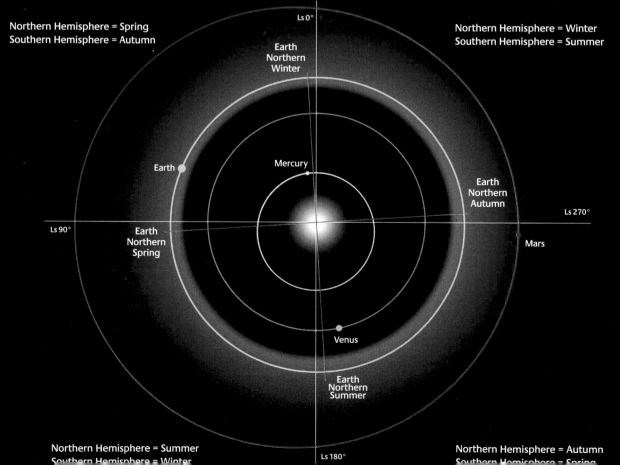

Ls 0°

Northern Hemisphere = Spring
Southern Hemisphere = Autumn

Earth
Northern
Winter

Northern Hemisphere = Winter
Southern Hemisphere = Summer

Earth

Mercury

Earth
Northern
Autumn

Ls 270°

Ls 90°

Earth
Northern
Spring

Mars

Venus

Earth
Northern
Summer

Northern Hemisphere = Summer
Southern Hemisphere = Winter

Ls 180°

Northern Hemisphere = Autumn
Southern Hemisphere = Spring

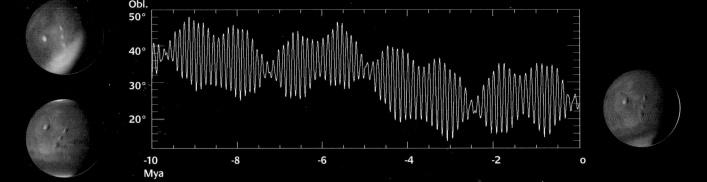

keep its oceans from freezing. Though human beings could not breathe this air, it would be perfectly capable of supporting evolved life forms such as plants. Unfortunately, Mars is only 11 percent as massive as Earth. It was not big enough to retain its primitive atmosphere of carbon dioxide for very long, and its "air" dissipated into space. All that remains today is a small, cold world where oceans froze early in its history.

Obliquity

The planet Mars has a variable and uncontrolled axis of rotation. Unlike Earth, which has a large moon, Mars has nothing to stabilize its inclination compared to the plane of its orbit (in other words, its "obliquity"). With a current inclination of 25.2 degrees, Mars has seasons like those on Earth, but it swings an average of 30 degrees every 100,000 years. As shown in the graph above, from 3 to 6 million years B.C., the obliquity varied from 5 degrees—when Mars would have been a planet with a calm atmosphere and big polar caps—to 48 degrees, when the atmosphere would be very active and permanent ice would be present at the equator. For example, from 20,000 to 10,000 years B.C., there was a gradual warming of temperatures at the poles, until a point of no return when the obliquity reached 27.5 degrees. Each pole then received longer periods of sunlight with the changing of the seasons. All the dry ice (frozen carbon dioxide) then sublimated, increasing the atmospheric pressure to 40 millibars. The water ice melted and increased the humidity in the atmosphere. At this time, it snowed between latitudes of 50 and 70 degrees. During these hottest periods, water would flow, forming the famous "Martian gullies" (*see page 96*). From 10,000 B.C. to

The three faces of Mars. Left: maximum obliquity (top) and minimum obliquity (bottom). Right: Mars today. (Sources: "The Last 10 Myr on Mars," by Manning, McKay, Zahnle. University of California, and "A New Astronomical Solution for the Long-Term Evolution of the Insolation Quantities of Mars," by Laskar, Gastineau, Joutel, Levrard, Robutel, IMCCE-CNRS, *Lunar and Planetary Science* XXXV/2004.)

present times, the situation has reversed. The obliquity has decreased. Atmospheric carbon dioxide condensed at the poles: the pressure dropped and trapped humid air at the poles, where the water vapor was deposited in the form of ice.

Even more dramatic changes took place further back in time. From 10 million to 2.5 million years B.C., the planet's average obliquity gradually increased to 38 degrees. At more than 35 degrees, the sun would have been strong enough in summer to sublimate and melt the polar caps. Conversely, the equatorial regions would have gotten less sun and must have become much colder, trapping the atmospheric humidity. Ice accumulated to a thickness of several yards or meters at a latitude of about 30° and remained for thousands of years, lasting even through the summer. The planet's atmospheric pressure would have risen to a maximum of 100 millibars and then quickly dropped again as the massive condensation of carbon dioxide plunged the hemisphere into darkness.

Mars has also known rare, short intermediate periods when the obliquity went down to 28 degrees, and ice began again to accumulate at the poles. When the average obliquity went down and stabilized for a longer period at 25 degrees, ice disappeared at most other altitudes, except in those places where it was now covered with an insulating layer of dust brought there by the winds. The polar caps were reborn, and Mars looked like the red planet we see today.

% | 2 | 2.8 | 3.6 | 4.5 | 6 | 6.3 | 6.6 | 7.5 | 8 | 8.8 | 9.5 | 16 | >32

6 pr-µm 23

A Water-Filled Planet

We detected water on Mars through a nuclear-physics experiment. Three instruments (a gamma spectrometer and two neutron spectrometers) were mounted on the *Mars Odyssey*, referred to as the "GRS" (for "gamma ray spectrometer"). This assembly measured the amount of hydrogen in the subsoil, made essentially of the water molecule H_2O. The results showed that Mars is filled with water (map no. 1). The blue areas show the places where the highest percentage of hydrogen was detected in the form of water ice in the subsoil. The yellow regions near the equator also indicate its presence, but in small quantities and mixed with rocks. From 70° N to the north pole (map no. 2), concentrations go up to 100 percent (red): here the cap is made of pure water ice. At the top left of this map, a large area around 72° N and 130° W reveals frozen lands containing at least 50 percent water less than a yard or meter deep; in the first 20 inches (50 cm) below the surface, the water concentration is as high as 70 percent.

By combining altimetric readings with temperature and pressure readings taken on the planet, a map could be created (map no. 3) that shows the lowest places on Mars (colored areas), where water could remain in the liquid state for twenty to thirty minutes per day. This data is coordinated with readings from places with maximum atmospheric humidity (measured in precipitable microns). The results indicate those areas (in yellow and red) where life on the planet surface (or a few inches/cm below), if any exists, could mostly likely be supported. (Not taken into consideration is the possibility of life hidden elsewhere under the surface, close to the water table, whose existence is suspected almost everywhere.)

In the past Mars had a huge northern polar ocean. Many traces of an ancient water flow bear witness to the convergence of water from the high equatorial plateaus to the low plains of the northern hemisphere. Map no. 4 (centered on the north pole) reconstitutes the second northern polar ocean that covered all the low plains periodically from 2.9 to 3.6 billion years ago and which finally froze. The water has not completely disappeared: instead, some of it remains, still in a solid, frozen state. Intermixed with all the sediment it has carried, it has been covered with some tens of centimeters of dust with the passage of time.

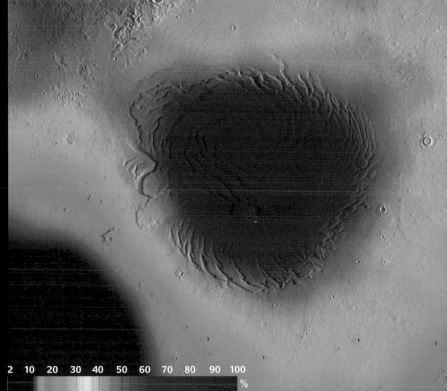

2 10 20 30 40 50 60 70 80 90 100
%

2. Data NASA/JPL/University of Arizona/Los Alamos National Laboratories. Altimetry: NASA/MOLA Science Team.

4. Altimetry: NASA/MOLA Science Team. Sources: "Fate of Outflow Channel Effluents in the Northern Lowlands of Mars," Kreslavsky, Head III, 2002, JGR, 107 (E12), 5121; and "Oceans on Mars: An Assessment of the Observational Evidence and Possible Fate," Carr, Head III, 2003, JGR, 108 (E5), 5042.

COMPARATIVE CHRONOLOGY OF EARTH AND MARS

From W. K. Hartmann and G. Neukum, "Cratering Chronology and the Evolution of Mars," *Space Science Reviews* (96), pp. 165–194, 2001.

Dates B.C. (in billions of years)	Earth's Geological Periods	Evolution of Life on Earth	Mars's Geological Periods*	History of Martian Geology
0.06	CENOZOIC	Mammals	LATE AMAZONIAN	Today's north polar cap
0.2	MESOZOIC	Dinosaurs		Volcanic eruptions on Tharsis
0		First reptiles		Outflows in Athabasca Vallis channel
0.4	PALEOZOIC	First plants		
0		Life on continents		Tiu Vallis channel formed
0.6		First invertebrates		
0			MIDDLE AMAZONIAN	
0.8				
0.9				Large growth of Olympus Mons
1				Mangala Vallis channel formed
1.1				
1.2				
	PROTEROZOIC			
1.4		Atmospheric oxygen		Large growth of Pavonis Mons
1.6				
				Large growth of Arsia Mons volcano
1.8				Large growth of Alba Patera volcano
1.9				
2				
2.1				
2.2		Traces of oxygen in the atmosphere	EARLY AMAZONIAN	
2				Athabasca Vallis channel formed
2.4				
2.5		First continents		Birth of the Olympus Mons volcano
2.6				Birth of the small Tharsis volcanoes
2				
2.8				Birth of the Elysium volcanoes
2.9				Vast northern ocean
3				First great outflow channels
3.1			LATE HESPERIAN	Great uplift of the Tharsis Bulge
3.2				Great lakes in Valles Marineris
3				Birth of the great volcanoes of Tharsis
3.4	ARCHEAN			Birth of the Alba Patera volcano
3			EARLY HESPERIAN	Valles Marineris begins to form
3.6		First algae	LATE NOACHIAN	End of Mars's warm period
3				Slowing of volcanic activity on oldest regions
3.8		First molecules of life	MIDDLE NOACHIAN	Huge oceans on Mars
3.9				
4				First volcanoes on ancient regions
4.1				Rise of Tharsis and first volcanoes
4.2			EARLY NOACHIAN	More dense and active atmosphere
4		First oceans		Formation of large basins including Hellas and Utopia
4.4		Formation of the moon		Intense asteroid bombardments
4				

* The names given to the geological periods of Mars are taken from the planet's characteristic formations, as follows:
• "Noachian" comes from the old region Noachis Terra (centered upon -40° S and 330° W) that is still marked by craters—evidence of the asteroids that bombarded the planet as the solar system was forming.
• "Hesperian" comes from the Hesperia Planum (centered around -20° S and 250° W) where ancient volcanoes sprouted on old terrain, without however obliterating the craters.

• "Amazonian" comes from the low plains of Amazonis Planitia, to the west of the giant Olympus Mons volcano (centered upon 15° N and 160° W). The late eruptions from this volcano obliterated all the ancient cratered and noncraterized terrains to create huge volcanic plains in the northern hemisphere. Amazonis Planitia extends to the west into Elysium Planitia with its great Elysium Mons volcano.

COMPARISONS BETWEEN EARTH AND MARS

CHARACTERISTICS	EARTH	MARS
Distance from the sun in millions of miles (kilometers) astronomical units (AU)	149.59 km 1 AU	from 206.65 to 249.22 km from 1.38 to 1.66 AU
Duration of revolution around the sun	365.25 days (1 year)	1.88 year (668 sols*)
Period of rotation (day)	23.93 hrs.	24.61 hrs. (1 sol)
Tilt of the equator to orbit (obliquity)	23.45°	24°
Mass (Earth=1)	1	0.11
Diameter (km)	12,756 km	6,779 km
Mean density (g/cm³; water=1)	5.52 g/cm³	3.94
Surface gravity (Earth=1)	1	0.38
Escape velocity	11.18 km/s	5.02 km/s
Albedo (visual)	29 %	16 %
Highest elevation	8,850 m (Everest)	21,300 m (Olympus Mons)
Lowest elevation	-11,035 m (Challenger Deep, Mariana trench, Pacific Ocean)	-8,210 m (crater bottom in Hellas basin)
Surface temperatures minimum average maximum	 -89° C (Antarctica) +15° C +58° C (Libya)	 -140° C (poles) - 63° C +32° C (south of equator)
Season lengths (northern hemisphere) spring summer autumn winter	 93 days 93 days 90 days 89 days	 194 sols (from Ls**=0°) 178 sols (from Ls=90°) 142 sols (from Ls=180°) 154 sols (from Ls=270°)
Composition of the atmosphere (%) nitrogen oxygen carbon dioxide (CO_2)	 78.08 20.94 0.033	 2.7 0.13 95.32
Atmospheric pressure at the surface	1,013 mb (at sea level)	5.2 mb (at 0 km elevation)
Solar flux received at surface (W/m²)	1 (1,320)	0.44 (580)
Satellites (name+diameter)	Moon: 3,480 km	Phobos: 27x23x19 km Deimos: 15x11x12 km
Satellite orbital distance from the planet's center	Moon: 384,400 km	Phobos: 9,378 km Deimos: 23,460 km
Satellite revolution period around the planet	Moon: 29 days 12 hrs.	Phobos: 7 hrs. 39 min. Deimos: 1 day 6 hrs. 21 min.
Altitude of an equatorial geostationary satellite above the surface // orbital speed	35,958 km //3.09 km/s	17,034 km //1.45 km/s

* The Martian day, a "sol," lasts twenty-four hours, thirty-seven minutes in Earth time.
** Solar longitude (Ls) is the coordinate of Mars's orbit around the sun, used to calculate the seasons.
One Martian year is the equivalent of Ls 360°; Ls 0° is the equinox of the northern spring and southern autumn;
Ls 90° is the solstice of the northern summer and southern winter; Ls 180° is the equinox of the northern autumn and southern spring;
Ls 270° is the solstice of the northern winter and southern summer.

COMPARISON OF COMPONENTS IN THE ATMOSPHERES OF EARTH AND MARS

IDENTIFIED GASES	MARS (in %)	EARTH (in %)
Carbon dioxide (CO_2)	95.32	0.033
Nitrogen (N_2)	2.7	78.08
Argon 40 (40AR)	1.6	0.93
Argon 36 (36AR)	4 ppm*	32 ppm
Oxygen (O_2)	0.13	20.94
Carbon monoxide (CO)	0.07	0.12 ppm
Water vapor (H_2O)	0.03	4 (variable)
Neon (Ne)	2.5 ppm	18.2 ppm
Methane (CH_4)	20 to 60 ppb**	1.70 ppm
Krypton (Kr)	0.3 ppm	1.14 ppm
Xenon (Xe)	0.08 ppm	0.09 ppm
Ozone (O_3)	0.03 ppm	0.4 ppm
Atmospheric pressure at the surface	*5.2 millibars*** at 0 m/km of altitude****	*1,013 millibars at sea level*

* ppm: parts per million
** ppb: parts per billion (for methane, variations were measured up to 250 ppb in some places)
*** millibars: the equivalent of hectopascals, another measure used by scientists
**** Now of 5.2 millibars. 6.1 millibars was the old figure for the average pressure on the surface of
Mars that was previously used by scientists, before the accurate topography built by the MOLA laser
altimeter aboard the Mars Global Surveyor orbiter, to determine the altitude "zero," at the season
corresponding to solar longitude 0° (Ls 0°) of Mars on its orbit. This value of 6.1 millibars, is no longer
valid and is now found at the altitude -5,250 feet (1,600 m) on the planet's new topographical map.

AVERAGE TEMPERATURE AND ATMOSPHERIC PRESSURES ON MARTIAN SURFACE, MEASURED OVER SEVERAL YEARS

LANDER	TEMPERATURES (in °C)						PRESSURE	
	Summer (local time)		Winter (local time)		During dust storms		(in mb)	
	5 A.M.	2 P.M.	6 A.M.	3 P.M.	5 A.M.	2 P.M.	Summer	Winter
Viking 1 (22.5° N and -3,600 m in elevation)	-85°	-30°	-95°	-57°	-83°	-69°	6.7	9.1
Viking 2 (48° N and -4,500 m in elevation)	-84°	-32°	-122°*	-92°	-81°	-71°	7.4	10.7

* A temperature sensor was positioned on the soil sampler collector head of the *Viking* landers.
In 1979, during the heart of the second winter at the *Viking 2* site, the lowest temperature readings
were -198.4° F (-128° C) at 6:00 A.M., and for a high that day only -155° F (-104° C) at 3:00 P.M.

GLOSSARY

Airbags: Inflatable cushions placed around the probe to protect it from the impact of landing.

Andesite: Volcanic rock, rich in silicon, from a subduction area where the planet's crust sinks into the mantle and is subject to partial fusion.

Clay: Earthy rock in lamina made of fine particles of hydrous silicate.

Asteroid: Small body within the solar system, with a diameter between 1 and 620 miles (1 and 1,000 km).

Basalt: Very common volcanic rock, rich in iron and magnesium, with a brown or black color.

Basin: Circular depression of various dimensions.

Caldera: Explosion crater or depression caused by a collapse at the center of a volcano.

Canyon: Valley carved out in a rocky plateau.

Chaos: Disordered pile-up of rocks (from the Greek for "confusion"). On Mars this also describes regions where the terrain has collapsed.

Channel: Long valley dug out by water (today on Mars, water no longer flows in huge volumes).

Conjunction: When two heavenly bodies are observed from Earth to be very close to each other. When the sun is between Mars and the earth, Mars is said to be in conjunction with the sun.

Convection: Circular upward and downward movement of a fluid, caused by variations in temperature and/or inner density.

Crater: Circular depression formed either by the blast of a volcanic eruption (volcanic crater), or dug out by the impact of a meteorite (impact or meteorite crater).

Crust: Outer envelope of a planet, made of low-density rocks, that covers the mantle.

Carbon dioxide: Colorless gas produced by the oxidation of carbon (CO_2), the main component of the Martian atmosphere.

Ejecta: Materials excavated from the surface and projected outward when a crater is formed.

Erosion: Wearing down of the surface by water, wind, or ice.

Lava: Melted rock in a liquid or pasty form emitted by volcanoes, with flows of varying length. After solidification, during which the inner gases escape, the rocks may have a vitreous or a porous appearance.

Maghemite: Iron oxide in the form of a highly magnetized mineral.

Magma: Melted rocks (liquids) in the interior of a planet.

Mantle: Rocky region in the interior of a planet, located between the crust and the core.

Meteorite: A rocky body that comes from space and survives its passage through the atmosphere of a planet to strike its surface.

Mineral: Inorganic body, resulting from a natural process, with a physical structure and a homogeneous chemical composition. Under certain conditions, minerals can form crystals.

Mons (pl. Montes): Important relief standing out from the surrounding topography (from the Latin *mons,* meaning "mountain"). Term used on Mars for the volcanoes.

Obliquity: For a planet, angle between its plane of the ecliptic (that of a planet's orbit around the sun) and its axis of rotation at the poles (25.2° for Mars and 23.45° for Earth).

Outflow channel: a large riverbed on Mars created by the sudden release of vast amounts of water and mud, with catastrophic and sporadic flood events.

Olivine: Common mineral found in volcanic rocks: $(Mg, Fe)_2SiO_4$.

Opposition: Mars is in opposition when Earth is found between the sun and Mars.

Orbit: Path followed by a planet around the sun.

Permafrost: Permanently frozen surface (also often found in great expanses in Canada and Siberia on Earth).

Planitia (pl. Planitiae, from the Latin): Extensive surface with low altitude and little topography.

Plate tectonics: Movements of a planet's crust that breaks it into individual plates (continents).

Precession: Cyclic and regular change in the orientation of a planet's axis of rotation.

Regolith: Layer of debris created by the pulverization of the surface due to the impact of meteorites.

Rover: Wheel-drive vehicle with motorized wheels.

Sedimentary rock: Rock formed on the surface of a planet by the gradual accumulation of rocky and organic sediment and from deposits created by chemical reactions.

Sediment: Fragment formed by the decomposition of surface materials that are displaced by erosion and transported by ice, water, or winds.

Silicates: Group of minerals containing silicon and oxygen (for instance, volcanic rocks).

Spectrometer: Instrument used to measure a spectrum, from which is derived a basic chemistry and the presence of minerals.

Subduction: Sinking of a tectonic plate of a planet's crust under another plate into the mantle.

Sublimation: Transition of a material from the solid to the gas state without going through the liquid state.

Tectonics: Fractures, diverse movements, and shakings that deform a planet's crust.

Terraformation: Action of transforming a planet to make it like Earth.

Vallis (pl. Valles): Used on Mars to name valleys (from the Latin for "valley").

Volcanic rock: Used here in reference to magmatic or igneous rock that results from the cooling of magma (granites and basalts).

Volcano: Exit point to the exterior of the crust for lava and hot gases coming from a planet's interior.

By the author

"Images from Space" and "2020 : Destination Mars," *The Cambridge Encyclopedia of Space* (Cambridge: Cambridge University Press, 1990).

A la Conquête de Mars. Larousse, 2000.

Visions de Mars. La Martinière-Tallandier, 2004.

By other authors

25 Years of Space Photography. The Baxter Art Gallery/IBM Gallery of Science and Art, California Institute of Technology, 1985.

The Art of Chesley Bonestell. Ron Miller and Frederick Durant III: Paper Tiger, 2001.

The Atlas of Mars: The 1:5,000,000 Map Series. NASA SP-438, 1979.

The Cambridge Encyclopedia of Space. Cambridge University Press, 1990.

The Case for Mars. Robert Zubrin: Free Press, 1996.

The Channels of Mars. Victor Baker: Adam Hilger, Ltd., 1982.

The Geology of the Terrestrial Planets. NASA SP-469, 1984.

The Grand Tour (2nd edition). Ron Miller and William Hartmann: Workman Publishing, 1993.

Magnificent Mars. Ken Croswell: Free Press, 2003.

Mapping Mars. Oliver Morton: HarperCollins Publishers, 2002.

The Mariner 6 & 7 Pictures of Mars. NASA SP-263, 1971.

Mars. Heather Couper and Nigel Henbest: Headline Book Publishing, 2001.

Mars. Don Davis and Peter Cattermole: Facts On File; BLA Publishing, Ltd., 1989.

Mars At Last! Mark Washburn: Abacus Sphere Books, Ltd., 1979.

Mars on Earth. Robert Zubrin: Tarcher-Penguin, 2003.

Mars, The Living Planet. Barry DiGregorio: Frog, Ltd., 1997.

Mars: The NASA Mission Reports, Vols. 1 and 2. Apogee Books Space Series, 2000 and 2004.

Mars, Uncovering the Secrets of the Red Planet. Paul Raeburn and Matt Golombek: National Geographic Society, 1998.

The Martian Landscape. NASA SP-425, 1978.

Mission to Mars. Michael Collins: Grove Weidenfeld Press, 1990.

Mission to Mars. James Oberg: New American Library, 1982.

NASA Visions of Space. Robin Kerrod: Prion Multimedia Books Ltd, 1990.

The New Mars: The Discoveries of Mariner 9. NASA-SP-337, 1974.

The New Solar System (4th edition). J. Kelly Beatty, Carolyn Collins Petersen, and Andrew Chaikin: Sky Publishing Corporation & Cambridge University Press, 1999.

On Mars: Exploration of the Red Planet 1958-1978. NASA SP-4212, 1984.

Out of the Cradle. William Hartmann, Ron Miller, and Pamela Lee: Workman Publishing, 1984.

Planetary Landscapes (2nd edition). Ronald Greeley: Chapman & Hall, 1994.

Project Viking. Irwin Stambler: G.P. Putnam's Sons, 1970.

The Quest for Mars. Laurence Bergreen: HarperCollins Publishers, 2000.

The Real Mars. Michael Hanlon: Constable & Robinson Ltd, 2004.

Robot Explorers. Kenneth Gatland: Blandford Press, Ltd., 1972.

To the Red Planet. Eric Burgess: Columbia University Press, 1978.

The Search for Life on Mars. Henry Cooper Jr.: Holt Rinehart & Winston, 1980.

The Smithsonian Book of Mars. Joseph Boyce: Smithsonian Institution, 2002.

Space Shots. Timothy Ferris: Pantheon Books, 1984.

The Surface of Mars. Michael Carr: Yale University Press, 1981.

A Traveler's Guide to Mars. William Hartmann: Workman Publishing, 2003.

Viking Lander Atlas of Mars. NASA CR-3568, 1982.

Viking Mission to Mars. NASA SP-334, 1975.

Viking Orbiter Views of Mars. NASA-SP 441, 1980.

Visions of Space. David Hardy: Gallery Books, 1990.

Web sites

www.msss.com The Mars Global Surveyor orbiter's MOC camera, at Malin Space Science Systems

http://themis.asu.edu The *Mars Odyssey* orbiter's THEMIS camera, at the University of Arizona

http://marsrovers.jpl.nasa.gov and *http://athena.cornell.edu* PANCAM camera of the two Mars Exploration Rovers (MER), at NASA/JPL and at Cornell University

http://marsprogram.jpl.nasa.gov NASA's Mars exploration program, at NASA/JPL

http://photojournal.jpl.nasa.gov NASA's Planetary Photojournal, a fully searchable, up-to-date database

www.esa.int The *Mars Express* orbiter, at the European Space Agency

www.marsunearthed.com Stereoscopic images and 3D anaglyphs of Mars (3D red-blue glasses needed)

www.lyle.org/mars Mars Exploration Rover imagery (site includes technical information about MER images, with automatically generated color composites and 3D anaglyphs)

http://pds-geosciences.wustl.edu/missions/vlander/lr.html The Viking Lander Labeled Release Data Set, with some evidence now pointing to the existence today of bacterial life on Mars (which might have been discovered in 1976)

www.planetary.org The Planetary Society, a site filled with information about Mars and planetary exploration

www.marssociety.org The Mars Society, with information about pioneering Mars and future manned Mars missions

PICTURE CREDITS AND ACKNOWLEDGMENTS

1. Except for those specified in points 2 to 6, all images used in this book came from public sources, including public-domain Internet sites. Some were also kindly made available to the public via the Internet by imaging team leaders (Dr. Michael Malin, for Mars Global Surveyor MOC camera; Dr. Philip Christensen, for *Mars Odyssey* THEMIS camera). *See pages 145–150* for descriptions of processing techniques employed by the author.

Credits are as follows:

Viking landers and orbiters (labeled "Viking") and *Pathfinder* lander ("MPF"): "Images NASA/JPL, processing O. de Goursac."

Mars Global Surveyor orbiter (labeled "MOC"): "Images NASA/JPL/Malin Space Science Systems, processing O. de Goursac."

Mars Odyssey orbiter (labeled "Themis"): "Images NASA/JPL/Arizona State University, processing O. de Goursac."

Mars Exploration Rover (labeled "MER"): "Images NASA/JPL/Cornell University, processing O. de Goursac."

2. The renderings of the Martian surface (labeled "MOLA") were done by the author according to a protocol he and Adrian Lark validated in cooperation with the Mars Observer Laser Altimeter team of the NASA Goddard Space Flight Center (many thanks to Dr. David Smith and Dr. Maria Zuber). Those images are credited "Data NASA/GSFC/MOLA Science Team, images O. de Goursac."

3. The renderings of the Martian south pole shown on pages 84–85 (labeled "USGS/MOLA" in the caption) were created from data made available by Dr. Laurence Soderblom and Dr. Trent Hare of the U.S. Geological Survey. Those images are credited "Data USGS, images O. de Goursac."

4. The mosaics of Mars (shown on pages 12–13, 18–19, 25, 48–49, 78, and 93) were produced in 1992 by the U.S. Geological Survey from images taken by the *Viking* orbiters (labeled "USGS" in the captions). Dr. Raymond Batson sent them to the author more than a decade ago. Spectacular and beautiful, these views provide an inspiring global vision of the red planet. Many thanks again to Dr. Raymond Batson and the USGS team.

5. Special thanks to the great space artist Pat Rawlings (*www.patrawlings.com*), art director of SAIC and one of the most popular artists in the world of aerospace, for permitting his work to be published herein (pages 128–129).

6. The color image showing the Venusian surface (page 151, top) was created from raw imaging data taken by the Russian *Venera 13* lander. It came to the author from Dr. James W. Head III and Stephen Pratt of Brown University. This image is credited "Data Brown University/Vernadsky Institute, image O. de Goursac."

7. For their longtime, friendly Martian cooperation, warmest thanks also to the following

• Dr. Phil Stooke of the University of Western Ontario, for his useful data on locating Martian landers, including the search for the *Viking 2* lander (*http://publish.uwo.ca/~pjstooke/*) described on pages 126–127.

• Dr. James Tillman of the University of Washington in Seattle, for the atmospheric and climatic data taken from the Martian surface by the *Viking* and *Pathfinder* landers (*http://www.atmos.washington.edu/~mars/*).

• Barry DiGregorio, professional science and aerospace writer, who often makes the author test his own limits in picture-processing techniques to get rational and geologic explanations for strange Martian features (*www.icamsr.org*).

• Dr. James Garvin, NASA chief scientist (at NASA headquarters), who kindly gave his valuable time to write the foreword section of this book.

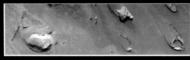

FOLD-OUT 1 (SHOTS FROM ORBIT)

1. Section 3.7 miles (6 km) across from top to bottom, at 79° S and 136° W, mesa at the south pole defrosting into "Dalmatian" spots (MOC).

2. Sunrise over Valles Marineris at the crossing of the Ophir Chasma (left) and the Coprates Chasma (bottom right) (MOLA).

3. Section 2 miles (3.25 km) wide and 4.3 mile (7 km) high, at 10° N and 204° W, traces of water and mud floods in the region of Cerberus, south of the Elysium volcanoes (Athabasca Vallis). The north is to the right. Ground compacted by crater impacts has been skirted by the flows coming from the northeast (bottom) to form teardrop-shape islands of sediment (MOC).

FOLD-OUT 2 (SHOTS FROM THE SURFACE)

1. *Viking 2,* on Utopia Planitia, at 6:50 A.M. On both sides, the antenna mast pointed toward Earth, the wind cover of the nuclear generator no. 1. The ultraflat landscape is deformed by the tilt of the probe (*Viking*).

2. Panorama taken in the late afternoon by Mars *Pathfinder*'s camera. Near the horizon, the Twin Peaks (MPF).

3. 11:00 A.M.: view from the summit of the Endurance crater's rim, 165 yards (150 m) across and almost 22 yards (20 m) deep. Left: near the horizon 1,312 yards (1,200 m) away, the nose cone with its parachute and in the foreground, the Burns Cliffs 5.46 yards (5 m) high with their stratified layers: they overhang the *Opportunity* rover located in the crater. In the middle, the 40° slope is less steep toward the bottom covered with a dune field. Right, the Namib and Kalahari promontories (MER).

VISIONS OF
MARS

Project Manager, English-language edition: Susan Richmond
Editor, English-language edition: Virginia Beck
Cover design, English-language edition: Michael J. Walsh Jr., Shawn Dahl
Design Coordinator, English-language edition: Shawn Dahl
Production Coordinator, English-language edition: Norman Watkins

Library of Congress Cataloging-in-Publication Data
Goursac, Olivier de.
 [A la conquête de Mars. English]
 Visions of Mars / Olivier de Goursac; foreword by Jim Garvin;
translated from the French by Lenora Ammon.
 p. cm.
 Includes bibliographical references and index.
 ISBN 0-8109-5910-0 (hardcover : alk. paper)
 1. Mars (Planet)—Exploration. 2. Mars (Planet)—Pictorial works. I. Title.

 QB641.G6913 2005
 523.43—dc22
 2004030412

Printed and bound in France

10 9 8 7 6 5 4 3 2 1

Harry N. Abrams, Inc.
100 Fifth Avenue
New York, N.Y. 10011
www.abramsbooks.com

Abrams is a subsidiary of
LA MARTINIÈRE